P9-CJI-651

Digital Photography for Teens

Marc Campbell and Dave Long

THOMSON

COURSE TECHNOLOGY

Professional ■ Technical ■ Reference

S

ISBN-10: 1-59863-295-7

ISBN-13: 978-1-59863-295-8

Library of Congress Catalog Card Number: 2006927154

Printed in the United States of America

07 08 09 10 11 BU 10 9 8 7 6 5 4 3 2 1

Publisher and General Manager, Thomson Course Technology PTR: Stacy L. Hiquet

Associate Director of Marketing: Sarah O'Donnell

Manager of Editorial Services: Heather Talbot

Marketing Manager: Heather Hurley

Acquisitions Editor: Megan Belanger

Marketing Assistant: Adena Flitt

Project Editor/Copy Editor: Cathleen D. Snyder

Technical Reviewer: Ron Rockwell

Teen Reviewer: J.T. Hiquet

PTR Editorial Services Coordinator: Erin Johnson

Interior Layout: Shawn Morningstar

Cover Designer: Mike Tanamachi

Indexer: Larry Sweazy

Proofreader: Jenny Davidson

THOMSON

COURSE TECHNOLOGY
Professional ■ Technical ■ Reference

Thomson Course Technology PTR, a division of Thomson Learning Inc.
25 Thomson Place ✦ Boston, MA 02210 ✦ http://www.courseptr.com

Dedication

To Mum and Dad, for helping me out when I was getting started in photography (and with many other things over the years).

—Dave Long

Acknowledgments

To MJ and Trowza, a big thanks for providing the atmospheric shot over the Ganges and the brilliant self-portrait. And to Rich and Jade, MJ, Jenny, Hayley, Ryhannon, Bonny, Lucy, Ian, Woody, Blue, Tess, Liesl, and Bella, thank you very much for helping set up or appearing in the photos for this book.

This book would not have been possible without the hard work and dedication of Megan Belanger, Cathleen Snyder, Ron Rockwell, JT Hiquet, Shawn Morningstar, Jenny Davidson, and the fine folks at Thomson Course Technology PTR, plus Neil Salkind, Stacey Barone, Linda Thornton, and the team at Studio B.

Dave would like to thank Marc for saying, "Hey, you interested in working on a photography book?" and then being a top bloke to work with and the best possible guide to the world of publishing.

Marc would like to thank Dave for offering his time, energy, talent, and humor in such abundance, for turning in stellar work on an impossible schedule, for being so consummately professional about it, and for thanking him in the previous paragraph.

About the Authors

Marc Campbell is a technology author, graphic designer, and instructor. His popular guides to computer graphics have appeared around the world in four languages. He spends altogether too much time at his computer. When he isn't trying to beat a deadline, you can find him out and about in Center City Philadelphia or at home with the lights down and the phone ringer off, his nose in a story about Robin Hood. This is his tenth book.

Dave Long of Canberra, Australia, has been a photographer for years. He went digital in 2004 and now works exclusively in the digital domain. His favorite subjects are the environment and animals, but he enjoys taking photos of pretty much everything. Rarely seen without a camera, he believes it's important to capture and reflect on moments and situations. He is still trying to convince Marc that not all Australians are convicts.

Contents

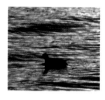

7
Adjusting Light and Color

135

8
Pushing at the Edges
(of a Digital Photo)

165

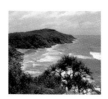

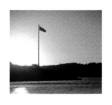

Introduction

Digital Photography for Teens.

We didn't come up with that title. We're not saying it's a bad one—we'd be the last ones to ask. When a publisher decides what to call a book, you can be sure that they know exactly what they're doing. And the title does say what this book is about—no questions there. *A Teen Guide to Insects* or *Look! It's Teens!* wouldn't quite cover it from our point of view. I doubt my suggestion of *Avocados and Mangos* would have gotten past Dave, much less the publisher.

It's the "for teens" part that's throwing me off. When I was a teen (not too terribly long ago), I was always suspicious of that particular qualifier. I was big into comic books in those days, and every now and then, the comics publishers would come out with a new line of titles "just for kids," or so it said on the covers. I stayed away from those books like I would a radiation leak. None of that kids' stuff for me, if you please! I required a more sophisticated, more literary comic, something along the lines of an *Amazing Spider-Man*, with people in costumes clobbering each other.

I always hated being seated at the kids' table, too. What, a guy doesn't shave, and he's a second-class citizen? I had my rights and I knew it, but nobody would listen.

And it's not like digital photography for teens is any different than digital photography for adults or digital photography for preschoolers or digital photography for senior citizens. The principles of photography don't suddenly change when you turn 18 or 21. For better or for worse, the photography in this book is the same photography that the parents use.

So in light of all that, we like to think of this book as *Digital Photography (for Teens)*, no matter what it happens to say on the cover. None of those smug "just for kids" labels here! This book is for photographers of all levels of experience who just happen to be in their teenage years.

We focus on the things that you, as a teen, most likely want to get out of digital photography, but this isn't the kiddie table, and it isn't patty-cake time. Photography is a technical field, and it links up with other technical fields. By Chapter 3, you'll be well into apertures and shutter speeds. By Chapter 8,

you'll be talking resolution and resampling. As you go, you'll make a casual acquaintance with optics, psychology, color theory, and aesthetics, among other subjects rare and strange.

At the same time, you don't need a lab coat or a diploma to get on with being a photographer, and we don't dump a lot of confusing jargon on you for no other reason than to make us look smart. This book isn't difficult, although it might be harder than you were expecting and it does get technical. But, it's nothing that you can't handle. If you come across a concept that doesn't seem to make sense, you might want to have a look back at the previous chapters. The chances are good that we snuck it in when you were busy looking at something else.

The main goal of this book is to help you have fun. We don't pretend to cover everything about digital photography, but we do stand by this promise to you: You will take better pictures after reading this book. You'll understand that photography is more than just pressing the shutter release, and you'll get more enjoyment than you ever thought possible from something that smells so much like science. Even better, you'll be ready for more advanced material, should this book awaken something photographic in you.

Some books are better to read by skipping around, but this one progresses from chapter to chapter, following the process of digital photography: setting up the shot, taking the picture, transferring it to the computer, editing it, and getting it ready for the screen or print. Your best bet is to start in Chapter 1 and work your way through to Chapter 12. Each successive chapter builds on the topics of the previous ones, so if you begin your journey in Chapter 7 or 8, you might feel a bit like you've landed in trigonometry class without your scientific calculator.

Here's how we set up the book:

+ Chapters 1 and 2 take you on a tour of digital photography in general and your camera in particular. You'll learn about the hardware and software. You'll get into how your camera works and what the various buttons do, and you'll sample some of the many ways that you can use your finished photos.

+ Chapters 3 and 4 are all about the art of photography. You'll learn about the effects of your camera's settings and how to use them to your advantage for almost any kind of picture. You'll explore techniques of composition and lighting, and you'll pick up a good many practical tips for the care and feeding of your photographer lifestyle.

+ Chapters 5 and 6 take your photos from your digital camera to your computer and show you how to keep them organized and safe.

✦ Chapters 7, 8, 9, and 10 talk about image editing, from the most basic of the basics to full-on photo doctoring. If you ever saw a bit of digital imaging wizardry—mismatched heads, somebody edited out of the background—and wondered how they did that and if you could do the same thing, then these chapters are for you.

✦ Chapters 11 and 12 are about your finished photos—how to prepare them for onscreen or print and what to do with them once they're ready.

Along the way, we provide sidebars to inform, clarify, assist, and amuse. They come in four flavors.

Dave Says. Dave is the guy behind the photos in these pages, but he pops into the words on a pretty regular basis to offer tips, tricks, reminders, advice, and the odd bit of trivia or strange-but-true fact.

In Depth. In Depth sections give you more information on the subject at hand. They're there for you if a particular topic catches your interest. Otherwise, feel free to skip them.

Muse Flash. You never know when inspiration is going to strike, so be on the lookout for Muse Flashes. They give ideas for fun, creative, and often slightly silly photo projects that pertain to whatever we're talking about at the time.

Caution. Cautions warn you about potential snags or drawbacks and offer suggestions for fixing them or working around them.

This wouldn't be much of a photography book if it didn't come with photos, so you'll find plenty of those—all digital, by the way—along with screenshots to illustrate the text. We tried to choose photos that stand on their own, so if words aren't your thing, you can get a decent introduction to digital photography just by looking at the pictures. But you *do* want to read the words too, right?

Getting Started

Know what's great about digital photography? Everything. And one of the best things about it is that it's so easy to get into.

Back in the days before digital photography, setting up as a photographer was an expensive proposition. Professional-grade equipment cost thousands of dollars. Film wasn't cheap either, and then you had to develop it, which added more money (and time) into the equation. Because the costs were so high, it was hard to get practice, unlike, say, a writer or even a painter. You had only a couple rolls of film to shoot, and when you were finished, the party was over. Then you had to wait around for the prints to see how well your work turned out. Mistakes and experiments gone awry cost just as much as the perfect, easy shot, so unless you were made of money, it just wasn't worth it to push the boundaries.

With digital photography, all of that has changed. The very best digital equipment still costs plenty, but decent gear is pretty cheap, and even the least expensive digital cameras can turn out surprisingly impressive work. Forget about film, because you no longer need it, and you don't have to install a darkroom in your closet. Digital storage is abundant and completely reusable, so you can get as much practice as any writer or painter. In some ways you're actually better off, because digital cameras are easier to carry around than bulky old notebooks and drawing pads.

Another bonus is that you see immediately whether you got the shot, which gives you the freedom of spontaneous do-overs. Better still, you can afford to experiment. You can take all kinds of creative risks. If something doesn't work out, press Delete, and it's gone, and you free up that space on your memory card. Digital photography enables you to focus less on all the annoying practical details and more on the art of photography, which is the whole point of photography in the first place.

But the benefits don't stop there. Because digital photographs are electronic, you can crop them, enhance them, sharpen them, stretch them, shrink them, cut them to pieces, string them together, put them one atop another, and do anything else to them that you can imagine, all on your computer. As with any skill, this takes practice to master, but once again, it's easy to get started, and it's far easier with digital than it ever was with film. Doctoring photos in the old days was a royal pain. Creating something as simple as a UFO hoax meant getting out the pen knives, glue, and scissors and fooling around with double exposures. Now all you need are a couple image files and some software. Cut the UFO from the one, paste it into the other, and you can bring the aliens to your hometown.

Start with two photos in Adobe Photoshop.

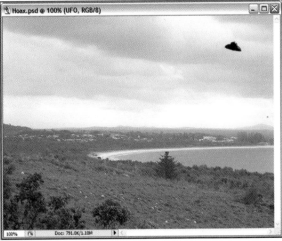

Do a little cutting and pasting and make a few other modifications, and you're ready to frighten the neighbors.

Digital photos are also more versatile than traditional photos. You can use the same shot for all kinds of purposes. Crush down one version for easy e-mailing to your friends. Post another to your profile on MySpace or your blog. Print out a high-quality copy for your portfolio. Store the original on your computer, and keep it around for whenever inspiration strikes. You can burn your photos to CD or DVD, turn them into a slideshow complete with background music and your voiceover, print them out on regular or glossy paper, make them into greeting cards or coffee mugs, or paste them into your homework assignments. Your teacher will be rendered speechless when you hand in an *illustrated* book report.

Want to score major points with your teacher? The next time you get a writing assignment, see about including some digital photos as illustrations. Just don't use the photos to pad your work—this trick will probably backfire.

If you're reading these words, the chances are good that you're already sold on digital photography. Maybe you have a digital camera and you're in the market for reasons to go out and use it. Maybe you always had a thing for photography, and you're seriously thinking about giving digital a try. Either way, this chapter will help you get started.

What You Need

For digital photography, you need a few things:

+ **A digital camera.** This goes without saying. No camera, no pictures.

+ **A computer.** Windows or Mac, desktop or laptop, new or old— whatever you prefer. You don't *absolutely* need a computer. It isn't the computer that's taking the pictures. But you won't be able to do very much with your photos if you don't have a computer to work with them.

+ **Computer software.** This is for organizing your digital photos as much as it is for editing them. When you first start out, you might use the same software application for both jobs. As you become more skilled, you'll probably find that you need separate applications for separate tasks. In any case, the software that came with your digital camera is enough to get you started.

Depending on what you want to do with your finished photos, you might need some extra computer gear:

✦ **A printer.** This is for making prints of your work. It's easier to survive without a printer than you might think. If you don't need physical prints, then obviously you can cross this one off the list. Some digital photographers work exclusively in the digital realm. They publish their work online, or they get their publisher to make the physical copies, so they have no need for a printer of their own. For quick prints here and there, you can always borrow a friend's printer or use the one at school. But if you plan to do a lot of printing, especially if you need your prints in a hurry, it makes good sense to have a printer on hand.

Printing at home isn't necessary, and it isn't always the best option. It is often cheaper —even if you already have a printer—to use a digital printing service, such as Kodak EasyShare Gallery (www.kodakgallery.com) or Shutterfly (www.shutterfly.com). These services are pretty straightforward. You send them your digital photos electronically, and they make the prints and send them back by mail. They can even put your pictures on gift items, such as mugs and pillowcases. The only drawback (aside from the wait time) is that you need a credit card to pay, so you have to get the parents involved.

If the credit card is an issue, or if you prefer to stay local, you can take your photos to most camera shops for processing. Just drop off a CD or your memory card the same way you would a roll of film. If instant gratification is more your thing, put the CD or memory card in one of those automated kiosks, and walk away with your prints.

Not every service provides the same level of quality, so it's worth doing a little research before sending in a large batch of photos. Try the service out on a small job first, and if you like what you see, consider using them again on larger jobs.

✦ **An Internet connection.** This is how you send your photos by e-mail or post them to a website. You don't need a super-fast Internet connection unless you want to send high-quality photos intended for printing. For quick and easy viewing on screen, such as in an e-mail or on a blog, even a really slow dial-up connection will work fine. Chapter 11, "Showing Your Photos on Screen," shows you how to crush down your digital photos so that they zip across the Net with ease.

✦ **A CD or DVD burner.** This is for making CD or DVD photo albums, scrapbooks, and portfolios. Some software will even enable you to create DVD slideshows that you can play in a normal DVD player. If you want to save a few trees, CDs and DVDs are great alternatives to good old-fashioned paper.

But now your humble authors are getting ahead of themselves. So let's go back to the three main requirements—the camera, the computer, and the software—and look at each of them more closely.

Choosing a Digital Camera

So which digital camera is right for you? Seriously, whichever one is nearest. You don't have to be on the cutting edge of technology to have a blast with your friends and express your creativity. All you need is a camera that gives you decent results, and digital technology has gotten so good that this applies to almost *any* camera.

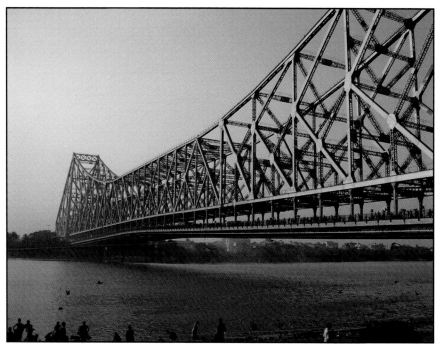

A bridge over the river Ganges, as captured by Dave's sister using a modest digital camera. You don't need pro gear to get impressive results.

When you're talking about price and features, there are three main kinds of digital cameras. The first kind is the point-and-shoot. Point-and-shoot or compact cameras are the least expensive of the three types. You can buy them off the shelf in electronics stores and pretty much anywhere that sells computers. You're probably using a point-and-shoot, but don't be embarrassed—these things aren't toys. Because they're so convenient (and because they take great pictures), many pros like to keep one handy at all times, even when they're lugging around their high-end gear.

The second kind of camera is the prosumer model—that's prosumer as in professional/consumer. As you might expect, these are somewhere between point-and-shoot and professional cameras. They give you more features, but they cost more money. They're good for photography majors and way-serious hobbyists, but you definitely don't need one to play this game. If you have one, great, but it's by no means necessary.

The third kind of camera is the professional model, which is the best but the most expensive. It's a professional camera for a reason—unless you make your living taking photographs, it's too much camera for your needs. For learning and experimenting with digital photography, a point-and-shoot camera is the way to go.

With that said, if you're shopping for a digital camera, you might as well get the most for your money. Here are some tips for making the best choice.

How Many Pixels?

A digital image is made up of tiny, colored squares called *pixels*. The more of these things that your camera can capture, the crisper and more realistic your photos will be and the larger in size your prints can be. We get into this more in Chapter 2, "Introducing Your Digital Camera."

Most manufacturers of digital cameras talk in terms of *megapixels*. One megapixel equals one million pixels, so a five-megapixel camera gives you five million pixels. For good, clear snapshot-sized prints, you'll want two to three megapixels. If you don't plan to print out your photos, one megapixel is more than enough. Table 1.1 shows you what you can expect to do at different megapixel levels.

If you're worried about not having enough pixels, don't be. These days, it takes a lot of looking to find a digital camera with fewer than three megapixels. Even the cameras that come in the latest cell phones give you more megapixels than yesterday's hottest cameras!

Table 1.1 Photo-Quality Print Size by Camera Megapixels

Megapixels	Good For
<1	On-screen use only (e-mail, blogs, websites, DVD photo albums)
1	Wallet-size prints
2	4×6 prints
3–4	5×7 prints
5	8×10 prints
6	11×14 prints

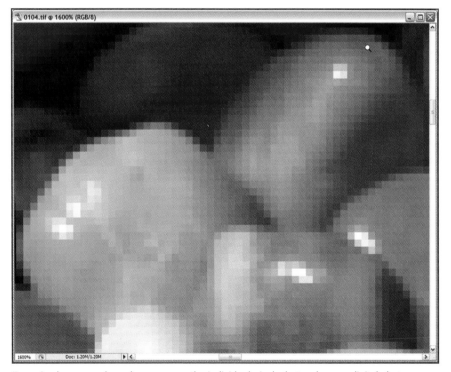

Zoom in close enough, and you can see the individual pixels that make up a digital photo.

How Much Memory?

Your camera stores digital images on its removable memory card, which is just like the memory in a computer and very much like the memory in your brain.

The more memory on the card (or in your computer, or in your brain), the more pictures you can store at the same time, and the higher quality these pics can be. Unlike film, a memory card is reusable. After you fill it up, you transfer your photos to the computer. Reformat the memory card, and it's as good as new.

Now for the bad news: The memory card that comes with your camera doesn't give you much in the way of storage. Whichever camera you buy, you'll almost certainly want to get a larger memory card for it. Don't forget to factor this into your budget.

But how much memory do you need? Other than the fact that more is better, that's hard to say. Every digital camera is different, with different quality settings —more on that in Chapter 2—but the higher the quality setting, the sooner you will fill up your memory card. And it isn't just the quality setting that makes a difference. The photo itself plays an important role. Busy shots with lots of color tend to take up the most memory, whereas not-so-busy shots usually take up less memory.

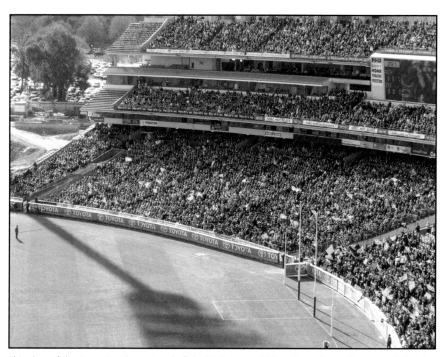

This shot of the Great Southern Stand of the Melbourne Cricket Ground contains tons of visual information, so it takes up more memory than usual.

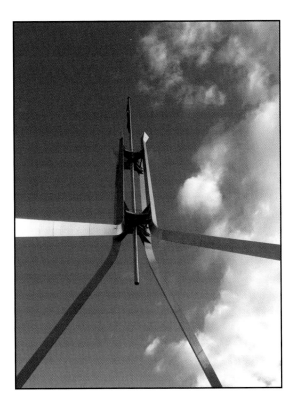

By contrast, this shot of the flagpole at the top of Parliament House in Canberra doesn't contain as much visual information, so it takes up less memory than usual.

If you look in the manual that comes with your camera, you ought to find a table in there somewhere that tells you how many high-quality photos you can expect to shoot before filling up your memory card. (Remember, though, your actual experience will vary!) This information, along with your best guess as to how many photos you need to shoot at a time, will give you an idea of how much memory you ought to have. For instance, if you think that you'll take 100 photos at a time, and each photo is expected to use around 2.5 megabytes of memory, then a 256-megabyte card should do the trick. (100 photos times 2.5 megabytes is 250 megabytes.)

If you're trying to decide between a lot of extra memory or a more expensive camera, go with the camera, since you're less likely to replace it as quickly. And don't worry about getting all the memory that you'll ever need right away, especially since the price of memory per megabyte continues to drop. (Recently I purchased a two-gigabyte card for less than the price of a 256-megabyte card in early 2004!) It makes good sense to get just as much memory as you need for the present, or maybe a little extra, and then add more memory cards later, as your needs grow.

It's worth pointing out that there are several different kinds of memory cards:

+ **SD (Secure Digital).** These cards are the most common ones around. Certain camera models from Kodak, Nikon, Casio, and Canon use SD memory cards. What makes these cards secure is their write-protect switch, much like the switch on old computer floppy disks.

+ **xD (Extreme Digital).** These cards are for Fujifilm and Olympus digital cameras. They're very small, so they're ideal for ultra-compact cameras, but sometimes they're slower than SD cards, meaning that it may take longer to store and transfer your pictures with them.

+ **Memory Stick.** These cards are for Sony gizmos. They tend to be the slowest of the memory cards, but broad support from Sony means that you can transfer and view your photos on a wide variety of devices, including some TV sets, without a computer.

+ **CF (CompactFlash).** Support for these cards is common in more expensive digital cameras. CF cards have a built-in microprocessor, which enables them to store and transfer digital photos very quickly —at least in theory. Some older CF cards are slow indeed, and some digital cameras don't take advantage of the microprocessor in the card.

As you can see, not every type of memory card works with every digital camera. If you're not sure which type to get, check the manual that came with your camera or go to the manufacturer's website.

It isn't always convenient to unload your memory cards, such as when you go on vacation and leave your computer at home.

If you find this happening to you a lot, it might be time to think about a portable hard drive. This is just like the hard drive on your computer, only it's a separate device, and it's small and light enough for you to carry with your camera. When you run out of space on your memory cards, you transfer your photos to your portable hard drive. Then when you get home, you transfer the photos from your portable hard drive to your computer. A portable hard drive isn't a computer—you can't run software on it— but it's great for storing pics when you're on the road.

Prices vary, but if you look around, you can find a decent portable hard drive for about the cost of a high-capacity memory card, and the hard drive comes with a lot more storage.

What Kind of Connection?

For any kind of serious digital photography, you need to connect your camera to a computer. Depending on your needs, you might also want to be able to connect the camera directly to your printer, your cell phone, or your MP3 player. There are a couple different ways to go about this:

✦ **USB.** Far and away, this is the most common type of connection. Almost every digital camera out there comes with a USB port. (The *port* is the receptor thingy on the camera that you plug the connector cable into.) One end of the USB cable goes into the camera, the other end of the cable goes into the computer, and presto—you're connected.

✦ **FireWire.** A few digital cameras come with FireWire ports. A FireWire connection is more for digital video and audio, not so much for still photography, but many digital cameras can shoot video too, so FireWire isn't much of stretch.

✦ **Wi-Fi.** Unlike USB and FireWire, Wi-Fi is a wireless connection. In other words, you don't need to run a cable between the camera and the computer to hook them up. Wi-Fi is popular on laptop computers, and a growing number of digital cameras come with Wi-Fi connections.

✦ **Bluetooth**. This is another type of wireless connection. It's handy for sending your photos to your cell phone or MP3 player (as long as these gadgets are Bluetooth-equipped), but it might not help you out with your computer. Not too many of today's computers come with a Bluetooth connection, although we're starting to see it more and more.

We'll talk more about connections in Chapter 5, "Getting Your Pictures into the Computer." For now, just be aware of the options, and keep in mind that you don't need all kinds of crazy connections to have fun with digital photography. The USB connection is the most important, because it gives you the most flexibility. You can connect to your computer through USB, and you might even be able to connect directly to your printer this way, too. (See Chapter 12, "Making Prints," and your printer manual for details.) If your camera comes with other connections, that's great, but all you really need is one that works, and for most digital photographers, that's USB.

IN DEPTH

To get new digital photography gear for your birthday, try this surefire plea.

[Insert gift-giver's name], all I want for my birthday is [insert gear desired]. Digital photography isn't just a phase for me, as it is for [insert names of cousins, siblings, and so on]. For me, it's a way of life. It's a way for me to express myself and become a happier, more fulfilled, just plain better person. Best of all, the suggested retail price is only [insert price], but how can you put a price tag on creativity anyway? I promise that, if I get the [repeat gear] for my birthday, I will use it only for the betterment of society and the preservation of all the time-honored values that you have sacrificed so much to teach me.

If I don't get the [repeat gear] for my birthday, of course I will understand, but I will never forgive you.

The most important thing to remember at this stage is this: Take any two electronic devices, be it your camera and your computer, your camera and your printer, or your camera and your cell phone. Both devices need to have the same kind of connection, or the connection won't work. So to connect with USB, your camera and your computer both need USB ports. To connect with Bluetooth, your camera and your cell phone both need Bluetooth. If your camera has Bluetooth but your cell phone doesn't (or the other way around), then you can't use Bluetooth to hook them up. If you think about it, it's just like making a telephone call. You can use your phone to call anyone in the world—as long as they have a telephone, too!

How Much Zoom?

One of the most important features of any digital camera is its zoom rating. *Zoom* makes faraway subjects appear closer (or already close subjects appear *really* close). For instance, a zoom of 5× means that the subject appears up to five times closer in the picture than it really is.

Digital cameras have two kinds of zoom—optical and digital. *Optical zoom* uses the lens of the camera to create the zoom effect. As the picture comes into the lens, the lens acts like a magnifying glass. By the time the camera records the picture, the image is already in a zoomed-in state.

With *digital zoom*, it's a little different. The lens doesn't do anything special to the image. The picture goes into the camera at normal size, and then the camera plays with the digital data, magnifying one portion of the total picture and cropping out (or cutting) the rest.

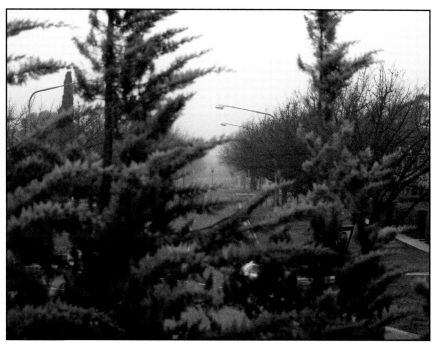

This shot could use a little zoom.

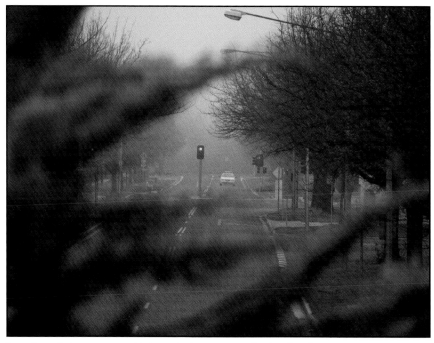

Peer through the greenery with 3× optical zoom. Note the detail in the trees on the right!

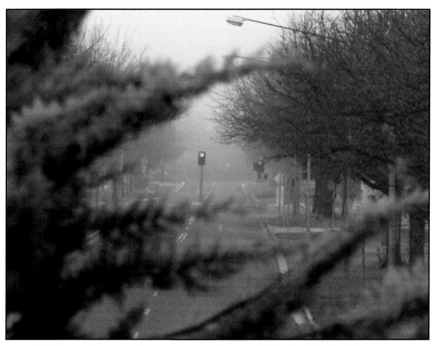

At 3× digital zoom, image quality is getting murky, especially in the little details.

Because of the way that digital zoom works, you lose some overall image quality. The picture becomes less crisp and clear. The more you zoom in, the more noticeable the effect. This isn't true for optical zoom. Because optical zoom happens in the lens, before the camera stores the picture, you don't lose any image quality at all. So if you're shooting at 5× optical zoom, your picture is *exactly* as crisp and clear as it would be if you were standing five times closer. But if you're shooting at 5× digital zoom, your picture is blurrier than it would be otherwise, so you're better off just moving closer to your subject.

If the option is available, you might want to turn off any digital zoom that comes with the camera, because it can trick you into thinking that you're getting a better-quality shot than is actually the case. Besides, you can add as much digital zoom as you like— no matter how much you get with your camera—after you transfer the photo to your computer. More on that in Chapter 8, "Pushing at the Edges (of a Digital Photo)."

Good optical zoom—say 4× or higher—saves you the trouble of moving closer, and for more serious digital photography, it's a must. (Of course, digital zoom

is fine for when you're horsing around.) So when you're shopping for a digital camera, look specifically for the optical zoom rating, and pay less attention to the digital zoom. Sometimes camera manufacturers try to fake you out by giving a combined zoom rating, so read the back of the package very carefully.

 Wide zoom cameras, which enable you to take wide-angle pictures, can also be useful. A wide-angle option adds a lot of potential artistically, and it can help to squeeze a larger subject (for instance, a large group of people) into one shot.

What Other Features?

Picture quality isn't just about megapixels and optical zoom. Here are some other important factors that may tilt you one way or the other when you're comparing digital cameras:

+ **The viewfinder.** This is what you use to determine what you're shooting. Many cameras have two of these—the optical viewfinder, which is the little window that you look through, just like the one on a traditional camera; and the digital viewfinder, which is the LCD display. Of the two, the digital viewfinder is the more accurate. It gives you a better idea of the actual size of the picture, and it does a pretty good job of displaying the results of whatever special camera effects you're using. The problem with some LCD displays is that they're hard to see in direct sunlight, and really low-light conditions might render them useless. We mention this because some smaller cameras give you the digital viewfinder only. All else being equal, it's better to have both kinds of viewfinders, because neither is perfect.

+ **The shutter response.** This is the time it takes the camera to capture your shot after you press the go button (or the *shutter release,* to be photographical about it). As you might expect, less lag is better. Shutter response isn't as much of a concern as it used to be because newer digital cameras tend to have workable shutter responses across the board, but there's no harm in checking out the manufacturer's ratings, just so you know what you're getting. As a general guideline, anything under one second is reasonable, and anything under half a second is very good indeed. Keep in mind that shutter response changes depending on all kinds of conditions, including the quality setting and whether you're using auto-focus. (See Chapter 2 for more on these features.)

◆ **The lens.** This is the eye of the camera, so to speak. The image comes into the camera through here. Better lenses give you better results. All modern lenses are good, including the one on your digital camera. Your lens is perfectly fine for general-purpose digital photography. At the same time, some lenses are better than others, so you might want to do a little snooping around online to see what the experts are saying about yours. Think of it as good practice for the future, because at the professional level, the lens becomes a *very* important consideration. In fact, pros use a variety of lenses for different types of shots. Your camera probably doesn't let you change lenses, but a professional's camera does.

◆ **The shutter speed.** The *shutter* is what lets the image in through the lens. When you press the shutter release, the shutter opens, the image goes in, and the shutter closes again. How long it takes all this to happen—usually just a fraction of a second—is the *shutter speed.* Because different kinds of shots benefit from different shutter speeds, better digital cameras give you a wider range of options. For more information on this, see Chapter 3, "Different Shots, Different Settings."

◆ **The aperture.** The *aperture* is the size of the opening in the lens. The larger the opening, the brighter the image that goes into the camera. Being able to control the aperture helps you get the perfect shot under a wide range of conditions, so better digital cameras give you a nice range of aperture settings. We talk more about the creative possibilities of apertures in Chapter 3.

◆ **The sensor.** This is what the camera uses to capture the picture coming in through the lens, as we will discuss in Chapter 2. More expensive digital cameras give you better sensors, which respond better to special conditions such as low light. Like the lens, the quality of the sensor is more a concern of the very serious student or professional.

◆ **The feel.** It might seem obvious, but there's no point in getting an expensive, major multi-pixel digital camera with a nice range of features and 12× optical zoom if it doesn't feel good in your hands. You're like a musician, and the camera is your instrument. You want it to feel comfortable. Even more importantly, you want to be able to reach the controls with ease, especially the shutter release and the zoom. This way, you're thinking about that next great shot, not where you're supposed to put your fingers.

Preparing Your Computer for Liftoff

Just as digital cameras have gotten so good that you don't have to worry about choosing the wrong one, computer technology has advanced so much that today's machines, no matter how modest, have more than enough in all the right places to work with digital photographs. Whether you have a stripped-down, no-frills ninja model or a turbo supercharged multimedia barbarian, you have computer enough to do digital photography.

You might want to take a few minutes here to go over some of your computer's specs, just to see how they fit into your photographer lifestyle.

Checking Connections

You won't actually get around to connecting your camera to your computer until Chapter 5, but there's no harm in scoping out the situation a little bit ahead of time. This way, you'll be ready for action when Chapter 5 rolls around.

In the last section, you saw that USB is the most common method of connecting a digital camera to a computer. As it turns out, USB is the most common method of connecting *everything* to a computer, from mice and keyboards to printers and scanners. Your computer only gives you so many USB ports, so what do you do if you run out?

Never fear: If all of your computer's USB ports are already spoken for, you have a couple easy options:

✦ **Temporarily unplug a device that you don't need.** Plug your camera into the freed-up port, transfer the photos, unplug the camera, and reconnect the device. It works, although it's kind of a pain. If you do this, make sure that you don't disconnect a vital piece of gear, such as your keyboard or mouse. It's fine to disconnect your printer because you'll print from the computer, not the camera. Just plug the printer back in before you try to print.

✦ **Get a USB hub.** A *USB hub* is a small desktop device that gives you more USB ports, usually more than you'll ever need. You plug it into one of the USB ports on your computer, and then you connect as many USB gizmos to the hub as you want. A hub is great, too, if all of your USB ports are on the back of your computer.

You might also be able to connect your camera to your computer using some other method entirely. If both devices have FireWire, Wi-Fi, or Bluetooth, then you don't need to connect with USB. Some computers and printers come with

memory card readers, so there's always that option, too. Or, you can get a portable card reader, although you need a spare USB port to plug it in.

Managing Memory

The more memory in your computer, the more information your computer can work with all at once. Just as larger memory cards enable you to store more digital photos, more computer memory enables your computer to work with more digital photos at the same time.

To get a little technical, we're talking about your computer's RAM here—that's *Random Access Memory.* You can think of it a bit like the computer's right-now or short-term memory. Whatever you're doing on your computer right now—whatever webpage you're viewing, whatever song you're listening to, whatever DVD you're watching, or whatever e-mail you're writing—it's all in your computer's RAM. If you're working with your digital photos right now, those are in RAM, too. The more RAM you have, the more digital photos you can work with. And your computer has a lot of RAM. Even a very modest computer has enough to handle digital photos from the most powerful multi-megapixel digital cameras.

You won't have to think about RAM unless you want to load a whole bunch of digital photos at the same time, such as if you're reviewing yearbook photos of all your classmates at once. For situations like this, 512 megabytes of RAM gives you plenty of elbow room. Professional photographers sometimes go to one or two gigabytes, just to be safe.

Handling Your Hard Drive

If RAM is like your computer's short-term memory, then your hard drive is a bit like its long-term memory. The hard drive determines how much information you can save for later. When you transfer digital photos from your camera, the hard drive is where they go. The more free space on your hard drive, the more digital photos it can hold.

Computer hard drives are ridiculously commodious, with the smallest drives these days weighing in at 40 gigabytes. With storage space like this, you can save many, many photos to your hard drive before you come close to filling it up. You will fill it up eventually, but you're far more likely to upgrade your computer first.

All told, I have about 4,500 digital photos in my archives. That's about 11 gigabytes worth of photos!

You might fill up that hard drive faster if you share your computer with a sibling or two or if the whole family uses the same machine. If this is your situation, you can maximize your share of hard drive space by burning older photos to CD or DVD. Pros call this maneuver *archiving,* as in making an archive. It's a good idea to do this anyway, because you don't want a hard-drive crash to wipe out all your work. At least one of your humble authors has gone through this unpleasant experience once, and believe me, once was enough. We discuss the value of making backups of your photos in more detail in Chapter 5.

Scoping Out Software

Your computer isn't just for storing digital photos; it's also for organizing and editing them. Although you don't need any special software to store your photos, if you want to organize and edit—and you do—you get the best results from dedicated photo software.

You know already that you can divide photo software into two main types:

+ **Software for organizing digital photos.** These applications keep a record of all the digital photos on your computer so that you can see at a glance what you have. You can name the photos, sort them, print them, label them, and manage them to your heart's content. Many organizers also give you a way to share your photos online or order prints. Picasa from Google, Microsoft Office Picture Manager (both on the Windows side), and iPhoto (for Mac heads only) are excellent photo managers. Ron, who is the tech editor for this book, recommends Adobe Lightroom and Macintosh Aperture. Everyone has a favorite!

+ **Software for editing digital photos.** These applications enable you to modify the content of your digital photos. You can make simple changes, such as adjusting the color or the sharpness, or you can make complex changes, such as removing an old boyfriend. Adobe Photoshop (for both Windows and Mac) is the image editor of choice for pros of all kinds , but it isn't the only image editor out there. (It's a good thing, too, because the full version of Photoshop costs *mucho dinero.*) Adobe Photoshop Elements, Corel Paint Shop Pro, Adobe Macromedia Fireworks, and GIMP are useful and popular (and less expensive) alternatives.

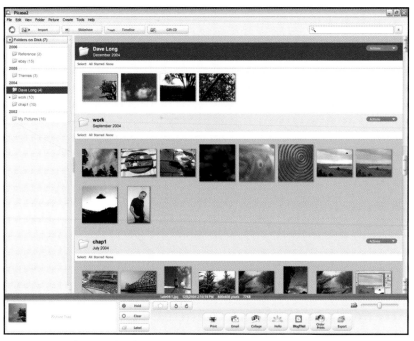

Organize your photos with software such as Google's Picasa 2.

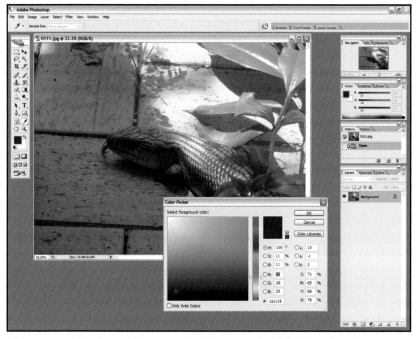

A blue-tongued lizard reveals the true color of its tongue in Adobe Photoshop CS2.

Much of the photo software that comes with digital cameras is for Windows only. If you're on a Mac, check the back of the camera package for platform compatibility.

There's plenty of overlap between these two types of photo software. You can edit your photos in Picasa 2, and you can do quite a bit of photo management in Photoshop. The software that came with your digital camera is very likely a hybrid, too. If you have a recent digital camera from HP, you know that Photosmart Premier is one such animal, as is the EasyShare software that comes with Kodak cameras. But generally speaking, organizers are better at organizing, and editors are better at editing. We get into photo management in Chapter 6, while Chapters 7 to 10 are all about photo editing.

If you want one application that does everything well, look no further than Adobe Photoshop Elements.

Photoshop Elements is the younger sibling of Photoshop, combining many of Photoshop's advanced editing capabilities with many of the management features of Adobe Photoshop Album, another member of the extended Photoshop family.

Photoshop Elements is so useful that we refer to it again and again throughout this book. At the same time, this isn't a commercial for Adobe. You don't need to get Photoshop Elements to use this book unless you really want to. You should have an easy enough time following along and applying the same techniques using the software tools of your preference.

In addition to organizing and editing software, there are hundreds and hundreds of software tools for putting your digital photos to use. You can insert your images into word processor documents. You can put them into page designs with desktop publishing applications. You can combine them with line art in drawing programs. You can turn them into Flash animations. You can add them to websites. There's software to make slideshows, charts, graphs, CD covers, and recipe books, and all of the software packages love it when you import your digital photos. Looking ahead, Chapters 11 and 12 will help you get productive with your work, be it in print, online, or anywhere in between.

But first, you need to take some photos. You get up to speed on your digital camera starting with the next chapter.

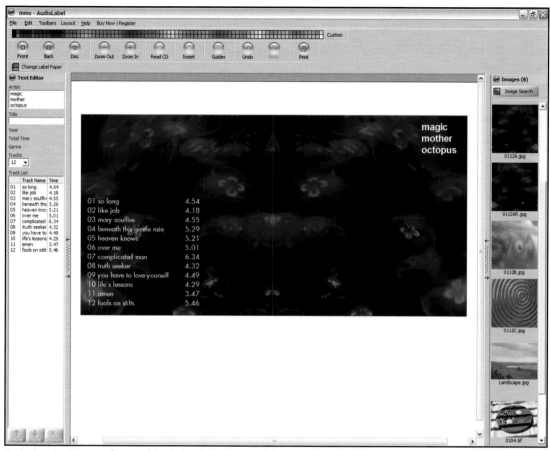

Designing the CD cover for your friend's band is only one of the many benefits of being a digital photographer.
This photo is of some jellyfish under ultraviolet light. The software is AudioLabel by Cripple Creek (www.audiolabel.com/).

Introducing Your Digital Camera

Camera, you. You, camera. Your humble authors have a feeling that you'll get along famously.

The better you know your digital camera, the better the work you do with it. Getting to know your digital camera is what this chapter is all about.

How a Digital Camera Takes Pictures

A computer and a typewriter are nothing alike. True, they both have keyboards with letters and numbers, but that's about where the similarities end. To say that a computer is a super-advanced typewriter is like saying that a sports car is a super-advanced wheelbarrow.

So it's something of a miracle of science that a digital camera and its film-based counterpart have so many things in common. They don't just look like one another; they work in similar ways. The optics of digital photography—that is, the way the image goes into the camera—are the same as they are in traditional photography, and in both cases, the camera plays the same role. The primary

purpose of any camera is to control the exposure of light to a light-sensitive medium. In traditional photography, this is the film. In digital photography, this is the sensor. Both kinds of cameras get the job done with a shutter that opens and closes very quickly, letting the image in through a lens.

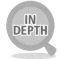

In 1826, a French gentleman scientist named Joseph Nicéphore Niépce snapped the world's first photograph, although *snapped* is hardly the word for it. The exposure process that he invented took as long as 20 hours to complete! Imagine trying to get your friends to strike the same pose for 20 hours straight.

Almost 100 years later, in 1925, the German manufacturer Leica came out with the first portable camera. It shot black-and-white images on 135 (35mm) film. To this day, 135 film is the most popular format for traditional cameras.

In 1986, Kodak introduced the first camera to replace film with a light-sensitive sensor—in other words, a digital camera. It had 1.4 megapixels.

"View from the Window at Le Gras" (c. 1826) by Joseph Nicéphore Niépce. This is the oldest surviving photograph in the world and one of the first photographs ever taken.

Unless you're a naturally mechanical person, optics might not be at the top of your list of interesting subjects to read about, and if it isn't, you're not alone. Photography would be a very small field if it were the same today as it was when it started. The first photographers were scientists, not artists. They were fascinated with the properties of light and film. It didn't matter so much what they were shooting; they cared more about how photography worked. These days, most photographers are in it for the art. They like taking pictures. They don't care how it works. But learning a little about the science definitely helps in the artistic department because you begin to understand how the camera sees, and that helps you to give it what you want it to see.

Want a great first photo for your portfolio? Do your own version of Niépce's famous "View from the Window at Le Gras." Take the picture from your window, of course, and call it "View from the Window at [the name of your street]." Le Gras was Niépce's country estate.

This is the view from the window at Chateau Dave…

...and the view from the window at Chateau Marc.

How the Image Goes In

Your humble authors are getting ahead of themselves again. Forget about how your camera sees for a minute, and consider instead how *you* see.

In simplest terms, you open an eye. Light from a source such as the sun or a light bulb bounces off the object in front of you. Some of these light waves go into your eye. They enter through a clear membrane called the *cornea* and into a small opening called the *pupil*—this is the black part in the middle of your eyeball. The *lens* of the eye focuses the incoming light onto the *retina* at the back of the eye. The retina is very sensitive, and it converts the brightness and color information in the light into a series of electrical impulses. Then the *optic nerve* sends the retina's signals directly to your brain, and you see the image.

A camera is very much like a mechanical eye, only one that is closed most of the time. To demonstrate, imagine that you're outside on a beautiful, sunny day, taking a picture of something nearby. Light coming from the sun shines on your subject, and some of this light bounces off and heads toward your camera. The light can't get in just yet, though. The shutter keeps the light out until you're ready for it, just like your eyelids block out the light around you while you're asleep.

So you point the camera, choose the best shot, and press the shutter release. The camera's shutter—its eyelid, so to speak—opens and closes very quickly, just long enough for the light to come in. Your camera's lens has a transparent outer covering, just like the cornea of your eye, and the opening for the light—the aperture— works just like your pupil. The light goes into the aperture and passes all the way through the lens, which focuses the light onto the film or sensor, much like the lens of your eye focuses light on your retina. In the case of digital photography, the sensor picks out the visual information in the light and converts it into a grid of pixels, which computer people call a *bitmap*. Look at the bitmap on screen or print it out on paper, and you see a record of the light that went into the camera. In other words, you see a digital photograph.

By way of this little detour into optics, one point in particular becomes glaringly clear: Your camera records the light that goes in. You need good light to do good photography. But it isn't always easy or convenient to control the source of illumination. If you're shooting outdoors, you can't expect the sun to do what you tell it. Even indoors under studio conditions, getting just the right light can be tricky. This is why knowing your camera is so important. You might not be able to rely on the light source, but by changing the size of the aperture or adjusting the amount of time of exposure, you affect how much light reaches the sensor, and this helps you to shoot better under any conditions. We go into this more in Chapter 3, "Different Shots, Different Settings."

How the Photo Comes Out

Your digital camera records a photo as a grid of pixels. But what's the size of the grid? And how many pixels does it contain?

As for the total number of pixels, you already know. That's the megapixel rating of your camera. A 5-megapixel camera gives you 5,000,000 total pixels spread across the area of the grid. As for the size of the grid itself, that depends on the aspect ratio of the sensor inside your camera.

To be completely precise about it, a 5-megapixel camera doesn't give you exactly 5,000,000 pixels, because the manufacturer's rating of 5 megapixels is a rounded-off value.

The *aspect ratio* is a shorthand way to describe the dimensions of an image. Think of televisions (and forget about widescreen or high-definition televisions for a minute). Some TVs are small enough to fit in your backpack, while others are so large that it takes two people to lift them. So some television screens are

physically smaller, while some are physically larger, but all of them share the same basic proportions. A TV screen might be 12 inches wide by 9 inches tall, 16 inches wide by 12 inches tall, or 48 inches wide by 36 inches tall, but the relationship of width (the left-to-right measure) to height (the top-to-bottom measure) is always the same. In this case, it breaks down to 4:3, which is the aspect ratio of standard TV. It's 16:9 for high-definition TV, so all high-def TVs must share the same 16-by-9 proportions, whether the screens are 16 inches by 9 inches, 32 inches by 18 inches, 48 inches by 27 inches, or anything else.

Your digital camera probably shoots at the 4:3 aspect ratio, just like regular television. If you have a more expensive camera, it may shoot at 3:2, which is the same aspect ratio as 35mm film. These are the most common aspect ratios, but they aren't the only ones. Some cameras shoot at 16:9, while others have 1:1 or square sensors, and so on.

Family, as seen in the 4:3 aspect ratio.

Photographers sometimes talk about the 1.33:1 and 1.5:1 aspect ratios, while 4:3 and 3:2 are more common among video people. Confusing, yes, but 1.33:1 is the same as 4:3, and 1.5:1 is the same as 3:2. Do the math if you don't believe me!

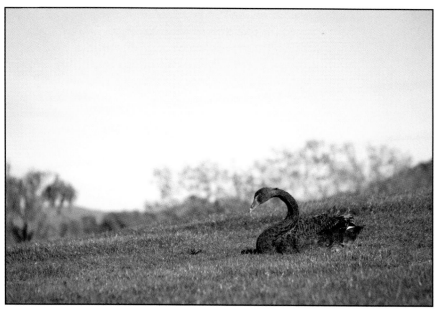

Swan, as seen in the 3:2 aspect ratio. Note that 3:2 feels wider than 4:3.

In any case, the size is fixed. The width and height of your raw digital photos always boils down to 4:3, 3:2, or whatever the aspect ratio happens to be, although you can change this later in your image editor. Common pixel dimensions at 4:3 are 2,560 by 1,920 (or about 5 megapixels), 2,048 by 1,536 (about 3 megapixels), and 1,600 by 1,200 (about 2 megapixels). We mentioned in Chapter 1 that the more megapixels your camera can capture, the physically larger your photos can be, all the while maintaining a crisp, clear image. Now you may begin to see why. Having more pixels lets you fill larger areas on screen or in print.

To figure out the number of pixels you need to cover a particular area while maintaining print quality, first determine the width and height of the area. For the sake of example, say 4 by 6 inches, which is standard snapshot size.

Next, convert these measurements to pixels. Assume that print quality is 300 pixels per inch. So you have 4 times 300 and 6 times 300, or 1,200 by 1,800 pixels.

Finally, multiply the pixel values. That's 1,200 times 1,800, or 2,160,000 pixels, which is just over the 2-megapixel mark. A 2-megapixel camera is close enough. A 3-megapixel camera gives you all that and then some.

Speaking of print, paper has an aspect ratio, too. For example, standard snapshot size is 4 by 6 inches, which works out to 3:2. To create a 4×6 print with a camera that shoots at 4:3, you need to open up the photo in your image editor and either do a little cropping or do a little stretching, as Chapter 8, "Pushing at the Edges (of a Digital Photo)," explains. Keep this in mind when you're out on a shoot. If you know that you eventually want to make 4×6 prints, you might want to shoot the photo a little wider than you normally would, knowing that you'll crop away this portion in your image editor later.

To make this 4:3 photo fit a 3:2 print, you can lop off—that is, crop—the top and bottom portions.

After the camera records the image, it stores the pixel grid in memory. Depending on the quality setting, the camera may apply a degree of compression to the image. *Compression* is a technique of fitting more information into a fixed amount of storage space. The lower the camera's quality setting—that is, the higher the compression—the more photos you can fit into memory, but the lower the image quality of each photo.

There are two basic kinds of compression:

✦ **Lossless compression.** By this method, the camera organizes the visual information more efficiently, just like you might rearrange your closet to make room for a new tripod or hockey stick. You lose absolutely zero picture quality with lossless compression. An uncompressed image looks *exactly* the same as the image compressed with a lossless method. TIFF (*Tagged Image File Format*) is a popular method of lossless compression.

✦ **Lossy compression.** By this method, the camera throws out a certain amount of visual information and organizes what's left more efficiently, like when you get rid of your old dollhouse to make that tripod or hockey stick fit. In general, lossy compression gives you smaller photo files than its lossless counterpart, but you do end up sacrificing some of the image quality in the deal. Normally, this discarded information is too subtle for the human eye to see, so it doesn't make much of a practical difference. However, too much lossy compression can be altogether too noticeable. You begin to see blemishes or *artifacts* in the image, or the range of color deteriorates too much. The JPEG (*Joint Photographic Experts Group*) format is a method of lossy compression especially for digital photos.

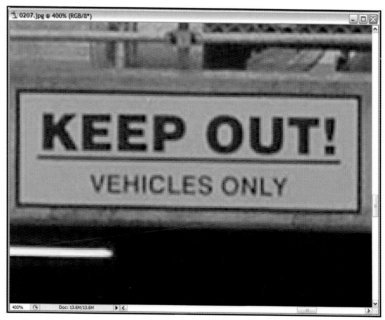

Artifacts crop up in the image when JPEG compression is too high.

Don't be scared by the term *lossy*. Although many professional photographers take their photos in lossless (or even uncompressed) formats, high-quality JPEGs provide shots that are in many cases indistinguishable from their much more memory-hungry lossless counterparts. The vast majority of shots taken in this book are high-quality JPEGs from a 5-megapixel camera.

In either case, compression happens in the camera, so once it's done, it's done. There's no way to undo too much compression other than to reshoot the subject at a higher quality. We discuss this in more detail in Chapter 3.

Is it possible to have too many pixels?

Suppose you want to make 4×6 prints. A 2-megapixel camera is all you need. So what happens when you have a 5-megapixel camera? Do your prints need to be larger to fit all the extra pixels?

Not necessarily. There are a couple of ways to tackle this problem. One way is to make the pixels smaller, which enables you to fit more of them into the same amount of space. This isn't always the best solution, though, because your printer may have trouble with super-small pixels.

Another method, which is usually more practical and much easier on your printer, is simply to discard the unneeded pixels. You can do this in your image editor in a matter of seconds.

So, yes, you might not always take advantage of the full megapixel count of your camera, especially if you don't make large prints. But more megapixels gives you greater flexibility all the way around. Who knows what you'll end up doing with your photos? Someday you might want to make a poster of your favorite shot, or a gallery in New York, Sydney, or Paris might be doing a retrospective of your early work. Having extra pixels on hand means that you can zoom in further digitally, too, before you lose too much image quality, as you'll see in Chapter 8.

You can always get rid of unneeded pixels in order to fit the smaller size, but you'll have a much harder time adding pixels that aren't there in order to reach the larger size.

What Does This Button Do?

So much for the science lesson. We turn now to the layout of your digital camera. Different cameras have different configurations, so we won't waste space presenting a schematic diagram of yours. That's what your camera manual is for. But almost all digital cameras follow the same basic design, and that's what we'll talk about here.

There are specific buttons, knobs, or switches for most of the things that you need to do at a moment's notice, such as shooting a picture or adjusting the zoom. Everything else, such as setting photo quality or adjusting the shutter speed, can usually afford to wait. These functions appear somewhere in the camera's on-screen menu. This section looks at both kinds of controls.

Checking Out the Controls

Just ask any player of video games—pressing the right button at the right time is often the difference between life and death when you're laser-blasting robots or putting the hurt on some zombies. You won't necessarily reach the bonus level when you press the correct button on your digital camera, but you will increase your chances of getting that once-in-a-lifetime shot or capturing that perfectly spontaneous moment. Your friends are notoriously unpredictable people. Who knows what they're going to do next? You want to be ready with your camera when they do it.

No matter what your intentions for digital photography, whether it's a fun hobby or a potential career, make sure you know by instinct where to find these controls:

✦ **Power switch.** If you want to take pictures, you have to turn on the camera. Some cameras power up immediately; others make you wait a few seconds. Also, to conserve power, some cameras turn themselves off after a period of inactivity. Watch out for this! You might want to turn off this feature entirely, although some cameras are stuck in power-save mode, and the best you can do is increase the default time.

✦ **Shutter release.** This is the biggie. When you point your camera's lens away from you, the shutter release should be at the top of the camera, on the right side. Your right index finger rests comfortably atop it or just beside it. If you're a lefty, this might take some getting used to, although by now you're probably well accustomed to dealing with a right-handed world.

◆ **Zoom.** This is usually a button or a pair of buttons on the back or the top of the camera, although sometimes the zoom is a ring around the lens of the camera. It's vital to know which button zooms in and which zooms out, or which way to turn the ring. Normally, you turn clockwise to zoom in and counterclockwise to zoom out.

◆ **Manual focus.** Your camera might have manual focus settings in the menus, especially if you have a number of built-in presets from which to choose. But if your camera enables you to eyeball the focus, then look for a ring around the lens or a button or two, and figure out which button or which direction does what. Turning clockwise generally focuses on faraway subjects, and turning counterclockwise focuses on nearby subjects.

◆ **Status display.** This is where you look to find out roughly how many pictures you have left. The status display also shows icons for various camera modes and settings. Sometimes this information appears on the large screen where you review your pictures, and sometimes it's in a separate LCD readout, which you usually find on the top of the camera.

Know the back of your camera like the back of your hand.

Your goal is to burn these controls into your brain. The best way to do this is to use them often. Play around with your camera whenever you can. You don't need to take pictures to get in some good practice. Go through the motions with your fingers, finding the zoom, setting focus, and clicking. You don't even need your camera to do this. All you need is your imagination. Picture yourself taking a picture. It might sound ridiculous, but it really does help.

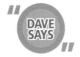

Many digital cameras include a knob or dial that you turn to take pictures under particular conditions. Your camera might have icons for daytime photos, nighttime photos, beach photos, cloudy-day photos, and so on.

This dial can be useful, especially if you're in a hurry, but don't make the mistake of thinking that you have to use it. All it does is adjust your camera's settings based on someone's best guess of your shooting conditions. You can compensate for a cloudy day or bright sand and surf easily enough on your own, and once you've gotten a little experience, your custom settings will be far more appropriate to the picture you're taking than the generic settings that the manufacturer provides.

Most digital cameras have several hoods, doors, or covers built into the case. It's a good idea to become familiar with what's under or behind them:

✦ **Memory card port.** This is where you plug in your memory cards.

There's the memory card port.

✦ **Battery port.** When you're out on a shoot, you'll most likely be on battery power. Knowing where to put the batteries in case you have to change them is a handy photography survival skill.

There's where the batteries go.

✦ **Data ports and AV (Audio/Video) ports.** Here you find the USB port and any other data connections that your camera offers. The AV ports may be nearby, or they may be elsewhere on the camera.

The data and AV ports are under the plug.

✦ **Power adapter port.** You plug a power cord or power adapter into here. This way, when you're at home, you can power the camera from the nearest wall socket and save the precious charge in your batteries. There may be a little rubber plug that covers this port when you're not using it.

It's not vital that you know where to find these intuitively, but the faster you can get to them, the easier your life will be. You would think it would be impossible to lose your bearings when you're dealing with something that fits in your hands, but a compact camera is often so compact that it's not hard to forget which cover is which.

Getting into the Menus

Out of the box, your digital camera is more or less ready to take pictures. All the important camera settings are on automatic or general-purpose defaults. People who want to take holiday snaps might not ever switch these settings. Maybe this was you when you first started out. But as you get more into the art of photography, you'll find that you want to turn off the defaults and specify exactly the settings you need.

To do this, you use your camera's menus. Press a button (usually labeled Menu), and the menus appear in the large display that you use to review your photos. Then you click through the various categories and options with a set of buttons or a directional pad, just like the one on a video game paddle. Sometimes these buttons do double duty as another kind of camera control. Zoom buttons can also be menu buttons, for instance. Only when you're in menu mode do they function as the controls that step you through the options.

No two digital camera models are alike, so the best place to learn about your camera's menus is the manual. But here are some of the most important settings that you'll likely discover as you poke around the menus:

✦ **Picture quality.** Here is where you determine the level of compression that your camera uses to store your photos. High quality equals low (or no) compression. Lower quality equals higher compression.

✦ **Focus mode.** Your camera probably has auto-focus, which means that it focuses itself based on whatever subject you seem to be shooting. This feature doesn't always work out because you aren't always shooting what's directly in front of you, so it's helpful to have manual focus settings. Your camera probably gives you a smattering of fixed lengths, such as 0.5 meter, 1 meter, and 3 meters. Naturally, if the subject is 3 meters away, choose the 3-meter focus mode. You may also be able to focus to a wide range of lengths by turning the focus ring on the lens.

Ah, there's the menu for the quality settings.

✦ **Flash mode.** Likewise, your camera probably has auto-flash. The camera detects the level of light in your environment and decides whether to use the flash. For more precise control, you can turn the flash on or off manually. Your camera may also offer special flash settings, such as fill-in flash and red-eye reduction.

✦ **ISO or sensitivity.** This sets your camera's level of light sensitivity. Higher ISO means greater sensitivity to light and therefore sharper pictures under darker conditions, but it also introduces more graininess in the picture. Again, your camera probably has auto-ISO. Better cameras give you the option of setting ISO to whatever you need on a shot-by-shot basis.

ISO is actually a group: the International Organization for Standardization. These people set and maintain all kinds of standards, from the way that machines are expected to work to the level of sensitivity in photographic film. Although there's no film in digital photography, professionals are accustomed to the ISO system, so they apply the same scale to camera sensors.

As an interesting aside, ISO invented JPEG compression. The Joint Photographic Experts Group is an ISO committee.

Find out more about this group at www.iso.org.

✦ **Aperture or f-stop.** This controls the size of your camera's aperture, which in turn affects the amount of light that comes into the camera and therefore the brightness of the image. It also affects how much of the image is in focus. The lower the f-stop, the larger the aperture, and the larger the aperture, the brighter the image and the smaller the depth of field. The ability to set the f-stop manually is not available on all cameras.

✦ **Shutter speed.** This determines the length of time that the shutter is open, which affects the amount of light that goes into the camera as well as the sense of motion in the shot. If your digital camera is a no-frills model, you may not be able to change the shutter speed.

Your camera might come with a built-in light meter that measures the level of ambient light and recommends the appropriate f-stop and shutter speed.

✦ **White balance.** This setting corrects the color of a shot. You show the camera what should look plain white under the current shooting conditions, and it shifts all the other colors accordingly. The correct white balance helps your photos to appear more natural, particularly indoors. You can also use this feature to add warmth or coolness. Auto-white balance, or AWB for short, is common on digital cameras. Advanced cameras let you adjust white balance manually.

✦ **Image processing.** Some cameras enable you to do quite a bit of processing after you've snapped the picture. For instance, you might be able to adjust the contrast or the sharpness. These features may be handy at a moment's notice, but if you can afford to wait, you tend to get better results in image-editing software.

We'll discuss these settings in more detail in Chapter 3, so it isn't absolutely vital that you know exactly what they are and what they do at this stage of the game. But it is important that you know where to find them, so take 15 minutes for a camera-menu scavenger hunt. See how quickly you can track down these features, and make sure you're clear about how to turn them on and off or how to change their values. This isn't a test, so when in doubt, feel free to reference your camera manual.

Taking Care of Your Digital Camera

Always wear a helmet when you're riding a bike. Always wear a seatbelt when you're in the car. And always observe the following practices for keeping your camera in tip-top shape:

✦ **Get yourself a camera bag.** This doesn't have to be fancy, although something water-resistant with a little soft padding that snugly fits your camera and gear is better than a recycled plastic bag from the grocery store. Look for pouches, preferably closable ones, for storing accessories such as memory cards and power adapters.

✦ **Clean the lens when it gets dirty.** But go gently, gently! The lens often has a fine outer coating that improves the performance of the camera, so don't touch the lens directly with your fingers, and don't rub too hard with a cloth. You don't want to scratch the glass or damage the outer coating. Any clean, dry cloth will do for cleaning, although avoid using tissues because they're pretty dusty. You may want to blast the lens with a little canned air before you wipe it down. To clean away smudges such as the kind from rain-drops, try a very mild glass cleaner and use it sparingly. And before you do anything, read the section in your camera's manual about lens care, and follow the recommendations there. Remember, your camera only has one lens!

Skylight or UV filters also work well to keep the face of the lens clean and safe, although this is more of an option for the pros. Less expensive digital cameras don't usually let you attach filters.

✦ **Avoid too much moisture, heat, and cold.** Your camera is a typi-cal electronic component, so it doesn't work well with weather extremes. A little light rain probably won't hurt it, but get it into your camera bag sooner rather than later or tuck it somewhere dry, say under your coat. Definitely don't submerge the camera! You need special underwater gear for that. Also, don't leave the camera out in the cold or up on the dashboard on a hot summer day, and keep it out of the direct sun. Don't let it bake on your beach towel! Throw a white T-shirt over it. Better yet, stick it in your camera bag.

✦ **Get smart (and serious) about repairs.** If your camera stops working, check the troubleshooting guide in your manual, and then go to the manufacturer's website and look for their knowledge base or customer service area. There may be a number to call for tech support, and this support may be free of charge if you registered your camera. Use this option if it's available to you. If you've done all that and the problem persists, there's a very good chance that something is broken. Check to see whether the camera is still under warranty. Round up your original sales receipt, too, as proof of when you purchased it. Then you want to take your camera to an authorized service center or return it to the manufacturer—your camera manual will tell you what to do. Just don't try to fix the thing yourself. You need custom tools and very clean conditions to work with any kind of computerized gear. Cracking the case for a peek inside is liable to make the problem worse, not better, and you'll void your killer warranty for sure.

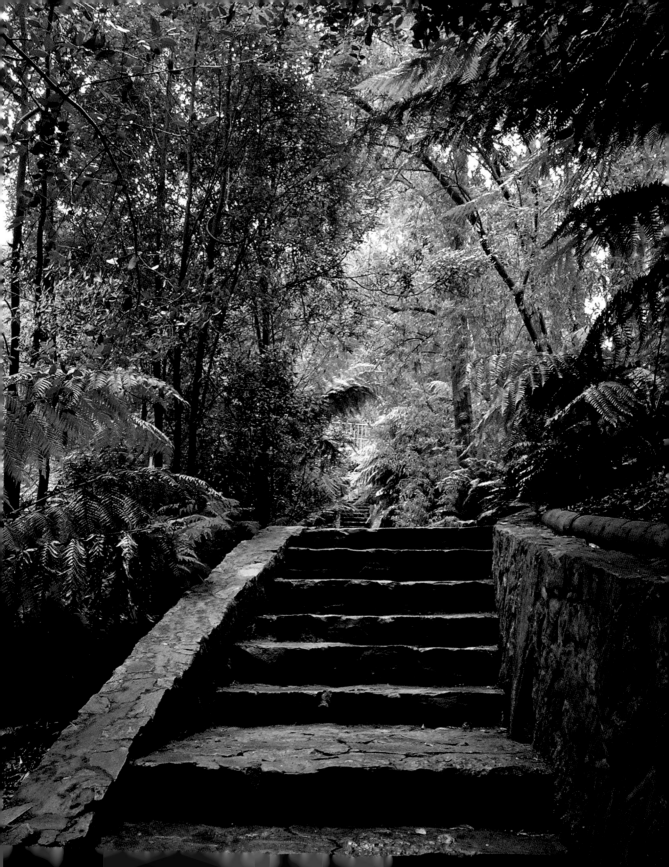

Different Shots, Different Settings

For two chapters now, your humble authors have been making the point that different kinds of digital photos benefit from different camera settings. It's time now to see what we've been talking about.

Considering Quality

You know from Chapter 2 that, depending on the quality setting, your camera may apply a degree of compression to your photos. More compression enables you to store more photos on your memory card at the same time, but you pay for this benefit by losing image quality.

But what do the various quality settings of your camera mean for you in practical terms? Check your camera manual for the last word on the subject, but in general, the following guidelines apply.

About Compression, Memory, and Time

If your camera records in TIFF format, then the highest camera quality setting gives you no loss of image quality at all, because TIFF is a lossless method of compression. Many, but not all, cameras have TIFF capability. Your camera might use JPEG only, and if so, then even the highest camera quality setting introduces a little loss of image quality, although this is practically unnoticeable. If we didn't make a point of mentioning it, the chances are extremely good that you couldn't tell a low-compression JPEG from a no-compression TIFF, unless you zoomed in to the pixel level in your image editor.

Most of the time, your camera's quality settings don't tell you much about the actual compression method. The camera might give you Best, Better, and Good, where Best is the same as TIFF compression, Better is the same as lower JPEG compression, and Good is the same as higher JPEG compression. You can't assume this, though. It's possible that Best is low JPEG compression, Better is medium JPEG compression, and Good is high JPEG compression. Be sure to see your manual for the specifics of each quality setting.

Because there are more pieces of information in a higher-quality, lesser-compressed photo, the time it takes to do anything with the photo increases all the way around. It takes longer to store the photo in the camera's memory card when you press the shutter release. It takes longer to transfer the photo to your computer. It takes longer to process the photo in your image editor. It takes longer to print out the photo or send it over the Internet. In fairness, the time lag isn't always human-detectable, especially during the capture and transfer stages, because even the slowest speeds are so inconceivably fast that they seem instantaneous to the human brain. But the lag is there nonetheless, and it may become a bit of an issue when you process a lot of photos at once.

Shooting in the RAW

Many cameras have their own special format for storing digital photos, such as ORF in Olympus cameras and KDC in Kodak cameras. *RAW* describes these custom formats. It sometimes has the same all-caps style as an acronym, such as TIFF, or an abbreviation, such as KDC, but the letters R, A, and W don't stand for anything in themselves, although the connotation of rawness is an apt one indeed. A RAW image file is exactly the image data that the camera perceives, exactly as the light comes in, with no compression whatsoever (or very, very little) and no correction or processing.

The camera manufacturer knows the inner workings of its particular product better than the math heads who developed TIFF and JPEG, so your camera's RAW format requires less memory than TIFF and looks better at close magnification levels than JPEG. RAW formats tend to be the slowest, though. They contain a lot of unprocessed information, so they take longer to write to your memory card. Depending on the camera, the lag is *really* noticeable, as in the camera takes a couple seconds to store the data. Even the best digital cameras give you a slight delay, which poses a problem if you're shooting multiple pictures in rapid-fire, news-photographer style.

Another drawback to RAW is that every manufacturer's version is slightly different. There's no such thing as a standard RAW file like there is a standard TIFF or JPEG. Instead, there's ORF, KDC, NEF (Nikon), RAF (Fuji), and so on. All digital cameras work more or less the same, so ORF files and KDC files are quite similar, but they're just different enough to cause mischief.

Unfortunately, you can't just post your RAW-format photos to your blog or website or send them off to your friends by e-mail. Well, technically you can, but you won't get the results you want.

For one thing, RAW files are way too heavy in terms of memory to make them suitable for sending across the web. More importantly, the RAW format depends on the camera, so it's only guaranteed to work in your camera model. Web browsers such as Internet Explorer and Mozilla definitely can't read them. Just convert your RAW photos to a standard web format such as JPEG, which is simple enough to do in the software that came with your camera.

Of course, if you and your friend have the same digital camera, you can swap RAW photo files by e-mail and see each other's work just fine, but there's still the problem of it taking too long.

As a result, image-editing software doesn't always read RAW picture data correctly. Sometimes the RAW format from one manufacturer comes in better than the RAW format from another. Software companies occasionally make the claim that their product "reads RAW camera data," but your first question to them should be, "Oh, really? Which RAW data from which digital cameras do you mean?" And sometimes *no* RAW format is compatible, no matter the camera. Such applications absolutely require standard graphics formats, such as TIFF and JPEG.

Some computer software doesn't accept the TIFF format, either. If so, simply convert TIFF to some other format, such as JPEG, in a decent image editor, such as Photoshop Elements.

In spite of these limitations, many professional photographers swear by their camera's RAW format because it gives them the closest digital approximation of the film experience, not to mention the greatest degree of flexibility. They prefer to apply their own levels of processing and compression afterward. They don't want a bunch of data algorithms to tie them down in the field.

As long as your image editor reads the RAW format of your camera, go right ahead and shoot in RAW. If your software doesn't—and the chances are so-so that it doesn't, even in a powerhouse such as Adobe Photoshop—then shoot in TIFF or JPEG instead, or use the software that came with your camera to convert RAW to something more standard.

More Photos Now Equals Less Flexibility Later?

Professional photographers don't agree on anything. They can debate all night about f-stops, and don't even get them started on ISO. So when a topic comes up that receives no argument, it behooves the rest of us to pay strict attention—and you'd have a hard time finding any professional shutterbug who shoots at anything less than the highest quality setting.

Hobbyist photographers tend to see the matter differently. They use the camera on vacations and at family gatherings. They don't have much of a photography budget, and they really don't like buying extra memory cards, so they use the camera's lowest quality setting and pack as many pictures into 16- or 32-megabyte memory cards as they can.

Here's the thing: You can always get more storage, but photographs are one of a kind. Any photographer, from Uncle Frank, designated documenter of holidays, to *Daily Bugle* freelancer Peter Parker, has just one chance to capture any given shot. The exact same opportunity will never come around again, not in the entire history of photography. Maybe the light will be a little different, or that funny moment will have come and gone, or Spider-Man will have already socked Electro in the kisser. Memory cards, no matter the cost, are far less valuable than the photos you take. Think about it—if you had to choose between your memory cards and your photos, which would you keep? The whole reason you get into photography in the first place is to take pictures, not to cram them onto a memory card.

A better way to deal with the tradeoff between image quality and storage space is to review your shots frequently in-camera. Get rid of obvious mistakes right away, and you'll have more memory to work with.

Take care about deleting too much, though. It's hard, if not impossible, to see fine detail on the camera's display. For that, you need to look at your photos on the computer. You can adjust nearly everything about the shot in software, including the composition, so don't toss something just because it didn't come out exactly right.

You don't want to trash a photo until you're absolutely certain that it's trash-worthy. Whenever the least doubt crops up, it's better to err on the side of caution and keep the shot, at least until you have a proper look at it on the computer. But there's no reason whatsoever to keep a shot that is clearly not a keeper.

Another excellent reason to shoot at the highest quality is that you never know what you'll end up doing with your photos. You might think that it's okay to shoot at low quality because these are only vacation pics or horsing-around pics with your friends. You don't need high quality, because you'll just crush the photos down anyway and send them out by e-mail. But what if you capture something extraordinary? What happens if the conditions just sort of line up and you get a brilliant sunset, the perfect snow-covered mountain peaks, or the most pensive rainy day? What happens if your friends do something so completely outrageous that you just have to slap it on a coffee mug or put it in the yearbook? This happens more often than you'd think. It has happened to every photographer with the least bit of experience. It has probably happened to you. And although plenty of photographers complain that they never seem to have enough room on their memory cards, they flat-out regret not having a better version of their favorite photo, which usually they just *happened* to take. They looked up one day, and there it was.

The only time you can afford to shoot at a lower quality setting is when you're practicing or experimenting, and even then, take care. You never know when an experiment is going to work.

Capturing the Shot No Matter What

Photography is perhaps the most improvisational art. Want proof? Just look at the nearest posed photo. You know the type. A bunch of people are standing in front of a building, wearing clothes that they don't normally wear and phony, frozen expressions on their faces, rather like a dragon's when the magic sword comes out. They're usually holding some kind of sign or maybe a huge bank check.

Such photos are boring. They have no spontaneity. They have no *life*. The people in the photo are nice enough, but you have no special desire to meet them.

Now look at the nearest spontaneous photo, the one you took when the moment struck, the one where your friends are goofing off. Pictures such as these brim with character. If you see someone else's silly shots, you want to meet their friends immediately. They seem like exactly your sort of people.

So if the best photographs tend to happen on the spur of the moment, does this mean that photography is a function of chaos? Does everything happen on the whim of chance? Are more orderly people better suited to careers in accounting or insurance adjustment?

Not hardly. Photography is all about precision rising to the occasion. You never know when a great shot will come along, but you can be absolutely ready for it when it does.

Keeping It Steady

One of the best, most low-tech ways to take good pictures is to keep the camera steady. A jittery camera gives your photos the shakes, while a steady one increases sharpness. This is especially true when you shoot something in the distance. Nearby subjects look physically larger in a photo, so a little bump or jar doesn't introduce much distortion. But faraway subjects look physically smaller, so even the slightest movements on your part are magnified, and you get blurriness and fuzziness instead of sharp detail.

When shooting by hand, here are a couple easy techniques for steadying the camera:

+ **Have a firm grip, but not a death grip.** Hold the camera firmly, but don't tense up your muscles. Squeezing the camera too hard can cause the shakes, too.

+ **Let the camera rest against your face.** The camera should make physical contact, but don't drive it into your face. You don't want to leave a welt.

+ **Plant both feet on the ground.** Take a stand! Be tall and confident. Spread your feet to improve your balance. When possible, you might try pressing your back against a wall or even sitting down.

+ **Keep your elbows close to your body.** Avoid making chicken wings with your folded arms. Imagine that you're lifting the camera off the ground and holding it up to your face instead of pulling the camera in from the side.

✦ **Easy does it on the shutter release.** Don't mash the button like you would on PlayStation. Press the shutter release smoothly and gently.

✦ **Breathe.** Right before you shoot, take a good, deep, natural breath. Let out half. Take the picture. Let out the rest.

Your camera might have a built-in stabilization system that electronically corrects small bumps and jitters. This is a nice feature to have, but it isn't a magical cure, either. Electronic stabilization improves sharpness under tricky conditions, but doesn't automatically guarantee sharpness. A better and more reliable stabilization system is the one we've been using for generations: the tripod.

There are times when holding the camera by hand is not enough, even if you're the Rock of Gibraltar, such as when you're shooting at high focal lengths or slow shutter speeds. (See "Achieving Focus" and "Getting Enough Exposure" later in this chapter.) To shoot clearly under all conditions, you should think about investing in or borrowing a tripod. Putting the camera on a steady surface, such as a table top, might do the trick in the meantime, although this way you have a harder time controlling the composition of the shot.

As a general rule, go for the tripod whenever the shutter speed value is less than the focal length of the lens. To use this trick, simply disregard all fractions and units and look solely at the number. So if the focal length of the lens is 50mm, you need to use a tripod when the shutter speed is slower than 1/50th of a second.

Achieving Focus

Your humble authors have used the term *focus* a couple times now without really saying what it means, but focusing is the technique of making the subject show up clearly in the photo. The outline of the subject is sharp and crisp when it's in focus, and the photo captures all kinds of surface detail, shading, color, and texture.

Creatively, focus has one main purpose: to draw attention. You focus on what you want your audience to see while letting less important elements recede into the haze. How much focus you give to the subject affects the overall mood of the photo. Softer, less sharp focus often lends a sense of quietness or peace—think of a field on a misty morning. It's also more forgiving on the little imperfections, so there's something dreamlike or idealistic about it. Sharp focus, on the other hand, tends to be ultra-realistic, and it's great for capturing the subject in motion.

All the great sports shots that you've ever seen, with the athlete hanging in space, every last detail in perfect clarity, were taken with sharp focus.

What's in and what's out of focus in a photo depends on the distance of the lens from the sensor. When the lens is relatively far away from the sensor, it focuses nearby subjects and *blurs* or softens distant ones, making the field of view narrower and pinpointing the attention of the audience. When the lens is closer to the sensor, it focuses faraway subjects and blurs the foreground, making the field of view wider and encouraging the audience to explore the photo. We have used the term *focal length* before, too, and that's exactly the concept here. It's the distance between the lens and the sensor to bring the subject into focus. The distances are pretty small in practical terms. Focal length starts getting long at 180mm, or just over seven inches.

Here the foreground is in focus, while the background is soft.

It's worth pointing out that digital cameras and their traditional, film-based counterparts operate at different focal-length scales. A long focal length of 180mm in a traditional camera might be only 40mm in a digital camera. The effect is the same—tighter field of view—but the actual distance between the parts of the camera is different. And because digital cameras themselves have different-sized sensors and therefore different focal lengths, it's easier just to talk about these things using the old standards for 35mm film. That's the way we do it for the purposes of this discussion.

Here the background is in focus, while the foreground is soft.

Two of the most common special-purpose lenses are the wide-angle lens and the telephoto lens.

A *wide-angle lens* has a short focal length, say 35mm or less, compared to a normal lens with a focal length of 50mm. Because of this, the wide-angle lens brings in more of the background in sharp detail, which creates sweeping landscapes, but it isn't so good at zeroing in on a particular feature or an individual in the scene.

By contrast, a *telephoto lens* has a long focal length, about 70mm or more. This kind of lens is great for up-close and personal shots. The narrower field of view brings the foreground into prominence, while the background practically melts away. For this reason, you won't take too many breathtaking panoramas when you use a telephoto lens.

So what's the focal length of your camera's lens? Actually, it changes depending on the level of optical zoom. (Another name for a lens with optical zoom is a lens with *variable focal length*.) As you zoom in, the focal length increases, and you get a narrower field of view. A lens with 4X optical zoom provides a range of focal lengths from about 35 to 150mm in the traditional scale, which gives you the option of going wide for vistas or up close and personal for character studies.

If your camera doesn't have optical zoom, then the focal length of the lens is always the same. This is a *fixed-focus* or *prime* lens.

Normally, a prime lens has a focal length of 50mm, which enables the camera to see more or less the same level of detail as the unaided human eye.

Most photos aren't all foreground or background, though. They aren't all either wide or narrow. They're a little of both. You want to show the expressions on the faces of your friends, and you want to show what's going on in the world around them. This is called *depth of field*—how much of the photo is in focus. When the image is clear all the way from the foreground to the background, it has a long depth of field. When only a very small portion is in focus, it has a shallow depth of field.

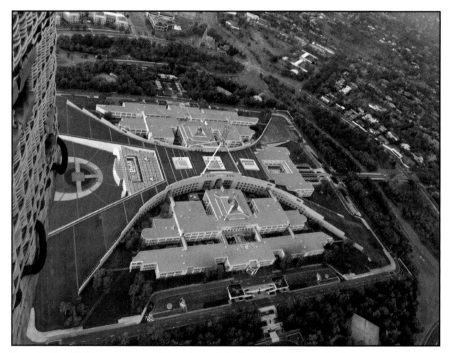

Long depth of field means more of the picture is in focus, from front to back.

Sometimes you want a long depth of field. You want a clear, crisp shot from front to back. Other times you don't. You want to call attention to one thing in particular and deemphasize the rest. You can achieve these results with different camera settings:

+ **Zoom out (decrease focal length) to increase depth of field.**
Use very little or no optical zoom, and your camera's lens gives
you better depth of field. You get a wider field of view and a better
sense of depth. For a shallow depth of field, stand back and apply
a lot of optical zoom. This emphasizes the subject and deempha-
sizes the surroundings. At long focal lengths, the background of
the photo often becomes indistinct.

+ **Increase the f-stop (make the aperture smaller) to increase
depth of field.** The smaller the size of the aperture, the larger the
depth of field of the camera, and therefore the greater the sense of
space in the shot. Conversely, the larger the size of the aperture, the
narrower the depth of field of the camera, and the more targeted
the focus of the shot. As we mentioned in Chapter 2, though, a
smaller aperture also makes the level of exposure go down, whereas
a larger aperture makes it go up.

+ **Move away from the subject to increase depth of field.** There's
more physical space between you and the subject, so you get a wider
shot, but you lose some detail. Be careful, though! If you compensate
for the greater physical distance by zooming in on the subject, you
cancel out the increased depth of field! (You can also back off a cliff.)

Don't hold the camera in your hands when you combine long focal length with slow
shutter speed. You really ought to use a tripod instead.

Getting Enough Exposure

Exposure is the level of brightness of a shot. Naturally, to get good exposure, you
need good light. Getting good light is one of the things that photographers think
about all the time.

There are two basic approaches to the quest for illumination:

+ **Controlling the light in the environment.** This happens before
the light goes into the camera. You increase or decrease (but usually
increase) the amount of environmental or *ambient* light by turning
on some lamps or pulling back the window drapes. There's only so
much you can do in this regard, especially when you're on the go.

+ **Controlling the light that goes into the camera.** This happens
the moment you take the photo. Here you're more concerned
about how much light reaches the sensor and for how long.

We look at both approaches in this section.

Using the Flash

The most common way to influence the light in the environment is to add a quick burst of it on your own. This is what the flash of your camera does. For the fraction of a second that the shutter is open, the camera sees much brighter light than the environment provides by itself.

A flash is ideal for moving subjects. As you'll see shortly, when you increase the amount of time of exposure, you increase the chances for different kinds of distortion, including the characteristic blur of motion. If you use the flash, you don't have to worry about long exposure times. You get plenty of light and less motion blur.

But the flash on your camera has its drawbacks, too. For one thing, forget about shooting through a window or windshield. The glass reflects the light of the flash, and you get a photo of an incandescent field of white. Aside from that, on the softness/hardness scale, a flash is hard light, and unforgivingly so. It's directional, like a spotlight, not diffuse, like the sun on an overcast day. It tends to create glares and dark, sharp shadows, which don't suit every subject that you care to shoot. If you want to capture the ambience of a candlelit room, there's no surer way to miss the mark than by drenching it with a camera flash.

Your camera might come with a special flash mode called *fill-in* or *fill flash*. This type of flash helps to cut down on shadows—filling them in, so to speak—when the subject is already fairly well lit. Try fill-in flash in conjunction with natural lighting, indoors or out.

When you're outdoors, natural lighting is best. There's usually enough of it around, and it tends to look better than the light from a flash. The best times of the day are sunrise and sunset, when the sunlight is softest. The worst time of the day is high noon, when the sunlight is hardest. Cloudy days are better overall.

Tech editor Ron suggests bouncing the flash, say off of the ceiling, to make the light less glaring. You need an external flash unit for this trick, or you can do what Ron used to do. He taped a piece of tinfoil beneath the built-in flash and used it to direct the light.

Adjusting the Light in the Camera

All light, but especially natural light, benefits from a little in-camera tweaking. As you know from Chapter 2, the three main ways to control the amount of light coming into the camera are:

✦ **Shutter speed.** The longer the shutter is open, the greater the level of exposure. When the shutter speed goes up (gets faster), the level of exposure goes down, and the photo gets darker. When the shutter speed goes down (gets slower), the level of exposure goes up, and the photo gets brighter.

✦ **F-stop.** The larger the opening in the aperture, the greater the level of exposure. When the f-stop goes up, the aperture gets smaller, the level of exposure goes down, and the photo gets darker. When the f-stop goes down, the aperture gets larger, the level of exposure goes up, and the photo gets brighter.

✦ **ISO.** The more sensitive the camera sensor, the greater the level of exposure. When ISO goes up, sensitivity goes up, the level of exposure goes up, and the photo gets brighter. When ISO goes down, sensitivity goes down, the level of exposure goes down, and the photo gets darker.

The shutter speed settings in your camera's menu (1/30, 1/60, 1/125, 1/250, and so on) are in fractions of a second, and each successive value or *stop* decreases the level of exposure by half. So a shot with a shutter speed of 1/125th of a second gets half as much exposure as one with a shutter speed of 1/60th of a second, which gets half as much exposure as one with a shutter speed of 1/30th of a second, and on it goes.

Remember to use a tripod when you shoot at slow shutter speeds.

The f-stop numbers in your camera's menu (1.4, 2.0, 2.8, 4.0, and so on) work in just the same way. Each successive stop halves the level of exposure. So a shot with an f-stop of 2.8 has half the level of exposure of one with an f-stop of 4.0. If you're wondering why these numbers look a bit odd, it's because they're ratios between the focal length of the lens (which is the *f* in f-stop) and the diameter of the aperture. So an f-stop of 4.0 (or f/4) on a lens with a focal length of 50mm gives you an aperture diameter of 12.5mm, because 50 divided by 4 is 12.5.

The ISO numbers in your camera's menu (50, 100, 200, 400, and so on) are exactly opposite. Each successive stop doubles the level of exposure. So a shot with ISO 200 gets twice as much exposure as one with ISO 100 because the sensor is twice as sensitive to light. Also, the higher the ISO, the more likely you are to introduce distortion into the photo. This is called *noise* or *grain*. In general, you want to watch out for this, although sometimes you can use it to creative effect. The grittiness or extra texture of the grain might help to enhance the mood that you're trying to capture.

When the ISO is too high, the photo goes grainy.

So which value do you tweak? That all depends on your photo:

✦ **Decreasing the shutter speed makes the photo brighter, but it also makes moving subjects look blurry, and you may lose some detail in the bright areas.** This isn't the best choice if you're dealing with motion, but it works great for a quiet, peaceful scene under low-light conditions. Don't forget to use a tripod!

✦ **Increasing the shutter speed makes the photo darker, but it also helps to capture motion, and you may lose some detail in the dark areas.** For a moving subject under bright-light conditions, such as an afternoon volleyball game on the beach, try this setting.

At slow shutter speeds, motion tends to blur.

Freeze motion in its tracks with high shutter speed.

✦ **Increasing the f-stop makes the photo darker, but it also increases depth of field, and you may lose some detail in the dark areas.** If you want to keep a large area of the photo in focus under bright-light conditions, try this setting.

✦ **Decreasing the f-stop makes the photo brighter, but it also decreases depth of field, and you may lose some detail in the bright areas.** When you want to emphasize one element of the photo in particular and you don't seem to have enough light, give this setting a try.

✦ **Increasing ISO makes the photo brighter.** Try this setting whenever you want to boost the ambient light without otherwise affecting motion or depth of field, but watch out for grain.

✦ **Decreasing ISO makes the photo darker.** This setting reduces harsh or glaring light without affecting motion or depth of field.

Tone down bright light for the best exposure.

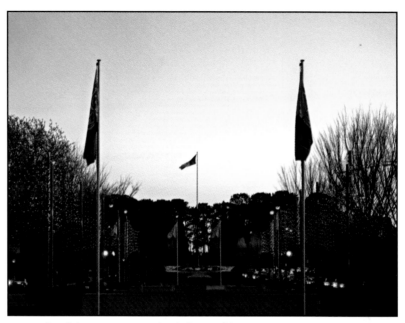

Increase low light to see more under darker conditions.

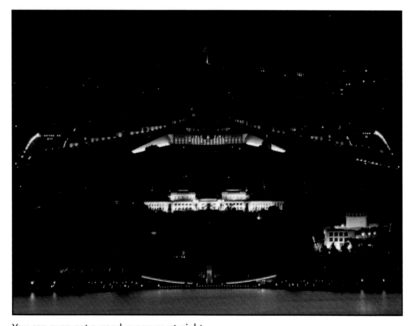

You can even get a good exposure at night.

Keeping the Exposure Constant

Your humble authors want to take you back to that volleyball game on the beach, but this time, let's assume that you already have the right light. Maybe it's early or late in the day. The sun isn't glaring down on the sand and water. What camera settings do you use?

You know from the previous section that increasing the shutter speed helps to capture motion, so you think that this might be a good setting to try. But at the same time, it makes the photo darker, and you don't need to reduce the level of exposure. The light is fine as it is. If you go too much darker, you'll underexpose the shot, and the picture will come out looking like night volleyball.

Here is where you come to realize that the people who invented cameras are geniuses. You know that shutter speed, f-stop, and ISO all fall on the same scale: As shutter speed and f-stop go down and ISO goes up, the level of exposure doubles. So when you take the shutter speed up a notch, you cut the level of exposure in half. But if you take the f-stop down a notch, you double (or un-halve) the level of exposure—effectively cancelling out what the shutter speed does to it—and the light is back to where you started! You would achieve the same results by leaving the f-stop where it is and taking ISO up a notch instead.

The combinations work exactly as you expect. Crank up the f-stop three notches for better depth of field, and turn down the shutter speed three notches to maintain exposure. If you need to capture motion, such as the crash and flow of a waterfall, leave the shutter speed where it is and turn down ISO three notches instead.

When your camera makes automatic adjustments to the level of exposure, it shuffles the shutter speeds and f-stops exactly the same way—one goes up, while the other goes down.

If you prefer to keep one or the other constant, your camera might give you priority modes. You might see the abbreviations *Tv* and *Av*. These are *time-value priority* (for shutter speed) and *aperture-value priority* (for f-stop).

When you're in shutter-speed priority mode, the camera maintains your shutter speed while adjusting the size of the aperture for exposure. If you need high shutter speed to catch fast action, and the depth of field isn't as much of an issue, shutter-speed priority mode makes good sense. Likewise, when you're in aperture priority mode, the camera maintains aperture size for the depth of field that you require while adjusting shutter speed for the right level of exposure.

Back to the volleyball game. You turned up shutter speed, say by two stops, in order to capture the motion better, but this cut the exposure in half twice. To get the exposure back to where it was, you can either turn the f-stop down by two or bump ISO up by two. Now it's just a matter of which side effect is better. Turning down the f-stop decreases depth of field. If you want to focus on one or two players in particular, this is your choice. But if you want to show the entire volleyball game, you might be better off with higher ISO. Just be careful that you don't get too much noise in the shot.

Correcting the Color

Not only can you adjust the amount of light that goes into the camera, but to a certain degree, you can also adjust its frequency, which changes the range of color in the photo. This section shows you how.

Setting White Balance

A stoplight shines red, the power indicator on your monitor shines green, and a UV lamp gives off a bluish glow, all because they put out visible light in the red, green, and blue frequencies. But ask your science teacher about white light, and you'll get an explanation that goes something like this: White light contains all the colors of the rainbow in equal proportions. Its red, green, and blue components are all the same, along with its oranges, yellows, indigos, and violets. When you talk about everyday light sources, such as a bedroom lamp or a fluorescent bulb, it's common to say that they give off white light, and your science teacher would probably let it pass.

To be absolutely technical about it, very little of the light that you see is pure white. The typical light bulb for a bedroom lamp puts out a little extra in the oranges, whereas a fluorescent light such as the kind at school gives you more in the blue range. Even natural sunlight has a yellowish tinge.

Light comes into your camera as it is, with whatever color cast it has. Shooting in fluorescent light lends a bluish tone to the picture, whereas shooting in sunlight tips the photo toward the yellows. This might be fine for what you're shooting, but many times it isn't. You might prefer to capture the subject in neutral, untinted, plain white light.

The white balance feature of your camera enables you to do just that. It analyzes the light coming into the camera and filters out whatever cast there may be. As a result, what is supposed to look white appears perfectly white, and all the colors in the photo follow suit.

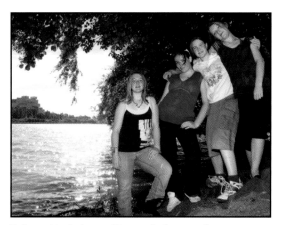

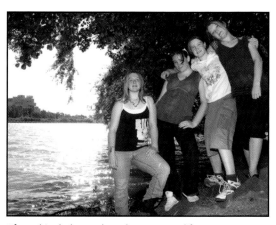

Before white balance, skin tone looks too pale. After white balance, the color comes to life.

Your camera probably determines white balance automatically, which gives you more or less satisfactory results. For even better results, set the white balance manually. To do this, you need to give your camera an example of what should look perfectly white under the present conditions. The blank side of a white index card should do the trick. Hold one up to the camera so that it fills the frame, and then follow the instructions in your camera's manual as to which button to press. Keep in mind that, although the white balance is just right for the current environment, it is probably all wrong for the next one. When you shoot in another location, even if it's just another room of the same house, don't forget to recalibrate the white balance with your index card.

Shifting the Color Temperature

Color temperature is a technical way of describing the color of light, whether it's orange-ish light from a bedroom lamp, bluish light from a fluorescent bulb, yellowish light from the sun, or anything else.

Many people think of color temperature in terms of the emotions that different colors convey. The red end of the spectrum is usually the warmer one, while the blue end of the spectrum feels colder. Oranges and yellows are homey, such as firelight, while blues call to mind ice floes and glaciers. This is why you probably feel more comfortable in the cozy glow of your bedroom lamp (orange-ish cast) than you do in the impersonal, industrial fluorescent glare of school (bluish cast). By this definition, warm color temperature suggests emotional warmth, whereas cool color temperature implies a chilly disposition.

This definition isn't quite right, though. Believe it or not, color temperature actually measures the physical temperature of something, as in how hot its surface is.

That something is a *blackbody,* which is an object that gives off different colors of light depending upon how hot it gets. Think of the heating element on a stove. When it gets hot enough, it turns orange-ish red. If you could heat it even higher, it would turn yellow, then white, and finally blue. This is what happens in a blackbody. So on the scientific scale of color temperature, fire-engine red is the coldest color, while frostbite blue is the hottest one!

Sometimes you want to normalize color temperature. You don't want it too warm, and you don't want it too cool. You'd rather it be comfortably in the middle. This is what standard white balance is for. But other times, you want to add color temperature for its emotional effect. Maybe you want to increase the sense of warmth of a scene by bathing it in a cool color, such as yellow, or you want to convey the crispness of a cold winter day by upping the level of a hot color, such as blue.

Ah, the good old days. By tipping the color temperature toward the cooler colors, you enhance the emotional warmth of the subject.

All's quiet in the enchanted forest—maybe a little *too* quiet. By tipping the color temperature toward the warmer colors, you enhance the feeling of coolness in the photo.

To do this, tweak the camera's white balance presets. These usually appear as a list of lighting conditions, such as Tungsten (for regular tungsten light bulbs), Fluorescent, Daylight, Flash, and Cloudy. These go from cooler to warmer in terms of color temperature, so Tungsten is the coldest, while Cloudy is the hottest (and if you have a setting for Shade, that's hotter still). Normally, you choose the setting that corresponds to your current conditions, but who says you always have to do the normal thing?

✦ **To add emotional warmth, choose a cooler color temperature.**
 Drop down from Daylight to Fluorescent or Tungsten.

✦ **To add emotional coolness, choose a warmer color temperature.**
 Move up from Daylight to Flash or Cloudy.

Depending on your camera, you might even be able to enter an actual color temperature value in degrees Kelvin. Remember that reds and oranges are cooler colors, while blues are hotter. Candlelight falls in the cooler range at about 1,000 degrees Kelvin, as does your cozy bedroom lamp at 2,500 degrees Kelvin, while the brilliant blue of a cloudless sky is blazing hot at 10,000 degrees Kelvin. Noontime daylight is right in between at roughly 5,000 degrees Kelvin.

If you can't set white balance on your camera, you can always adjust the color temperature of your photos after you transfer them to your computer. An image editor such as Photoshop Elements does the trick admirably.

Expressing Yourself

Every picture tells a story. You look at it, and it says something to you. Maybe it tells you a little something about a person who you've never met. Maybe it speaks of a place that you always wanted to visit. Maybe the story is more subtle, and it doesn't have much to say about the people or things in the photograph, but it goes on at great length about the interesting way that the colors offset each other or how the shadows seem to dance around the light. Some photos have so much to say that you'd swear you're watching a movie instead of looking at a still.

When artists of all stripes talk about finding their voice, it sounds edgy and mysterious, and it's a great way to make the parents nervous, but it boils down to nothing more hardcore than figuring out how to tell a story. Your voice as a photographer is the way that you tell the stories in your photos. It's also the kinds of stories that you choose to tell. Getting your photos to say what you want them to say is what this chapter is all about.

Designing the Shot

Designing the shot? The idea may seem a bit odd. Because you're taking pictures of people and events in the real world, you might not think that there's much to design. You see something that catches your eye, you take out your camera, and you snap the picture.

But remember that your voice as a photographer isn't just about what subjects you choose to shoot. It's also about how you choose to capture them. To say it another way, your photography reveals a bit about how you see the world, and your best photos encourage others to share your perspective. This is where design comes in. It isn't so much about making the world do what you want it to do—"Sit here! Arms down! Hands on lap! And for crying out loud, smile!"—it's about finding the most effective way to present the world as you see it.

For each photo, you might ask yourself a simple question: What about this is most interesting to me? When you know the answer to that one, your job as a photographer becomes exceedingly easy. All you have to do is show it. Show the world exactly what about the subject caught your eye. In other words, take pictures of qualities—the happiness that you felt when you were with your friends that day, the prettiness of the sunset on the river, the melancholy of the rain through the window—rather than of the people or things themselves. Don't assume that your audience will just naturally get it. Everyone has their own point of view. Show them the quality as you perceive it in as clear a way as you can express.

But how do you take a picture of happiness? How do you take a picture of prettiness? And how do you get melancholy to pose for you? Who knows? Nobody does for sure. Smarter people than your authors have tried many times to figure it out, and mostly they've come up with zilch, although they have uncovered little tricks of the trade that seem to work more reliably than others. These aren't really rules, because photographers break them all the time, but they do tend to deliver, so they're well worth discussing. This section does just that for some of the most common and useful tricks in the bag.

Using Composition Techniques

Composition is the way that you arrange the different elements in the shot—the subject in relation to the surroundings. Once again, it isn't so much about ordering the world to your liking as it is choosing where to place the subject in the frame or deciding how much or how little of the surroundings to show, all to the effect of conveying more clearly the quality of the scene that most catches your eye.

Filling the Frame

All right, so your picture tells a story. Sometimes other elements creep into the frame, such as something in the background that distracts from what's going on in the foreground. This is like an interruption in the story that you're telling.

Sometimes this effect is just annoying. One of your authors was once photographed receiving an award. There was a light fixture in the background, and the way the photographer angled the shot made it look like the thing was

growing out of my head! That picture went into the local paper, and don't think for a minute that my friends let it slide. My bionic helmet turned out to be much more interesting than me standing around accepting an award, so the original story of the photo got garbled.

But sometimes the interruption is so distracting that it's like another story going on at the same time, as if you're trying to show two movies at once. Sometimes you're lucky if it's only two. Your audience isn't sure which story to follow: the volleyball game on the beach, the laughing seagulls flying in circles, the bratty kid building the sandcastle, or the lifeguards jumping in to save somebody.

Always try to keep your photo's story as simple as possible. This isn't to say that there can't be a lot going on in the photo, but all the action should be part of the same story.

Whenever there's so much going on that you can't fit it into a single shot, don't. Shoot a series of photos instead, with each photo telling one part of the story. Start out with an *establishing shot,* or one that sets the scene for the audience and helps to draw them in. Then move on to tell the rest of the story. Put the prints together in the same frame or the same Web page, and they have even more of a punch than they would individually.

The best way to avoid interruptions is to fill the frame with the subject, whatever your subject happens to be. If it's somebody accepting an award, move in close so that you show only that, or choose an angle where the light fixture stays in the background. If it's a volleyball game on the beach, keep clear of the rescue operation, or maybe take a photo of that instead. Or why not take a couple of photos? Instead of one crowded shot, multiple shots give you the scope to capture each interesting element in the way that best suits it. You can take a shot of the seagulls as they wheel overhead, or get down low and shoot them as they stroll across the sand. Capture the volleyballers with a close-up action shot of a flashy spike or block (with a high shutter speed to freeze the action). Get the lifeguards on their watch, staring intently out to sea, or if you're lucky—and someone else isn't!—dashing to pull someone out of the surf.

When the subject of the photo is the scenery itself, as in a classic wide-angle shot, avoid potentially distracting objects in the foreground. This is especially important because your audience automatically assumes that the foreground is the subject of the photo. You don't want that magnificent mountain range to become the backdrop for a tourist consulting his guide book, unless of course you're taking a photo of the tourist. Anything that doesn't look like it belongs in the scene is a prime candidate for distraction, so wait until the tourist wanders out of frame, or choose a different angle.

When you fill the frame with the subject, you help to avoid distractions in the shot. The shallow depth of field doesn't hurt, either!

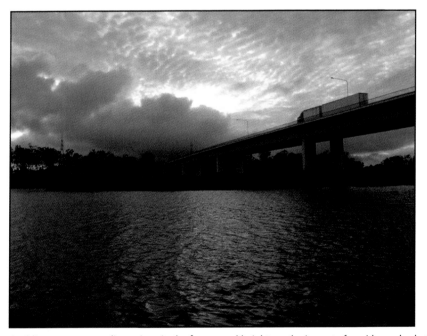

Avoiding unnecessary distractions in the foreground heightens the impact of a wide-angle shot.

Placing the Subject

You know what you're shooting. Now, where to put it? There are three main approaches to placing the subject in the frame:

1. Centering
2. Using the rule of thirds
3. Using dynamic symmetry

Most people lean toward centering by instinct, probably because they're used to centering other things when presenting them, such as putting a vase of flowers in the middle of a table. It's called a centerpiece for a reason, right? Placing the subject front and center does help to draw attention to it, which is always good, but at the same time this technique isn't a magic recipe for making a photograph visually interesting. In fact, many times centered subjects seem less dynamic than off-center ones, sometimes to the point of being lifeless or boring. When you're trying to convey vitality or motion, centering often falls flat in the frame.

Where centering in photography really shines is when you have *symmetrical balance.* That's when the subject of the photo is front and center, with surrounding elements spaced evenly on either side. These don't have to be actual objects—negative space can be in symmetrical balance, too. Imagine that the composition of the photo is a scale or seesaw. The middle part—the *fulcrum* or pivot point—is dead center in the frame. For symmetrical balance, both sides of the scale should have the same *visual weight.* That is, when you look at the photo, they feel like they even each other out. You don't want either side of the scale to tip one way or the other.

The tree is centered, and the negative space around it is in symmetrical balance.

Symmetrical balance doesn't give you much in the way of action or excitement, but maybe you're not trying to convey these qualities. A symmetrically balanced composition appears more stately and calm, as if everything is in its proper place.

To liven up your action shots, try the *rule of thirds* instead of centering. By this technique, you imagine two evenly spaced horizontal lines and two evenly spaced vertical lines across the frame, creating a three-by-three grid. Then you put the main focus of attention in any one of the places where the lines intersect. This often improves the zip and visual interest of the shot, even when you aren't specifically conveying motion, because one of the sides of the imaginary scale seems to be in the process of tipping.

When you compose by the rule of thirds, the main focus of interest appears where the gridlines intersect (or thereabouts).

You might also try the technique of *dynamic symmetry*. Draw a diagonal line across the frame, from one corner to the other, and then draw a perpendicular line from the diagonal to one of the opposite corners of the frame. This makes a titled T shape. The main focus of attention goes where the lines intersect, or where the top part of the T meets the bottom part.

When you compose by dynamic symmetry, the main focus of interest appears in the vicinity of where the diagonal and perpendicular lines meet.

Choosing the Point of View

The *point of view* of the photo is the position of the camera in relation to the subject. Often, the camera is level with the subject, which gives the photo a direct, head-on, eye-to-eye feel, but by no means is this the only point of view.

A *low-angle shot* is one in which the camera is below the subject, looking up. This sort of angle emphasizes the height of the subject, and it makes the subject seem stronger, bolder, and more powerful, whether for good or for ill. All good heroic portraits look up from below. So do all good shots of menacing obstacles. When you shoot them from a low angle, heroes look more heroic, and obstacles look more menacing.

By contrast, in a *high-angle shot,* the camera is above the subject, looking down, which tends to create exactly the opposite effect. You emphasize the smallness of the subject, or you make it seem less formidable. Low-angle shots literally look up to the subject, while high-angle shots look down on it. It seems funny that it should actually work like this, but it does.

Looking up from a low angle.

Looking down from a high angle.

When thinking about point of view, the orientation of the photo comes into play.

Landscape orientation, in which the width of the photo is greater than the height (6 inches wide by 4 inches tall, for example), emphasizes the breadth of the shot. Wide things look wider, so it's ideal for breathtaking views. But *portrait orientation,* in which the height of the photo is greater than the width (6 inches tall by 4 inches wide), emphasizes height, so tall things appear taller. Combine this with a low-angle shot, and your audience can't help but feel the height of the subject.

It also works the other way around. A small subject appears smaller in portrait orientation. Looking down on the subject from a high angle in addition to using portrait orientation makes the meek seem meeker and the humble seem humbler.

Tech editor Ron suggests shooting an interesting subject in both landscape and portrait. Composing it both ways gives you a different point of view, and sometimes the unexpected or less obvious orientation makes for a better photo. Plus, if you have two versions of the shot, you have more flexibility in what you can do with them. Maybe the landscape version works well in a frame, but the portrait version is better for the yearbook.

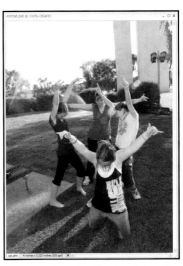

A landscape photo is wider than it is tall.

A portrait photo is taller than it is wide.

Directing the Eye

One method to emphasize a particular quality is to put it right up front in the frame. Another method is to lead the audience's eye toward it, almost as if you were drawing an arrow, although you don't need an actual arrow to point the way. You can use any line that appears in the surroundings, whether it's a road, a river, a sidewalk, some construction beams, a coil of rope, a baseball bat, a hockey stick, the stem of a flower, or the horizon itself. The line can be perfectly straight or curved—it doesn't matter. Look at any picture with a strong, unbroken line in the composition, and your eye naturally follows it. When this happens, you have a *leading line,* as in the line is leading the way.

The pole acts as a leading line, directing you to the subject.

Watch out for too many leading lines going off in too many directions. The audience gets confused and doesn't know which one to follow. Look for one leading line only, or if you have several, make sure they're all going the same way.

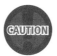

Use leading lines to your advantage whenever you find them. They really help to draw the audience into the shot, and they can point to anything of interest, not just the quality that you want to call out. Place the subject in the frame using some other method, and then use a leading line to show where the subject is going or where the subject has been.

Different kinds of leading lines tend to emphasize different kinds of qualities. A straight vertical line speaks of strength and solidity—think of a marble column. A straight horizontal line suggests peace and tranquility, like a long, quiet field in which to take a nap. Straight diagonal lines are all about direct and speedy action, while curved lines suggest a more graceful and fluid kind of motion.

Think about the orientation of the photo, too. Landscape orientation works better with horizontal leading lines, while portrait orientation works better with vertical leading lines.

Getting Perspective

Perspective is the sense of depth in the photo. Different kinds of perspective enhance different qualities. A dense, flat, tightly packed shot feels constrictive, a lot like your cramped locker at school. A wide-open shot feels spacious and free, and a shot of a long road feels all the longer when a succession of signposts or other markers gradually recedes into the distance.

Controlling perspective gets a little tricky because a photograph exists in two dimensions, while the world that it represents exists in three. Fortunately, painters and illustrators have been grappling with perspective for centuries, and you can readily borrow some of the tricks from their bag. One of the most effective is to use visual markers.

Consider any object. When it appears up close in a photo, it looks physically larger. When it appears far away, it looks physically smaller. The trick, then, is to find some objects in the scene—nothing too distracting, nothing too unusual—and use them to give the audience a clue about the depth in the shot. The subject

itself can be one of these objects, and how big or small it is in relation to the others suggests how near or how far away it is. If all the objects happen to be the same kind of thing, such as trees in a row or posts in a fence, it's all the better. Not all perspective markers fall in a neat sequence, but then again, they don't need to. You can usually establish depth with one nearby object and one faraway object. It's all about showing them in relation to each other.

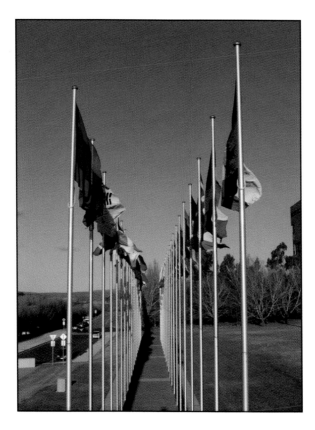

As the flagpoles get smaller, the sense of depth increases.

A leading line going into the picture is an excellent way to create a sense of depth.

Similarly, you can flatten or *compress* the sense of depth in the shot by specifically avoiding perspective markers. When these are unavoidable—for instance, when you're shooting a scene in wide angle—see about lining up the perspective markers so that they stack one atop the other, with each one in its own vertical zone or band. This technique is called *layering*, and it works best to compress the scene when there's not very much apparent distance between the different bands.

Divide the frame into vertical bands, and then stack them up to compress depth.

Let There Be Lighting

You know from Chapter 3 that light is crucial to photography from a purely technical standpoint. It probably comes as no surprise that the way in which you shoot the light helps to set the aesthetic mood of the scene. Equally important, it affects the presence and prominence of shadow.

We haven't discussed shadow much at all until now, but don't gather from this that it's not a major factor. We humans often take shadows for granted when we come across them in the real world. Think about it—when was the last time you remember seeing a shadow when you weren't specifically looking for one? But in photography, just as the color cast of the light becomes more obvious, the shadows that come off of objects become more obvious, too. You can use shadows to your advantage if you're going for certain kinds of creative effects, but most of the time, they're just distracting. They take away from the quality you're trying to capture, or they create too much of a contrast with the rest of the scene.

In your quest for illumination, consider the direction from which the light is coming:

✦ **Frontlighting.** The light comes from behind you—"over your shoulder," as the old saying goes—and illuminates the front of the subject. Shadows fall away from the camera, so often they aren't visible at all. For these reasons, frontlighting is the general-purpose, can't-go-wrong, problem-free, all-season lighting for anyone taking pictures of anything. Uncle Frank can use it to document as many family gatherings as he likes. The drawback to front-lighting is that it just isn't that interesting most of the time. Because there usually aren't any shadows at all, photos come out looking especially flat. If you're going for compression, then great, but if not, you might want to try a different kind of lighting. Also, because the light shines on the front of the subject, it tends to overpower fine texture and small detail. This is a flattering way to get rid of the little imperfections in glamour photography, but perfection is never as interesting as character.

Frontlighting gets the job done, but it's not terribly interesting most of the time.

- **Backlighting.** The light comes from in front of you and illuminates the back of the subject. Shadows fall toward the camera, so if you don't want them, and you probably don't, be careful about how much of them you pick up in the frame. Because the light is behind the subject, the subject doesn't squint, which allows for a more realistic, natural-looking face, and translucent objects, such as glass, take on something of a glimmering, magical quality. If the light is really strong, though, you might get a halo around the subject or create a silhouette effect. Because of this, backlighting is often best for the dramatic look.

Backlighting can be very effective in creating spectacular photographs, but it can be a nightmare when you are taking photos of people. If you want to take a shot of someone against a bright background, say your family at the Grand Canyon with the sun on the horizon, turn on your fill-in flash, and it will prevent the shot from turning into a vague silhouette in front of breathtaking scenery.

Backlighting often creates a dramatic effect.

 In a backlighting situation, watch out for the light coming directly into the lens! It can create a common visual distortion called a *lens flare*.

◆ **Sidelighting.** The light comes in from the side and illuminates the subject at an angle. Sidelighting is great for picking out the little details that frontlighting blasts away. It also throws dramatic shadows off to the side, which enhances the sense of depth and lends itself to interesting possibilities in composition, but may also provide unwanted distraction. If you're looking to create strong contrast or to call out one aspect or facet of the subject, sidelighting is the way to go.

Sidelighting typically gives you prominent shadows.

✦ **Flat lighting.** *Flat* or *diffuse* (as in scattered) light doesn't seem to come from any direction in particular, like sunlight on a cloudy day. It reduces or eliminates the problem of shadow, it isn't glaring like direct light, and it helps to coax out color and detail. When you aren't using light for creative or dramatic effect, flat lighting is as good as it gets. Uncle Frank may not realize it, but his holiday photography will be much better off if it's overcast for every family picnic.

Flat lighting doesn't seem to come from anywhere, yet it appears to be everywhere.

Taking All Kinds of Pictures

So that's the theory. Now for some examples. Here are some suggestions for taking three kinds of photos: portraits, landscapes, and still-lifes.

Shooting People (with the Camera, Silly)

Even today, in the 21st century, many indigenous peoples around the globe don't like it when you take their picture. They claim that photography steals the soul. As it happens, the best portraits do exactly that, although *steal* may be too harsh of a word. Revealing a bit of the person's character is perhaps more of what's going on. And anyway, indigenous peoples don't have much to worry about, because if they ever saw Uncle Frank's photography, they would realize that he's nowhere near the soul.

When it comes to discussing pictures of people, it's helpful to note the difference between a shot of a person and a shot of a person doing something. One of your authors was a philosophy major in college, so it'll please my old professors to no end if we draw up a couple of categories: "being" shots and "doing" shots. When you shoot the person, you're going for a particular personal quality of the individual. In other words, you're capturing something about who this person is—a "being" shot, if you will. You don't want and don't need to show the person in action, which is what we mean by a "doing" shot. In "doing" shots, the most interesting thing is the activity going on, not necessarily who's doing it. But the best portraits are "being" shots, and those specifically are what we talk about here.

Despite whatever the clergy has told you, stealing souls isn't hard at all:

+ **Go for portrait orientation.** People are taller than they are wide. Hold the camera so that the height of the picture is greater than the width.

+ **Try eye-to-eye point of view.** For the most intimate shot, without the added connotation of status politics, don't put the person on a pedestal, but don't look down on him or her, either.

+ **Shoot against a simple background.** You don't want the background to upstage the subject of the photo, so avoid crazy, distracting shapes and patterns and extreme, attention-grabbing colors. To deemphasize the background as much as possible, go for a shallow depth of field. Switch to aperture priority mode, and take the f-stop down a couple notches. Then bump up the shutter speed the same number of stops to maintain the level of exposure. Humans are notoriously jittery creatures, always twitching and blinking, never at rest for very long, so the higher shutter speed has the additional benefit of preventing streaks and blurs of motion.

+ **Use sidelighting.** Sidelighting helps to coax out the little bits of character, and it increases the overall sense of depth so that the subject doesn't come off as a flat, two-dimensional bore. Make sure that the light hits the correct side! Don't put the most interesting thing about the subject in the shade. Remember, too, that sidelighting gives you big, dark, dramatic shadows. Try your camera's fill-in flash to offset more extreme sidelighting conditions, unless you're going for an arty, high-contrast look, in which part of the person is super-illuminated and the rest is in inky black shadow.

✦ **Fill the frame with face.** "Head and shoulders" isn't just a shampoo product. It's also the byword for portrait photography, so come up nice and close to the subject. The *most* you should show is the head and the top part of the shoulders. You're not in the market for the arms or the torso. For a more intimate look, zoom in toward the eyes, even to the point of cropping off the top of the head.

✦ **Avoid poses at all costs.** Surely you've heard the term *poseur*. Perhaps you've used it to describe one of your classmates. A poseur is one who poses, as in one who takes a phony stance on something. In Jane Austen's times, they called it *affectation*. The surest way to distract from whatever interesting quality you're trying to shoot is to obscure it with the posed, affected look, the one that you've seen in countless photographs, which makes everyone appear exactly the same. And the best way into the person's character—better than the right lighting, the right angle, the right camera, and the right settings—is to catch the person in an unguarded moment. This isn't always easy because we're trained at birth to freeze and smile every time the camera comes out, and who wouldn't get a little self-conscious when a photographer pushes a lens into their nose? The trick here is to be sneaky. Don't tell the subject when you're going to shoot, and definitely don't mention anything about cheese. Talk about something else instead. Try to get the person in the frame of mind that helps to bring out that interesting quality in him or her, and then, when the person least expects it—*snap!* If you have a particularly twisted mind, fake the person out with a warning shot, only don't say that it's a warning shot. Once the subject thinks that you've taken the photo, guard goes down, honesty goes up, and the wonderful quality that you're looking for tends to light up like a beacon. *Snap!*

If you have an older digital camera, watch out for shutter lag. Your subject might move or close his or her eyes, thinking that you got the picture, when in fact your camera is still gearing up.

To take a self-portrait, first scope out the scene for lighting and potential distractions, just as you normally would. Keep in mind that frontlighting and backlighting are the opposite of what they usually are! What would normally be frontlighting —the light behind you, coming over your shoulder to illuminate the front of the subject—is now backlighting, because the light is catching your back, and you're the subject of the shot. Also, you'll be shooting at arm's length, so set your camera for a shallow depth of field.

Dave steals a bit of his friend's soul.

Character study time! Your friends are characters in their own right, so why not show it? Make it your personal project this year to do portraits of all your friends. Pick out the most interesting personal quality of each, and then get it in a picture to the best of your skill.

At the end of the year, create your own mini-yearbook on the computer, and hand out a copy to everyone involved. It's a big job, but you'll be glad you did it. Twenty years down the pike, when you crack open your yearbook, instead of a bunch of poseurs looking back at you from the page, you'll see the real people, just as you saw them then. That's a priceless keepsake if ever there was one.

Once you've sorted out the lighting, the photography is simplicity itself:

1. Find your balance.
2. Get in a comfortable, natural position.
3. Hold the camera at arm's length.
4. Turn the lens toward yourself.
5. Let it fly.

If your camera has a timer, you can use that for taking self portraits, too. Place the camera on a tripod or even a sturdy table or chair, set the timer, and get into position in front of the lens.

Don't worry if the picture isn't perfect the first time around. You don't have the benefit of seeing what you're doing through the camera's viewfinder. Repeat the process as often as you like.

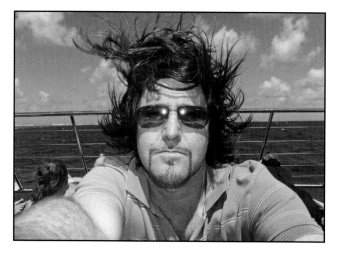

Dave's other friend reveals his inner rock star.

Framing the World around You

You live in an interesting world, whether it's the city, the town, the countryside, or out in the middle of nowhere. Revealing the character of a particular place can be as fun and rewarding as taking pictures of your friends, although the guidelines are a little different.

+ **Choose one subject and focus on it.** This might seem obvious, but a landscape is different than a person. When you shoot a person, you have a very clear focus of attention, and the way that you compose the shot helps to call out that one special quality. In a landscape, there's usually a lot more going on. There's a wider angle of view and a longer depth of field, so more of the environment appears in the frame. Nevertheless, out of everything you see, choose the most interesting feature, and make that the official subject of the photo. Place it in such a way as to call out the quality that caught your eye. And then...

◆ **Make sure the rest fits.** After you choose the subject of the photo, there's still the rest of the environment to consider. Check that the subject really is the most interesting thing in the frame. If it isn't, try another angle. Watch out for other distractions, too. Anything that seems out of place for the given scene—a telephone pole, a radio tower—even if it's actually a part of the landscape, steals attention from the main point of interest.

◆ **Try framing.** Framing is a technique in which you place the subject inside or behind something. Think of a person standing in a doorway—the doorway frames the person. Framing helps to draw attention to the subject of a photo, so look for objects in the environment, such as tree trunks and branches, and see about choosing an angle that uses these things as frames. This way, the environment isn't causing a distraction; it's actually helping you to tell the story that you want to tell.

◆ **Go for breadth and depth.** The world is a three-dimensional place, so use every trick at your disposal to make it seem that way in your photos. Look for a leading line going into the picture. Use unobtrusive features of the landscape to help establish perspective. Zoom out all the way for the widest angle of view, and crank up the f-stop to increase the depth of field. Don't forget to take the shutter speed down the same number of stops for the sake of exposure. Because slow shutter speed can give your photos the shakes, mount your camera on a tripod.

◆ **Watch the horizon line.** If the horizon is visible, make it level. When something about the sky is the most interesting feature, place the horizon lower in the frame. When something about the land is the most interesting feature, place the horizon higher in the frame.

◆ **Be careful about lighting.** The vast majority of landscape photography relies upon natural lighting, so the time of day and atmospheric conditions become important factors to consider. Shooting early in the morning or late in the evening eliminates the glare of the high midday sun, and the long shadows lend a sense of depth to the shot. An overcast sky gives you good, diffuse light, although it may strike an unintentionally somber chord.

It's an interesting world out there.

Capturing Still-Lifes

A *still-life* is a deliberate arrangement of everyday objects that you use for the subject of a photograph. The real subject, of course, isn't the objects for their own sake, but the way that their colors, shapes, and textures interact to create something interesting to look at.

Dave sees still-lifes in real life.

Still-lifes can be fun to set up and shoot. Here are some tips:

◆ **Mix it up.** The great advantage to still-lifes is that you don't have to wait around for something special to catch your eye. You create the scene, so the no-pose rule goes right out the window. Pose like crazy. In fact, go out of your way to remove the objects from their everyday settings, or try unusual combinations. This makes the photo more interesting, and it encourages the audience to look past the objects themselves and focus on the interplay of their colors, shapes, and textures. Along similar lines, there's no need to shy away from vivid colors, bold shapes, and rich textures, although the chili pepper rule is in full force—a little goes a long way. By all means, go extreme, but do it in moderation!

◆ **Hint at patterns.** A great still-life trick is to repeat certain themes: a particular sequence of colors, alternating shapes, and so on. The human brain is a sucker for patterns. It looks for them everywhere. So when you go to the trouble of putting one in your still-life, you delight and perhaps even captivate your audience.

◆ **Bring the background into the foreground.** The background doesn't have to stay in the background. Use it to contrast or complement the interplay of the objects in the arrangement, and apply depth compression to reduce the amount of apparent distance between foreground and background.

◆ **Try the unexpected point of view.** Half the fun of still-lifes is seeing everyday objects out of their usual settings. You can enhance this effect by coming at the objects from an unusual angle. Show them in a way that you don't typically see them.

◆ **Use backlighting.** This is a trick from the advertiser's playbook. In photographs designed to sell products, the subject is almost always illuminated from behind. It gives the product that warm glow, which helps the company to move more units. Even when you aren't selling anything, backlighting adds drama and visual interest to otherwise fixed, inanimate objects.

◆ **Be silly.** Put an apple in a baseball glove. Fill a fishbowl with marbles. In a still-life, you can afford to get a little ridiculous.

The study of fine art in college is famous for three things: vases of flowers, bowls of fruit, and nude models. You don't need college for the first two. Do your own photographic take on the classic vase of flowers and bowl of fruit, only fill the vase or bowl with something else, something kind of similar yet unusual enough to catch the eye. You might try lollipops instead of flowers or tennis balls instead of fruit.

Living Like a Photographer

Being spontaneous and unpredictable. Seeing the world in unusual ways. Keeping odd hours. Constantly coming up with new ideas for projects. Caring about details that no one else seems to notice, while ignoring those that everyone else says are obvious. Sound like anyone you know?

You probably already adhere to the artist's lifestyle, so you might as well make it official. We conclude this introduction to the art of photography with a word to two about the practical side.

Practicing Like Crazy

The best way to learn how to ride a bike is to hop on and give it a try. (Don't forget your safety helmet!) Likewise, the best way to learn how to take pictures is to get out there and take them. Constantly.

With digital photography, there's no film to use up, so you don't have to be so choosy about the where and when. Take your camera everywhere you go. At the end of the day, if you haven't filled up your memory card—why not? Who cares if every shot isn't breathtakingly brilliant? This isn't a test, and you're not being graded.

The only time to use the least bit of restraint is when you're deciding upon the subject of the shot. It's good to be mindful about people's privacy, especially if they're strangers, so taking a photo of everyone you meet probably isn't the best idea. But your friends and family are fair game, and the world around you is full of interesting things: trees, buildings, clouds, flowers, bugs, spider webs, and sidewalks, to name just a few. You can also give yourself mini-challenges or make your practice into a game. Find the most boring, mundane object in sight, and see whether you can find the right combination of angle and lighting to make the shot stand out, or see how many different ways you can shoot a single subject in one minute.

A great way to pass the time on a long trip is to play the game "I Spy." Surely you know how it works. Someone says, "I spy," and then describes a nearby object without telling what it is. Everyone else gets busy looking, and the first person to shout out the name of the object wins the round.

You can adapt this game to your photography practice sessions. Choose an object, the sillier the better—a trash can, one shoe without the other, a misspelled word—and on your many travels, whenever you spy this object, document it for posterity. You'll give yourself a chuckle every time.

It's almost too embarrassing to admit, but one of your authors used to do this as a kid—with pigeons. Whenever I spied a pigeon, no matter where I was, out came the camera. Somewhere in my closet, there's a box of pigeon photos, and someday the wrong person is going to discover it.

Practice time is ideal for getting the hang of your camera controls. You gain all kinds of valuable experience, which means that when it's time to shoot for keeps, your results are that much better, and you make fewer mistakes. Want to see what too much ISO does under certain conditions? Crank it all the way up and let it fly. And don't just take our word about the relationship between aperture and depth of field. Switch to aperture priority, play around with the f-stop, and see for yourself.

Practice is also the time to experiment and grow. Do the unexpected. If you find that you're really good at people shots, shoot nothing but landscapes all day, or if you're used to taking pictures by the light of early morning, wait until the glare of mid-afternoon. Every experience taking pictures is a valuable one, so practice time is almost impossible to waste.

Getting Involved Everywhere

Being a photographer isn't just about practicing, though. It's also about putting those skills to use.

You shouldn't have to look too hard to find all kinds of venues for your pics. School is the obvious place to start. The yearbook and the school paper are the biggies. Sign on as a photographer for one or the other, or even both if your schedule can afford it. Maybe even team up with a writer friend, and go on all your assignments together. Creative collaborations can be a nice change of pace if you're used to going it alone all the time. Try working with other photographers, too. See how the other half does it. This broadens your experience all the way around. You learn just as much from them as they do from you.

The yearbook and the paper aren't the only groups in need of photos. The drama society needs headshots, costume reference shots, makeup reference shots, pictures of dress rehearsal, and so on. Sports teams need pictures of practices, drills, and matches. The cheerleading squad needs pictures of routines. The marching band needs pictures of formations. The science club never shies away from documenting empirical evidence. Homecoming needs pictures. Prom committee needs pictures. Student council needs pictures. Who knows? Maybe the debate team and the chess club need pictures, too. It never hurts to ask. Depending on your school, there might even be a photography club. Definitely sign on to that one.

And these are just the venues at school. Countless community groups, volunteer groups, social clubs, amateur sports teams, amateur theater companies, political activists, and religious groups are at work right now in your city, town, or munic-ipality, wondering where they're going to get their next set of pictures. There are so many opportunities, in fact, that the options can be overwhelming. Sometimes you don't know where to start.

For the maximum benefit to your photography, try to give yourself a nice range of photo commitments. If you do one type of photography at school—the yearbook, say, where you're typically shooting people—see about balancing that out with a different kind of photography outside of school. Maybe a local advocacy group is looking into the environmental impact of something or other, which would give you the chance to shoot nonhuman subjects.

It's also good to start out slow. You don't want to over-commit. So if you're on yearbook and the paper, and in the photography club at school, that's more than enough to start. Give it a month, and see how it goes. When you feel that you're in the rhythm of things and juggling your commitments with ease, think about picking up a few more gigs. When you start to feel like you're doing too much, it's definitely time to reassess your schedule. No sense in driving yourself batty. Keep the gigs you like the most and those from which you learn the most, and politely pass or hand off the rest. If you feel bad about leaving a group, check with your other photography pals. Maybe you can give the group a couple solid recommendations about who might be interested in taking your place.

Making Your Own Opportunities

If all else fails, you have a creative mind. All you have to do is use it. Sometimes the most rewarding opportunities are the ones that you dream up yourself.

The school newspaper doesn't need any photographers? Not a problem. Grab a bunch of friends, and start an independent alternative paper. Is anyone in town investigating UFO or ghost sightings? If not, why not you? And not every school has a photography club, but that doesn't mean that you can't start one.

Another priceless opportunity is tagging along with a professional photographer. A wedding photographer or a shutterbug for the local paper might be amenable to bringing you with them on a job. You could offer to carry their gear or run an errand for them in return. No matter what, it's worth asking. Every pro today was once where you are now, and they remember what it was like waiting for that one big break. There's only one potential snag. If your family doesn't already know the photographer, you should clear your plan with the parents first, just so everyone's comfortable.

When you're on the job, be on your manners and absorb everything you can about the experience. See how the photographer sets up the shots, and also take note of how the photographer interacts with the client. Don't shy away from asking questions, but be careful about interrupting the photographer when he or she is working. Make a note of your question for later if you need to. After the job on the way home is the perfect time to talk.

If you prove that you're reliable, courteous around the client, and helpful in a pinch, who knows? You might find yourself with a new part-time job. Bye-bye, burger joint.

Making your own opportunities is also about being ready for anything, like Dave was a little while ago. He was taking part in a human sign, where people stand together to spell out a message.

The organizers of the event had hired a photographer to take pictures from a helicopter, but Dave noticed that there wasn't anyone taking pictures from the ground. As always, he had his camera with him, so he approached the organizers and offered his services. Just like that, he had an assignment.

Getting Your Pictures into the Computer

The camera is any photographer's best friend, but the computer is a close second for any digital photographer. No better photo studio exists. Fantastic tools that were once beyond the means of many photographers now come standard on the typical home computer, and the very applications that the pros use to win Pulitzer Prizes and influence the perception of world events are within the reach of everyone up to and including Uncle Frank.

As far as processes go, getting your photos into the computer is an easy and painless one. This chapter shows you how it's done.

Setting Up Folders

Before you move the photos from your camera to your computer, it's a good idea to get yourself organized. You're going to be working with a lot of pictures, so it's very easy to lose track of what goes where.

As doubtlessly you already know, your computer stores information in a system of files and folders. The *file* is the document itself, whether it's your word-processed term paper, an MP3, a video clip, or even a piece of software (although most software these days is a collection of many different computer files). The *folder* is simply a container for files. It's nothing more complicated than that. It doesn't do anything to the files besides giving you a convenient place to store them. Think of a dresser. Your socks, underpants, and so on are like the computer files—the items that you actually use—while the drawers are like the folders. You open the drawer where you keep your socks when you need a fresh pair, but otherwise the drawer doesn't do anything special besides making your socks easy to find. You can put folders inside other folders, too, whenever you need an extra container for a particular set of files. This is like keeping a jewelry box in the top drawer of your dresser so that your jewelry isn't rolling around loose.

IN DEPTH

Another name for a folder is a *directory*. Back in the early 1980s, many home computers had very simple operating systems with only one place to store files. The directory was a helpful and accurate description for this file container, so the name caught on. One directory was fine, too, because storage space was much more limited. Back then, an entire home computer with all the trimmings wouldn't have had enough memory to store a single high-quality digital photo!

Soon enough, computers got more powerful, storage space became more abundant, and more and more home computers came with multiple directories. But now that there was more than one place to store files, the term *directory* didn't make much sense. By the time that graphical operating systems such as Mac OS and Windows first came out, directories had become folders: same idea, same function, different word.

Computer people still talk about directories all the time, so whenever you hear the term, just think folders.

Your digital photos are computer files, too. When you transfer the pictures from your camera to your computer, the computer automatically creates a brand-new folder, puts the picture files into it, and then slides the whole package into the default images folder on your hard drive. On Windows machines, this is the My Pictures folder inside My Documents. On Macs, it's the Pictures folder in your home directory.

Your computer assigns a generic file name to each digital photo, such as *Image 001* or *Picnic 014*. You're certainly free to change the names of the files to something more specific, and for your favorite photos, this is usually smart to do.

However, generic file names are perfectly fine. As you'll see in Chapter 6, your time is better spent assigning keywords to your photos. This way, no matter what the file names happen to be, and no matter how often you change them, you can do a quick search for *soccer* and find all the photos in your archive that you tagged with that word.

Here's where it starts to get tricky. Sometimes you have several different kinds of pictures on your memory card at the same time. You might have some school activities, some weekend practice shots, and some goofing-off pics, all in the same batch. If all these shots are going into the same new folder, in a couple weeks you might not remember which folder it is, especially if you take lots of pictures. You know that you should look somewhere in the default images folder, but after that, it's anyone's guess.

Happily, the solution is easy: Create some new folders of your own. There's no right or wrong way to go about doing this, just like there's no right or wrong way to organize your dresser. Whichever way works best for you is the one that you should use. But here's one method that many photographers find helpful:

1. **Review the photos on your camera.** Flip through the shots on the memory card, and make a quick list of what you have. Try categorizing the photos according to event. So if you have photos of a birthday party, a soccer match, and a meteor shower, your list looks like this: Birthday party, soccer match, meteor shower.

2. **Go into the default images folder, and create one new folder for each group of shots.** Three events mean three groups of shots, and three groups of shots means three new folders. Name the folders according to the events: Birthday Party, Soccer Match, Meteor Shower. You might also want to put the date in front of the description. This can be today's date or the date that you took the pictures—whichever you prefer. If you do include the date, use this format: the year, the number of the month, and the number of the date, and put a zero in front of anything less than 9. So August 5, 2007 for the meteor shower becomes 2007-08-05 Meteor Shower. Why the odd format? Because your computer's operating system automatically sorts folders alphabetically, and this way you trick it into sorting them chronologically, too. At a glance, you find that all the folders for a given year are together, all the months in that year are in order, and all the dates of each month are in order, too.

3. **After you transfer the pictures to your computer, move each group of shots to the proper folder.** Let your computer go ahead and create its own new folder for all the pictures. Then, once your photos have transferred, open up that folder, select all the birthday party shots, and move them to the Birthday Party folder that you created in Step 2. Do the same for the soccer and meteor photos.

4. **Delete the folder that the computer created.** The folder that the computer created should be empty now. Trash it. You don't need it anymore.

I organize my folders first into years and then into shoots, with each shoot in the order that it occurred in the year. The first shoot, 01-Random, is for the odd shots I'll take here and there, while the others are for when I've gone out with photography in mind and come home with 200 to 700 photos. Inside the folders, I like to rename the files to reflect the shoot in question, which Photoshop Elements makes very easy when you import the photos directly from your camera.

Here's how Dave organizes his folders and files.

Making That Connection

After you've created some folders for your shots, you're ready for the old camera-to-computer switcheroo. Every camera model is a little different, so break out your manual to see exactly what you need to do, but in general, the procedure goes like this:

1. **Turn on the computer, and turn off the camera.** The computer should be up and ready to go before you do anything with the camera. Leave the camera turned off for now. While the computer is getting itself organized, you might want to pull out your camera's power adapter and plug it into the nearest wall socket. You don't want the camera's batteries to die when you're in the middle of transferring photos.

2. **Connect the USB cable.** Plug one end of the cable into a USB port on your computer, and plug the other end into the USB port on your camera. Make sure that both ends of the cable are secure! If you're connecting with FireWire, do the same thing, only use the FireWire cable and the FireWire ports. If you're connecting wirelessly, such as with Bluetooth or Wi-Fi, skip ahead to Step 3.

3. **Turn the camera on, and set it for transfer mode.** Some cameras have a special setting for transferring photos. If yours does, or if you're connecting wirelessly, set your camera to the connection mode at this time. If yours doesn't, you don't have to do anything special. Simply turning on the camera gets the ball rolling.

4. **Let the computer's operating system take over.** The camera and the computer will send brief electronic greetings to each other. No, seriously, they really do! That's their way of establishing the data connection. Once this happens, Windows or Mac OS steps you through the transfer process. Don't continue to Step 5 until the computer tells you that you're finished.

5. **Take the camera out of transfer mode, and turn off the camera.** Congratulations! Your photos are on your computer. It's safe to switch out of transfer mode and turn off your camera. Your computer may bark at you that it has lost the connection. If so, just disregard the message.

6. **Disconnect the USB cable.** Unplug the cable from the computer and the camera. It doesn't matter which end you unplug first.

Your operating system gives you the option of deleting the photos automatically from the memory card, but you might not want to do this. It's often better to reformat the memory card in your camera rather than in your computer.

When you reformat the memory card in your computer, the card's counter might jump back to zero. If it does, the next batch of photos might have the same file names as a previous batch. Depending on where you save the files, this could cause trouble. Reformatting the memory card in the camera keeps the counter current, so you're less likely to run into this problem.

Tech editor Ron recommends that you keep the photos on the memory card until you've made backups of the files. (See "Backing Up Your Work" later in this chapter.) Then and only then, reformat your memory card, and do it in the camera rather than in the computer.

Some computers come with built-in memory card readers. If yours does, and if it reads the memory cards that your camera uses, you can simply take the card out of your camera and pop it into the slot on your computer. This saves you the hassle of running the USB cable. You can also get a portable USB card reader that does the same thing.

Backing Up Your Work

By now, you're probably chomping at the bit to do something with your photos. You want to edit them, print them, or just look at them on the screen. But your authors can't stress enough the importance of delaying the pleasure just a little longer and making electronic backups of your new files. You put a lot of time, effort, and tender loving care into your pics, and you don't need something as silly as a power outage or a computer crash to cause you to lose your work. And you never know when you'll delete the wrong folder by mistake, to say nothing of what your little brother might do to your files in a burst of revenge.

The simple truth is that most people don't make backups of anything, which is a shame because it isn't hard or expensive to do. You can pay for multiple gigabytes worth of CDs or DVDs by cutting out a trip or two to the burger joint. No, the real culprit is that it's just plain boring to create backups—and it is, make no mistake. But a little boredom now is much, much better than losing a favorite photo later on, because once it's gone, it's gone for good.

So you should create backups of all your files on a regular basis. Now, how best to do this? Here are some tips:

✦ **When at all possible, use external media.** Simply pasting copies of your new folders somewhere else on your hard drive is better than nothing, but it isn't as good as putting these folders somewhere else, such as on a CD, DVD, or external hard drive. If your computer comes down with a virus or starts giving you technical problems, you might have to reformat or even replace the entire hard drive, in which case the backups are in the same jeopardy as the original files. Even if nothing goes wrong, when you get a new computer, what happens to your data then? But if you put your backups on something that isn't part of the computer itself, your entire computer can explode if it needs to, and you won't lose a single pixel of picture data. And when you get a new computer, you can simply pass the old one to your younger brother without the bother of copying all your files at the last minute.

More and more computers come with multiple hard drives these days. If this is your computer, you can offset some of the risk of losing photos by copying the backups to one of the extra hard drives. This is better than putting them on the same hard drive as your computer's operating system, and it's more convenient than burning a disc, but it still isn't quite as reliable as backing up to something external.

Be careful also that you really do have multiple hard drives. Some computers look like they have multiple hard drives, but what they really have are multiple sections or *partitions* on a single hard drive. The computer treats them as separate volumes, but they're all on the same physical disk.

✦ **Make the backup a part of your routine.** Every time you transfer photos to the computer, make a backup of the new files. The first few times, it feels like a pain. After that, you don't notice it so much, and before long it becomes a habit. Unlike most habits, this one is good for you.

✦ **Label the backups.** Another good habit to get into is to write a quick label on the DVD or CD liner. Better yet, get a permanent marker and write the label on the disc itself. The date and a note about what the disc contains will serve you well. You'll be glad you did it, too, when you're searching for a specific DVD.

Keep in mind that optical media such as CDs and DVDs aren't forever. Even stored vertically in a cool environment, some brands might last only five to ten years, and some may last even less. For this reason, it's always a good idea to make fresh copies of older discs.

✦ **Find a safe, convenient place to store your backups.** Backups aren't much help if you can't find them. You can put your discs in those plastic sleeves and store them all in a three-ring binder, or you don't even need to get that fancy. Any old cardboard box will do. Stick it on a shelf in your closet. If you go the box route, make sure each disc is in some sort of case or container, even if it's just one of those paper wrappers with the cellophane windows. You don't want the surface of your discs to get scratched. Also, the best way to store discs is vertically, preferably in a cool environment.

Making backups might not be much fun, but who says that your backup binder or box has to be boring? Decorate it profusely. Cover every free square inch of the thing with prints of your work. There's no reason that it can't be as interesting as any scrapbook or keepsake box.

✦ **Have a couple of stages of backup.** DVDs are great for storing vast quantities of digital photos, but they're not too convenient to use for a single batch of photos. Each DVD gives you 4.7 gigabytes of storage space, and you would have to try extremely hard to take 4.7 gigabytes worth of photos on a single shoot. But if you wait around until you've shot enough photos to fill a DVD, you run the risk of losing the data before you've backed it up. This is where a device such as an external hard drive becomes extremely useful. Put your daily backups on the external hard drive, not on a DVD. Then, when you have enough data, move the photos from the external hard drive to the DVD. Afterwards, you can delete the files on the hard drive and start from scratch, or, as an extra insurance policy, keep the photos in both places. As long as you haven't filled up the external hard drive, why not?

For backups, I like to have a secondary external hard disk, as well as burned DVDs. The best way to store discs is vertically, in individual plastic cases, but I also have a folder for older backup discs.

For backups, Dave uses an external hard drive as well as optical discs.

Keeping the Original Files Safe

When you make backups of your photos, you do more than protect them from computer gremlins. You also protect them from yourself!

Your authors mean no offense. Even the most skilled computer user can be a danger to data. We're far from being the most skilled computer users out there, and data of all kinds are in dire straits whenever we're around.

It's just that digital data is so easy to edit. Software makes it a breeze to change almost anything. Most of the time, this is the recipe for getting things done, but not all the time. Sometimes you start out well, cutting here, pasting there, but along the way you find that you took a wrong turn. You might decide that you shouldn't have cropped a photo in a certain way, or you might wish that you could put back the pixels that you took out in order to make the photo easier to e-mail.

So here is one of the best pieces of advice in this entire book: *Never* work on a file for which you don't have a copy. If you've made backups of your photos, you're in the clear. You can always go back to the original if you have to.

Even after you've made backups, the files in your My Photos or Photos folder have a certain value in an untouched, unedited state. For one thing, if you decide that you made a mistake, you don't have to dig out your backup. Or if you need to make another backup because you misplaced a DVD, you still have the original files.

One way to make sure that the files in My Photos or Photos stay in their original state is to create a separate folder for the edited versions. Call it anything you like, although *Work* or *Edits* works pretty well. You can pop a single work folder right inside My Photos or Photos and use it to store edited pics of all kinds, or you can create a separate work folder for each collection of shots (in which case, going back to the earlier example, you'd create three different work folders: one inside the Birthday Party folder, one inside the Soccer Match folder, and one inside the Meteor Shower folder). This second method is probably the more useful of the two, because if you do a lot of image editing—and you will—a single work folder can fill up quickly, which makes it harder for you to find any given photo. But by all means, choose the method that makes the most sense for you.

In Photoshop Elements, you can save the original file and its edited versions in a special group called a *version set*.

With version sets, you don't have to create a special folder for edits. Photoshop Elements keeps track of all the versions of the photo, all the while preserving the original.

For more information on version sets, see Chapter 7, "Adjusting Light and Color."

Pop a work folder into each folder of photos, and you always have a place to store the edited versions of the files.

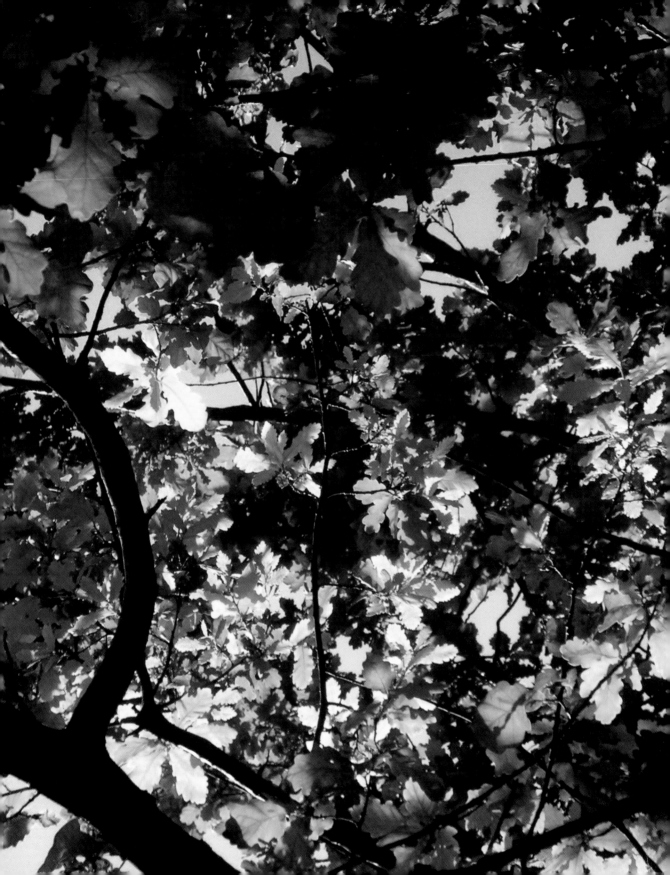

Organizing Your Photo Library

By now, you have some pictures. In all likelihood, you have hundreds of them. A hundred of anything calls for a little organization, and the software for the job is your photo manager.

Getting into the swing of organizing your photos isn't hard at all. It's fun, if we may be so bold, and it's also a very good idea. When those hundreds of photos turn into thousands—and they will—you'll be glad that you've imposed a little order on the chaos.

This chapter gets you up to speed with your photo manager. Throughout the proceedings, we refer to Adobe Photoshop Elements, but feel free to apply this information to your photo manager of choice.

Working with a Photo Manager

The purpose of a photo manager is to help you organize your digital photos. The software shows you the photos that you have on your computer, usually by presenting a bunch of *thumbnails,* or smaller versions of the actual photos. Thumbnails are helpful because they enable you to see a number of different photos at a glance, although you don't get very much in the way of fine detail. For larger, more detailed thumbnails, many photo managers also give you the option of browsing your photos one at a time. Use this feature when you're trying to decide among similar versions of the same basic photo.

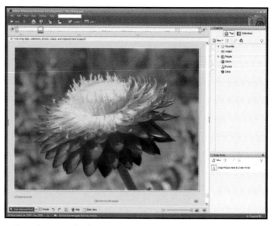

Thumbnail images are usually small… …but they can be large, too.

 DAVE SAYS To adjust the size of the thumbnails in Photoshop Elements, drag the slider at the bottom-right of the interface, or click the Small Thumbnail Size or Single Photo View icons on either side of the slider control.

You can sort your photos in a number of different ways. For instance, in Photoshop Elements, you choose from the date that you took the photos (newest first or oldest first), the date that you imported the photos to your computer, or the folders in which you store the photos.

 DAVE SAYS In most photo managers, you can rotate the thumbnail if it isn't facing right-side up. To do this in Photoshop Elements, click the thumbnail, open the Edit menu, and choose Rotate 90° Left or Rotate 90° Right. Or, just click the Rotate icons at the bottom of the screen.

To select a particular photo, single-click its thumbnail. This often calls up helpful information about the photo file. In Photoshop Elements, the information appears in the Properties palette in the Organize bin along the right side of the interface. If you don't see the Properties palette on screen, choose Properties from the Window menu, and then click the arrow icons to the left of the other palette names. This temporarily collapses those palettes and gives you more room for the photo properties.

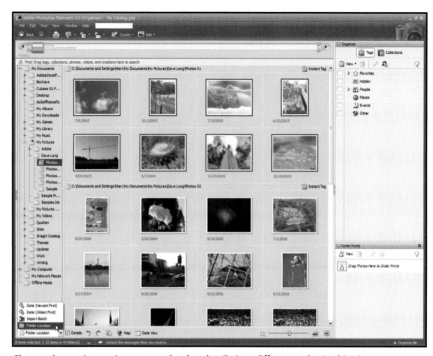

Change the sorting options to see the thumbnails in a different order. In this view, you see your photos by their folder locations.

If your Properties palette appears in a separate window, choose Window > Dock Properties in Organize Bin to place it in the bin with the other palettes.

Another way to call up the Properties palette is to click the Show or Hide Properties icon along the bottom of the interface, directly to the left of the Map button. You can also press Alt+Enter (Windows) or Option+Return (Mac).

The Properties palette divides its information into four sections:

✦ **General.** Here is where you find the file name of the photo, the caption, and any notes that you have added. These fields are completely editable.

✦ **Tags.** These are the categories under which you have organized the photo. (See the "Tagging Your Pics" section later in this chapter.)

Get the scoop on the selected photo with the Properties palette.

✦ **History.** Here you review the digital history of the photo file, from the date that you transferred the photo to your computer to all the times that you edited the image.

✦ **Metadata.** *Metadata* are little snippets of text that describe the camera settings, the physical dimensions of the photo, the tags that you assigned to the image, and so on. Not all photo files contain metadata. In fact, if you were to strip out all the metadata for a particular photo file, you wouldn't change a thing about the photo itself. It still looks exactly the same. Some computer software references the metadata for functions such as searches, but otherwise the metadata are there solely for your convenience. You can switch between Brief view—the most useful pieces of metadata —and Complete view—the entire set—by clicking the appropriate radio button at the bottom of the Properties palette.

View brief metadata to get the most important bits.

Here's the same photo with complete metadata.

Digital photos aren't the only computer files that keep track of metadata. Surely you're familiar with MP3 music files. You probably have a large collection of these things on your computer. (Hopefully they're all legal downloads!)

MP3s also make use of metadata. The MP3 file itself contains only the recording of the song, just like the photo file contains only the image. The artist name, album name, play time, songwriter, lyrics sheet, musical genre, and so on are bits of metadata attached to the MP3 file, just like the information about the camera model, focal length, and shutter speed of your digital photos.

To switch among the four kinds of properties, click the icons at the top of the palette.

And that's essentially all there is to it. As long as you can browse the photos on your computer, select a photo in particular, and review the properties of that file, you're ready to start organizing with your photo manager.

The very first time you use the software, you might not see any thumbnails, even though you have photo files on your computer. This is because the photo manager hasn't looked for photos on your hard drive yet, which is easy enough to correct. See the "Getting Photos into the Photo Manager" section later in this chapter for details.

Even so, you might want to take a few minutes to go exploring. In all likelihood, your photo manager comes with all kinds of other features that might prove useful in the future. Pop open the menus and see what's inside, or click the various icons and buttons to see what they do. You certainly don't have to memorize every little thing. You don't even have to remember every feature that you discover. The goal here is to achieve a level of comfort—to make friends with the software, if you will. The more you get to know your photo manager, the easier managing photos becomes.

Devising a Process

For as helpful as the software is, it doesn't automatically organize and categorize the photos on your computer. Maybe someday this will be the case, and that day

might come relatively soon, but for now, your photo manager is counting on you to tell it what to do and how to do it. Before you start managing photos in earnest, it makes good sense to come up with an organizational game plan.

This may sound complicated, but it really isn't. All you need are a couple steps to follow whenever you transfer photos to your computer. Your process can be whatever you want it to be, but here is one that many photographers use:

1. Get the photos into the photo manager.

2. Review the photos all at once, and create stacks as needed.

3. Review each photo one by one, and add tags.

This section takes each step in turn.

Getting Photos into the Photo Manager

Your photo manager keeps track of the photos on your computer by maintaining a list or *catalog*. This gives you the option of telling the software exactly which image files to add to the list and which to exclude, so that you're managing only the files that matter. The downside is that the thumbnails in the photo manager don't always reflect the most up-to-date record of the photos on your computer, because the software hasn't yet checked to see whether there are any new photos to add to its inventory. It's almost like you're keeping a list of the contents of your closet, but then your little brother dumps a bunch of his old toys in there when you're out shooting pictures. Until you actually open the closet door and see what's inside, you don't realize that your list is out of date.

Updating your photo manager's catalog is easy enough. There are a couple different ways to go about this:

✦ **Set up your default images folder for automatic monitoring.**
The software automatically adds your new photos to the catalog every time you put new photo files into the default images folder on your hard drive.

✦ **Add the photos manually.** You pick and choose the photos to add to the catalog by hand.

Many photo managers give you other ways to add new photos, too. For instance, Photoshop Elements enables you to add images directly from your camera, card reader, scanner, and cell phone. But for the purposes of this discussion, we focus on the two methods just mentioned.

When you run your photo manager the very first time, the software might search your entire computer for certain types of image files, such as JPEGs and TIFFs, to serve as the starting point for its catalog. This process finds all the digital photos on your computer, but it also brings in a lot of images that aren't digital photos. You end up cataloging images from websites that you've visited, the sample images from other pieces of software, and so on.

If your photo manager does this, let it run all the way through, but then be sure to remove the files from the catalog that you don't need to manage. See the "Removing Photos from the Catalog" section later in this chapter for details.

Photoshop Elements doesn't search your computer for image files automatically, although you can instruct it to do so at any time. Go to the main menu, and choose File > Get Photos > By Searching.

Monitoring Folders Automatically

Depending on how you set up your software, your new photos may already be in the catalog when you launch the application. Many photo managers monitor your My Pictures or Pictures folder by default and automatically create thumbnails for any new photo files that you place in this folder.

Automatically monitoring folders for new image files is certainly a convenient way to work, but it isn't always the best way. Your computer uses My Pictures or Pictures for all kinds of image files, not just the ones that you transfer from your camera. For instance, if you capture an image with a scanner, the computer drops it into the default images folder, and your photo manager treats it exactly like a photo from your camera. You get a thumbnail for it, and you see it alongside all your photos. If you're trying to use your photo manager for photography only, you end up bringing in unwanted clutter. You can always remove non-photos from the catalog (see the "Removing Photos from the Catalog" section later in this chapter), but if this becomes too much of a pain, you can simply choose not to monitor any folders at all and add new photos to the catalog by hand.

To set up Photoshop Elements to watch your default images folder, follow these steps:

1. **Choose File > Watch Folders from the main menu.** This will bring up the Watch Folders dialog box.

2. **Review the list of watched folders.** In the Folders to Watch list, look for My Pictures (Windows) or Pictures (Mac). If this folder already appears in the list, then Photoshop Elements is already monitoring your default images folder. Skip ahead to Step 5. If not, go on to Step 3.

3. **Click the Add button.** Another dialog box will appear, this one showing the folder structure of your computer.

4. **Select the default images folder.** Browse to My Pictures or Pictures, and select this folder with a single click. Don't double-click the folder to select it—that opens it up instead. After you select the folder, click OK. The current dialog box will close, and Photoshop Elements will add the default images folder to the list in the Watched Folders dialog box.

5. **Set the options.** At the top of the dialog box, make sure that the Watch Folders and Their Sub-Folders for New Files option is checked. Then, at the bottom of the dialog box, under When New Files Are Found in Watched Folders, choose Notify Me if you want Photoshop Elements to tell you that there are new files before adding them to the catalog, or choose Automatically Add Files to Organizer if you don't need a heads-up.

6. **Click OK.** Photoshop Elements will make note of your settings, and the Watch Folders dialog box will close.

In Photoshop Elements, you can monitor your default images folder for new photos.

To turn off automatic monitoring temporarily, uncheck the Watch Folders and Their Sub-Folders option at the top of the Watch Folders dialog box. To turn off automatic monitoring permanently for a particular folder, select the folder from the Folders to Watch list, and click Remove.

Adding Photos Manually

As an alternative to automatic monitoring, many photo managers enable you to add photos to the catalog by hand. You don't get any extraneous image files this way, although it requires a little more effort because you have to tell the software to update its catalog whenever you transfer new photos to the computer. Still, if it saves you from having to remove unwanted image files, the extra busywork might well be worth it.

To add new photos to the catalog by hand in Photoshop Elements, follow these steps:

1. **Choose File > Get Photos > From Files and Folders from the main menu.** The Get Photos from Files and Folders dialog box will appear.

2. **Navigate to the image folder.** In the dialog box, step through the various folders until you come to the one that contains the images you want to add to the catalog. Single-click this folder to select its entire contents, or double-click the folder to open it up, and then hold down Ctrl (Windows) or Command (Mac) and single-click individual photo files.

3. **Set the options.** At the right side of the dialog box, check the Get Photos from Subfolders option to add the photos from any subfolders inside the selected folder. You're welcome to use the Automatically Fix Red Eyes option and the Automatically Suggest Photo Stacks option by checking either of these (see the "Making Stacks" section later in this chapter), but you're usually better off unchecking them and processing your image files on a case-by-case basis. These options take a bit of time, too, so if you want to add the photos to the catalog quickly, don't call for any extra processing.

4. **Click Get Photos.** The Get Photos from Files and Folders dialog box will close, and Photoshop Elements will add the selected photos to the catalog.

Use the Get Photos from Files and Folders dialog box to add pictures to the catalog by hand.

Removing Photos from the Catalog

Getting rid of unwanted image files in the catalog is a good way to keep the clutter to a minimum. These image files aren't hurting anything if you choose not to zap them, but at the same time, no one wants to wade through a bunch of unneeded thumbnails when they're looking for a specific photo.

Removing images from the photo manager's catalog isn't the same as deleting the image files themselves from your hard drive. When you remove an image from the catalog, the original image file remains in your computer. All you're doing by removing it is saying that you don't want to manage it with your photo software anymore.

Deleting the file from the hard drive is the more permanent operation. You move the image file to your Recycle Bin or Trash Can, and the file will be erased the next time you empty the trash.

When you delete a photo file outside your photo manager, the photo manager might not realize that the file is no longer on your computer. You still see the thumbnail for the deleted photo, even though you've sent its file to the Recycle Bin or Trash Can. If this happens, simply refresh the thumbnails. In Photoshop Elements, choose View > Refresh.

To remove photos from the catalog in Photoshop Elements, follow these steps:

1. **Select the photo to remove.** Single-click on the photo's thumbnail, or hold down Ctrl (Windows) or Command (Mac) and single-click on several photo thumbnails.

2. **Choose Edit > Delete from Catalog from the main menu.** You can also just press the Delete key on your keyboard. Either way, the Confirm Deletion from Catalog dialog box will appear.

Removing a photo from the catalog isn't necessarily the same thing as deleting it from your hard drive.

3. **Decide whether to delete the photo file from your hard drive.** If you check the Also Delete Selected Item(s) from the Hard Disk option, Photoshop Elements will erase the image file from your hard drive. Leaving this option unchecked removes the image from the catalog but doesn't delete the file from your hard drive. If you aren't sure what to do, leave this option unchecked. You should only delete image files that you're sure you don't need anymore.

4. **Click OK.** Photoshop Elements will zap the thumbnail and remove the image from the catalog. Depending on your choice in Step 3, the software will also delete the image file from your hard drive.

To restore a photo to the catalog that you previously removed, simply add it back in again from File > Get Photos > From Files and Folders. Of course, this trick doesn't work if you deleted the photo file from the hard drive.

Making Stacks

Some photo managers enable you to group similar-looking shots together. This way, instead of row upon row of virtually identical thumbnails, you get a single thumbnail that represents all the shots in the group. In Photoshop Elements, these groups of similar-looking photos are called *stacks*.

When you add new photos to the catalog by hand, Photoshop Elements picks out potential stacks for you if you check the Automatically Suggest Photo Stacks option in the Get Photos from Files and Folders dialog box. You can also create your own stacks at any time:

1. **Select the photos to stack.** Hold down Ctrl (Windows) or Command (Mac) and single-click the thumbnails of all the photos that you want to stack.

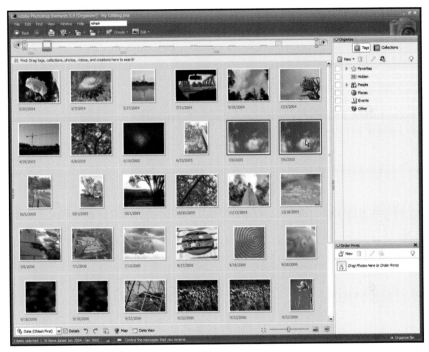

Select the photos to stack.

2. **Choose Edit > Stack > Stack Selected Photos** from the main menu. Photoshop Elements will turn the selected items into a stack.

Now, when you browse your photos, the items in the stack appear as a single thumbnail with a small stack icon in the upper-right corner. To expand the stack and see all the photos inside it, click the arrow icon to the right of the thumbnail. To collapse the stack back down to a single thumbnail, click the arrow icon again.

The stack collapses to a single thumbnail.

Expand a stack by clicking the arrow icon on the right.

Here are some useful commands for managing your stacks:

✦ **Put a different photo at the top of the stack.** Expand the stack, select the thumbnail of the photo that you want to use to represent the entire stack, and choose Edit > Stack > Set As Top Photo.

✦ **Take a photo out of the stack.** Expand the stack, select the thumbnail of the photo that you want to remove, and choose Edit > Stack > Remove Photo from Stack. The removed photo will remain in the catalog, but it is no longer part of the stack.

✦ **Unstack all the photos.** Select the thumbnail of the entire stack, and choose Edit > Stack > Unstack Photos. The unstacked photos will remain in the catalog as separate thumbnails, just as they were before you stacked them.

✦ **Remove all but the top photo in the stack from the catalog.** Select the thumbnail of the entire stack, and choose Edit > Stack > Flatten Stack. A dialog box will appear, asking you to confirm the deletion. Check the Also Delete Photos from Hard Disk option if you want to erase the photo files themselves. Leave this option unchecked if you don't want to do anything to the files.

When you flatten a photo stack, Photoshop Elements gets rid of all but the top photo.

Tagging Your Pics

Tags in Photoshop Elements are the keywords that you assign to a photo for ease of reference later. When you search your photos for a specific term—*people,* for instance—all the photos that you tagged with the People keyword appear in the results. Almost all photo managers have a similar capability, although the process isn't always called tagging. Attaching keywords is perhaps the most common description, but no matter what you call it, the effect is the same.

The various tag categories at your disposal appear at the top of the Organize bin. By default, these are Favorites (five stars through one star), Hidden, People (with separate tags for family and friends), Places, Events, and Other.

By default, Photoshop Elements gives you these tag categories and subcategories.

You can create as many tag categories of your own as you like. These may be top-level categories, such as People, Places, and Events, or they may be subcategories within an existing set. Once you have a system of categories that you find useful, you can create very specific individual tags within these categories. Then you simply attach the tags to your photos.

Creating a New Tag Category

Say you want to create a brand-new, top-level tag category called Pets because the existing categories—People? Other?—don't quite cut it. To do this, follow these steps:

1. **Click the New button at the top of the Organize bin.** A context menu will open.

2. **Choose New Category from the context menu.** The Create Category dialog box will appear.

3. **Type a name for the category in the Category Name field.** For the purposes of this example, type Pets.

4. **Choose an icon from the Category Icon list.** The cute kitty, the parrot, or the dog is a good choice for a Pets category.

To make a new tag category, fill out the Create Category dialog box.

5. **Click OK.** Photoshop Elements will add the new tag category to the list in the Organize bin.

Your new tag category appears in the list.

To edit your new category, select it in the list and click the Edit (pencil) icon at the top of the Organize bin. To delete the category, select it and click the Delete (trash can) icon.

Creating a New Tag Subcategory

A tag category such as Places is pretty general. You're probably better off dividing this into a couple of subcategories, such as Home and Away for starters. To create a new subcategory, follow these steps:

1. **From the list in the Organize bin, select the tag category to which you want to add a subcategory.** In this case, it's the Places category.

2. **Click the New button at the top of the Organize bin.** The context menu will open again.

3. **Choose New Sub-Category from the context menu.** This will call up the Create Sub-Category dialog box.

4. **Type a name for the subcategory in the Sub-Category Name field.** You want a subcategory for home shots, so you type Home.

5. **Review the parent category.** The parent is the category that contains the new subcategory. You already selected the Places category, so this is the one that should appear in the Parent Category or Sub-Category drop-down menu. If it doesn't, or if you want to change the parent, open the drop-down menu and make another choice.

To make a new tag subcategory, fill out the Create Sub-Category dialog box.

6. **Click OK.** Photoshop Elements will add the new subcategory to the Organize bin, right under Places.

As with top-level categories, you can click the Edit or Delete icon to change or scrap your new subcategory.

Your new tag subcategory appears in the list.

Creating a New Tag

Now that you have a tag category for pets, suppose you want to create a specific tag for Margot, your pet squid:

1. **From the list in the Organize bin, select the category or subcategory in which you want to create the tag.** The tag for Margot belongs in the Pets category, so choose that one. (If you were creating a tag for your younger brother, Graham, you'd choose the Family subcategory under People.)

2. **Click the New button at the top of the Organize bin.** This will give you the context menu.

3. **Choose New Tag from the context menu.** The Create Tag dialog box will open.

4. **Review the category.** You already selected the Pets category, so this is the one that should appear in the Category drop-down menu. To change to a different category or subcategory, choose another item from the menu.

5. **Type a name for the tag in the Name field.** Margot works well.

So what makes a good tag name? Tags are most useful when they say something specific about the photo. The names of your friends, family members, and pets make good tags. So do the names of the places you've visited. If you tend to take a lot of photos of one kind of thing, such as trees, bugs, flowers, or buildings, these are excellent tag-name candidates.

Tags can represent technical details about your photos, too. You might create separate tags called Landscape and Portrait, and assign them to photos based on their orientation. Or you might create tags for wide-angle shots, shallow depth of field, high shutter speed, and so on. Dave does something similar for his own photo collection, so when I suggest a certain kind of shot for this book, he does a quick search and comes back to me with a ridiculous number of options.

A good way to think about the whole question of tag names is to use a little reverse psychology. Ask yourself this: "When I'm searching my computer for photos of *x*, what will I try to type in the search field?" The answer that you give is an ideal name for a tag.

6. **Type a note if you want.** The text in the Note field is optional. If you're likely to forget that Margot is your pet squid, then you might as well spell it out for yourself here. Otherwise, feel free to leave this field blank.

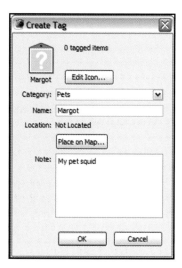

To make a new tag, fill out the Create Tag dialog box.

7. **Click OK.** Photoshop Elements will add the new tag to the category or subcategory that you specified.

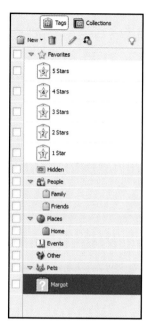

The new tag for your pet squid appears in the list.

Notice that the new tag's icon is a big gray question mark. This is because you haven't assigned this tag to any photos yet. Once you've tagged a couple photos of Margot, you can choose the one that you like best to serve as the icon for her tag.

Assigning Tags to a Photo

With your Margot tag in hand, you're ready to start assigning it to all the photos of your pet squid. To do this in Photoshop Elements, drag the tag from the Organize bin and drop it on top of the appropriate photo. The icon of the new tag will change to a small representation of this photo, and the thumbnail in Photoshop Elements will show your Pets category in the lower-right corner.

To change the icon of a tag in Photoshop Elements, select the tag in the Organize bin and click the Edit icon at the top of the bin. The Edit Tag dialog box will reappear. Now click the Edit Icon button for the Edit Tag Icon dialog box. You can adjust the portion of the photo that appears in the tag's icon, or you can change the photo entirely by stepping through all the photos that have this particular tag. Click OK to close the Edit Tag Icon dialog box, and click OK again to close the Edit Tag dialog box.

To assign a tag, drag the tag from the Organize bin and drop it on the photo.

Afterwards, the thumbnail of the photo will show the tag category icon.

You can—and should—assign as many tags to a photo as makes sense. For instance, if you created a My Room tag for the Home subcategory of the Places category, and if Margot's aquarium is in your bedroom, drag the My Room tag to the photos of Margot, too.

Attach another tag to the Margot shots, and the thumbnails show an additional category icon.

To remove a tag from a photo, move the mouse pointer to the tag icon below the thumbnail and right-click (Windows) or Command-click (Mac) for a context menu. Choose the Remove option, and then left-click.

Doing Searches for Specific Tags

Here's where all the time you've spent tagging your photos pays off like the lottery. Search for the keywords that you've attached, and you get instant, accurate results in your photo editor. There is no better way to cut through hundreds, if not thousands, of photos and zero in on precisely the ones that you want.

In Photoshop Elements, as with most photo managers, there are many ways to search your photos. To find tags specifically, you use the Find by Details command, or you simply check off tags in the Organize bin.

To search for tags with the dialog box, follow these steps:

1. **Choose Find > By Details (Metadata) from the main menu.** The Find by Details (Metadata) dialog box will appear.

2. **Choose Tags from the Criteria drop-down menu.** You're looking for tags, so that's the option to pick. But just have a look at all the other bits of metadata that you can use to search!

3. **Choose a tag from the Include drop-down menu.** Assume that you're looking for all your Margot pics, so choose Margot from this menu.

Search your photos based on the tags.

4. **Add another search criterion if you need to.** As of right now, you're searching for all photos with the Margot tag. But suppose you want to add another criterion, such as all photos of Margot that you took in your bedroom. Click the + button, and you get a new row. Go back to Step 2, and fill out the additional fields. When you've constructed the perfect search, proceed to Step 5.

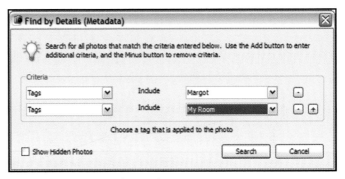

Add another criterion to the search.

5. **Click Search.** Photoshop Elements will return the list of results.

Photoshop Elements pulls out all the Margot shots from your bedroom.

Fine-tune the current search by clicking the Modify Search Criteria button at the top-right of the interface.

To search for tags from the Organize bin, just click the box to the left of the tag, tag category, or tag subcategory for which you want to search. A binoculars icon will appear in the box, and Photoshop Elements will display all the photos with that particular tag. To add additional search criteria and narrow the results, you can click as many tags as you like.

You can also search by clicking categories, subcategories, and tags in the Organize bin.

When you search from the Organize bin in Photoshop Elements, you can also exclude a particular category, subcategory, or tag from a search. To do this, right-click (Windows) or Command-click (Mac) inside the box to the left of the item, and choose the Exclude Photos option from the context menu.

Adjusting Light and Color

Here begins your introduction to photo editing! We talk in this chapter about two of the all-time most popular editing projects: enhancing the exposure level and enhancing the color of your photos.

If you've ever taken a shot that's too dark, too bright, too washed out, too vivid, or too full of red-eye—and who hasn't?—this chapter is for you. Before you consign your so-called bad shots to the Recycle Bin or Trashcan, see what sort of digital magic you can work with the tricks herein.

Working with an Image Editor

Before jumping in with the commands and techniques, a little software orientation is in order, just to give you an idea of what you're getting into. Every image editor is different, but most of them follow the lead of Adobe Photoshop. In this book, we discuss Photoshop Elements, which takes after Photoshop more obviously than most, but you shouldn't have too hard a time finding the corresponding features in your image editor of choice.

Photoshop Elements has two image editing modes: Quick Fix and Full Edit. Although you can perform many of the same functions in both modes, Full Edit is the more useful of the two because it gives you more options and more precise control over the photo. We focus on Full Edit mode throughout this book.

That's not to say that Quick Fix isn't useful at all. If you're looking to make simple adjustments, it gives you exactly what you need without the bother of a bunch of menu commands and dialog boxes.

To switch between the two modes, click the Quick Fix and Full Edit tabs just below the main menu.

Getting the Hang of the Interface

Most likely, the workspace in your image editor gives you a set of tools, as well as a series of palettes or panels. The tools enable you to do different things with the photo—anything from zooming in or out to adding text or erasing part of the image. The palettes are kind of like control panels. They provide information about the photo or give you additional editing commands. In Photoshop Elements, the tools appear in the Toolbox, which runs down the left side of the screen, while the palettes appear in the Palette Bin, which runs down the right side of the screen.

To select a tool, move the mouse pointer over the tool's icon, and click the mouse button. You can then adjust the properties of the tool before you apply it to your photo. In Photoshop Elements, the tool properties appear across the top of the screen. These properties change depending upon the tool that you select.

Many image editors, including Photoshop Elements, organize their tools into sets to reduce the amount of space that the tools area takes up. The downside is that you don't see all the tools on screen at the same time, so look for some sort of marker in the tool icon. In Photoshop Elements and many other image editors, it's a little black arrow. This marker tells you that there are additional tools in the set, hidden underneath the current tool, so to speak. To reveal the hidden tools, press and hold down the mouse button on the tool's icon. The hidden tools are sticky, to use tech editor Ron's description. Once you select one of the hidden tools, that's the one that will appear in the Toolbox until you pick another tool from the set.

The Toolbox in Photoshop Elements appears down the left side of the screen…

…and the Palette Bin appears down the right.

The tool properties appear in a bar along the top of the screen.

Hold down the mouse button on a specially marked tool icon, and you reveal the hidden tools under it.

To show or hide the Toolbox in Photoshop Elements, choose Window > Tools from the main menu.

With the palettes, it's rather a different story. You determine which ones appear on screen by collapsing and expanding them. In Photoshop Elements, click the little arrow next to the palette name to collapse or expand the palette in question. To add new palettes to the Palette Bin, open the Window menu and choose any palette you like. The new palette might open in a window of its own. If it does, just drag it to the Palette Bin, and then expand and collapse it at need.

To remove a palette from the Palette Bin altogether, first click More to get the palette's menu, and then uncheck the Place in Palette Bin When Closed option. Then drag the palette out of the Palette Bin and close its window.

To show or hide the Palette Bin in Photoshop Elements, choose Window > Palette Bin from the main menu, or click the Palette Bin arrow at the bottom-right of the interface.

Using Color Management

Ever notice how the colors of a photo onscreen don't always match the colors of the photo when you print it out? This is a very common occurrence. It happens because monitors and printers have different ways of displaying color, as well as different ranges or *gamuts* of color. That's all well and good, but knowing why it happens doesn't make it any less of a pain! You want to minimize color variation as much as possible, so that the colors you see onscreen are as close as possible to the colors that you get when you make a print.

This is where color management comes in. It helps different devices to display the same color by applying a standard called a *color profile*. In other words, the color profile enables your monitor and printer to speak the same language when it comes to color. What one device describes as a particular shade of bright blue gets translated to the same (or a very similar) color in the other device.

Two very common color profiles in the world of digital photography are sRGB and Adobe RGB. Almost all digital imaging devices, whether cameras, scanners, monitors, or printers, understand the sRGB profile, so it's a good default choice for color management. Adobe RGB provides a wider range of colors, but fewer devices support it.

Color management works best when you calibrate your monitor. If you're using an LCD screen or laptop, your display comes with a color profile from the manufacturer. You should use this profile when you work with your photos. On Windows systems, go to the Control Panel, choose Display, look under the Settings tab, click Advanced, and choose Color Management to review your monitor's color profile.

Also, if your monitor comes with a calibration utility, be sure to run it before you get down to serious editing.

To work with color management in Photoshop Elements, choose Edit > Color Settings from the main menu. Then pick an option from the Color Settings dialog box.

Set up color management with the Color Settings dialog box.

✦ **No Color Management.** This option turns off color management. Not recommended!

✦ **Always Optimize Colors for Computer Screens.** This option puts the image in sRGB. For your purposes, go with this option, even if you plan to do a lot of printing, since your printer understands sRGB just fine.

✦ **Always Optimize for Printing.** This option puts the image in Adobe RGB. Adobe RGB might make sense for you if you shoot in RAW format and you have a printer that understands Adobe RGB. Otherwise, stick with sRGB.

Don't use Adobe RGB for photos that you want to display onscreen, such as the ones that you e-mail or post to your blog. Computer monitors speak sRGB.

✦ **Allow Me to Choose.** This option uses sRGB by default, but enables you to specify Adobe RGB for images such as your RAW camera files.

If the colors of an image don't look right when you view it in Photoshop Elements, it could be because you're using color management and the image file doesn't have a color profile associated with it.

To work around this, before you load the image file, temporarily turn off color management. Choose Edit > Color Settings from the main menu, select No Color Management from the Color Settings dialog box, and click OK. Now load the image file. If color management was the problem, the colors of the photo should look all right.

Now apply a color profile to the photo. Choose Image > Convert Color Profile > Apply sRGB Color Profile, or choose Image > Convert Color Profile > Apply Adobe RGB Color Profile, depending upon your preference.

Finally, save the photo, and turn color management on again from the Color Settings dialog box.

Editing a Photo

Of course, an easy-to-use interface and color management features don't mean much until you open up a photo and get busy with the editing. This section shows you how it's done.

Opening the Image File

As you know from Chapter 5, when you transfer your photos from your camera to your computer, you create image files. Opening these files in your image editor couldn't be simpler.

Photoshop Elements is something of an odd bird, in that it's a very good photo organizer as well as a top-flight image editor. To use Adobe's terminology, the software has two different *workspaces*: Organizer and Editor. The method that you use to open files depends upon which workspace you're in.

To open a photo when you're in Photoshop Elements Organizer, follow these steps:

1. **Select the photo to edit.** Remember how this works from Chapter 6? Just click the thumbnail of the photo. To select more than one photo, hold down Ctrl (Windows) or Command (Mac) as you click.

2. **Click the Edit button.** A menu will open.

3. **Choose Go to Full Edit.** The Editor workspace will launch, and Photoshop Elements will load the photo or photos that you selected in Step 1. If you'd rather work in Quick Fix mode, choose Go to Quick Fix instead.

To open a photo when you're already in Photoshop Elements Editor, follow these steps:

1. **Choose File > Open from the main menu.** The Open dialog box will appear.

2. **Navigate to the photo file that you want to open, and select it.** Hold down Ctrl (Windows) or Command (Mac) to select more than one photo file.

3. **Click the Open button.** Photoshop Elements will open the photo or photos.

No matter how you get there, the Photo Bin at the bottom of the Editor workspace shows thumbnails for all the currently opened photo files. Click the thumbnail to switch to that photo.

The Photo Bin appears along the bottom of the screen.

Another way to juggle multiple photos is to use the window display options in the upper-right corner of the interface. Click these buttons to cascade or tile the windows for all open photo files, or choose Maximize mode to see one photo on the screen at a time.

Setting the View

When you're editing a photo, you need to be able to see what's going on. Sometimes you want to see the entire photo at a glance, such as when you're adjusting the tonal range or color saturation—more on those later in this chapter. Other times, you want to zoom in on a particular region of the photo, such as when you're fine-tuning the appearance of the UFO that you pasted into the sky.

In Photoshop Elements, look no further than the Zoom tool to set the view of the window. The Zoom tool is the one with the icon of the magnifying glass. Click this tool to select it (or press the Z key on your keyboard), and then do any of the following:

✦ **Click anywhere in the photo.** This zooms in on the region where you clicked. Repeat to zoom in even more. (For better control, drag the mouse over the region.) To zoom out instead, go to the tool options at the top of the screen and click the icon of the magnifying glass with the minus sign. Switch back to Zoom In mode by clicking the icon of the magnifying glass with the plus sign.

✦ **Type a value in the Zoom field in the tool options.** This sets the overall level of zoom. It's in percent, so typing 100 shows the photo at its actual size. A value of 200 is twice the actual size, while a value of 25 is one quarter of the actual size.

✦ **Click the Actual Pixels button in the tool options.** This sets the zoom level to 100 percent.

✦ **Click the Fit Screen button in the tool options.** This shows the entire photo onscreen.

✦ **Click the Print Size button in the tool options.** This sets the view of the photo to the physical dimensions of the print.

Get in close with the Zoom tool.

When the zoom level is less than 100 percent, your photo may appear to be jagged or blocky, when in fact it isn't. That's just the way Photoshop Elements displays the photo at a smaller size. So be sure to look at your photo at 100-percent zoom before editing it.

To change the visible portion of the photo when you're zoomed in nice and close, use the Hand tool:

1. **Select the Hand tool from the Toolbox.** It's right below the Zoom tool.

2. **Move the mouse pointer anywhere onto the photo.**

3. **Hold down the mouse button and drag the mouse.** The Hand tool will push the view of the photo in the same direction.

Tired of constantly switching between the Hand tool and the other tools in Toolbox? Hold down the spacebar, and Photoshop Elements will automatically swap in the Hand for whatever tool you're currently using.

Push the visible area of the photo with the Hand tool.

Saving Your Work

It goes without saying that, after you edit your photo, you want to save the modified version to your computer. Perhaps less obviously, it's also a good idea to save early and save often, to borrow a catchphrase from the world of election fixing. You never know when a computer crash is going to come along, so saving your work in progress goes a long way toward thwarting the gremlins.

In almost every image editor ever made, the Save commands appear under the File menu, and Photoshop Elements is no exception. Pop open the File menu, and you find options for Save and Save As:

✦ **Save.** Use this command when you want to replace the original file on your computer with the edited version. Be very careful about doing this! We gave you a bunch of reasons in Chapter 5 not to save over the original file.

✦ **Save As.** Use this command when you want to create a brand-new file for the edited version. This is almost always the better option.

The Save As command enables you to change the file name and save location of the new file. So to save the edited version to the Work folder you created in Chapter 5, just navigate to the Work folder in your image editor's Save As dialog box.

Another advantage to Save As is that you can change the format of the image file. This is particularly important if your original photo is in a format with lossy compression, such as JPEG. Each successive save in JPEG format gives you additional compression, and image quality begins to suffer. The solution is to choose a file format without lossy compression, such as TIFF. To do this, just choose TIFF from the Format menu in the Save As dialog box.

The Save As dialog box enables you to specify the save location, file name, and file format.

CAUTION Another way to get around lossy compression is to save the photo in your image editor's native file format. For Photoshop Elements, this is PSD. See Chapter 9 for more information about PSD files.

In Photoshop Elements, you can also choose to save the edited photo in a version set. As you may recall from Chapter 5, a *version set* is a special stack consisting of the original photo plus all its edits. To save your edited photo in a version set with the original, check the Include in the Organizer and Save in Version Set with Original options in the Save As dialog box. Make sure you check both! When you switch back to the Organizer workspace, you see the thumbnail for the edited version in a stack with the original photo.

When you save an edited photo in a version set with the original, Organizer marks them as such and stacks the files.

So that's the nickel tour of the software. Let the photo editing commence!

Correcting the Exposure

The best way to get good exposure is to use good light, but the perfect light isn't always easy to come by, and anyway, you don't always have time to fiddle with camera settings when a great shot presents itself. Tweaking the exposure level after the fact is one of the advantages of working in the digital domain. Of course, there's only so much that your image editor can do. Really poor lighting is often a lost cause. But assuming that you start with at least a so-so exposure, you can nudge the photo toward more ideal conditions with ease.

Of the many handy exposure tools that your image editor gives you, the handiest (and probably also the least understood) is the histogram. A *histogram* is a bar chart that shows the *tonal range* of the photo: the darks or *shadows*, the lights or *highlights,* and the *midtones* or everything in between. When you look at the histogram of a photo, the shadows are on the left side of the chart, and the highlights are on the right side. The midtones go from darker to lighter, left to right. A peak or spike in the chart means that there's a lot of that particular tone in the photo, while a valley means that there isn't much of that tone at all.

Many times, just by looking at the histogram, you can tell how good or how bad the level of exposure is. You don't even need to see the actual photo! A shot with good exposure usually has a pretty even distribution across the entire histogram, from the shadows through the midtones, all the way to the highlights. In an overexposed photo, or one that's too light, the bar chart is really low in the shadows, and then it spikes somewhere in the midtones. Likewise, in an underexposed photo, or one that's too dark, the bar chart suddenly drops off as it passes through the midtones toward the highlights.

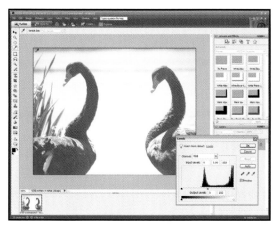

The histogram of an overexposed photo lacks in the shadows.

The histogram of an underexposed photo lacks in the highlights.

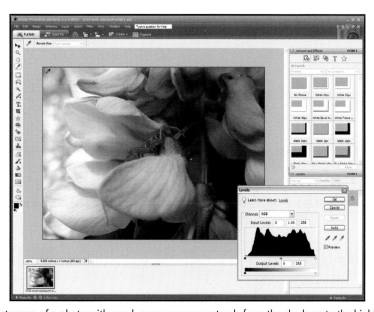

The histogram of a photo with good, even exposure extends from the shadows to the highlights.

So the first step in correcting the exposure of a digital photo is pulling up the histogram in your image editor. In Photoshop Elements, choose Enhance > Adjust Lighting > Levels, and if the histogram shows the signs of too little or too much exposure, you can correct the tonal range by dragging the sliders:

✦ **Drag the white slider to the left to brighten an underexposed photo.** Put the slider where the histogram drops off on the right. This closes the gap in the light part of the tonal range.

✦ **Drag the black slider to the right to darken an overexposed photo.** Put the slider where the histogram drops off on the left to close the gap in the dark part of the tonal range.

Dragging the white slider to the left helps to correct an underexposed photo.

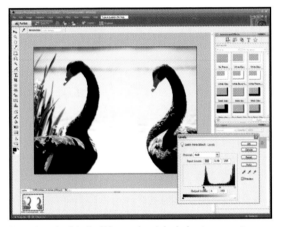

Dragging the black slider to the right helps to correct an overexposed photo.

✦ **Drag the gray slider to the left to lighten the midtones.** This doesn't affect the tonal range of the photo. It just pushes the midtones toward the light side of the range.

✦ **Drag the gray slider to the right to darken the midtones.** The tonal range stays the same, but the midtones skew toward the darks.

Click OK, and Photoshop Elements will redistribute the tonal range of the photo according to your adjustments.

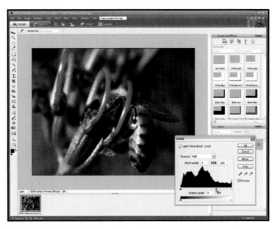

| Dragging the gray slider to the left lightens the midtones. | Dragging the gray slider to the right darkens the midtones. |

Want a histogram onscreen at all times? Photoshop Elements has a special Histogram palette, which you call up by choosing Window > Histogram from the main menu. This palette doesn't give you adjustment sliders like in the Levels dialog box, but it does give you before and after versions of the histogram as you edit the exposure level of the photo.

Adjusting Shadows and Highlights

Sometimes even photos with a decent tonal range benefit from a little work in the shadows and highlights, especially when you want to bring out (or gloss over) the subtle details. Many image editors give you a couple different ways to go about doing this: You can adjust the shadows or highlights in the entire photo all at once, or you can "paint" particular areas of the photo with relative darkness or lightness.

To adjust shadows and highlights for the entire photo in Photoshop Elements, use the Shadows/Highlights dialog box. Choose Enhance > Adjust Lighting > Shadows/Highlights, and then just drag the sliders:

✦ **Drag the Lighten Shadows slider to the right to increase the level of detail in the darks.**

✦ **Drag the Darken Highlights slider to the right to increase the level of detail in the lights.** This is handy for correcting problems with backlighting.

✦ **Drag the Midtone Contrast slider to the left to make the lighting appear softer.** Shadows become grayer, and fine details smooth out.

✦ **Drag the Midtone Contrast slider to the right to make the lighting appear harder.** Shadows become darker, and highlights seem more glaring.

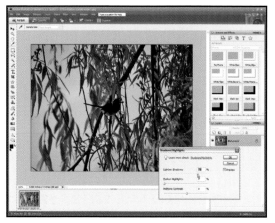

Hey! There's a bird in that tree! Increasing the detail in the darks helps to bring him out.

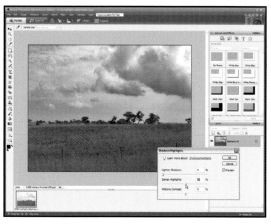

Increasing the detail in the lights gives shape and weight to the clouds.

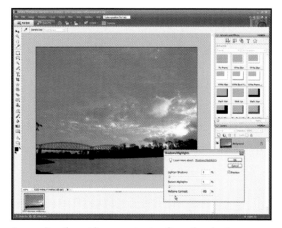

Decreasing the midtone contrast softens the shadows.

Increasing the midtone contrast makes the lighting harder.

To make particular areas of the photo lighter or darker, use the Dodge and Burn tools. The Dodge tool lightens, while the Burn tool darkens, but other than that, they work the same way. Imagine that they're paintbrushes, but instead of adding a streak of color, they lighten or darken whatever you paint with them.

1. **From the Toolbox, select the Dodge or Burn tool.** They're both underneath the Sponge tool, at the very bottom of the Toolbox. Remember, the Dodge tool lightens, while the Burn tool darkens.

2. **Adjust the properties.** You can change the size and style of the brush, the tonal range that it targets (Shadows, Highlights, or Midtones), and the exposure level. Increasing the exposure makes the effects more dramatic.

3. **Move the mouse to position the tool, and hold down the mouse button to lighten or darken.** The longer you hold the tool over the same spot, or the more often you go back and forth over the same region, the lighter or darker that region will become. Careful! A little goes a long way. If you make a mistake, release the mouse button and choose Edit > Undo.

The land mass in the lower-right corner got scrubbed with the Dodge tool.

The top half of this frozen leaf got scrubbed with the Burn tool.

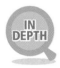

IN DEPTH

From whence come the names *dodge* and *burn?* According to tech editor Ron, they come from darkroom tricks in old-school photography.

Dodging involves taping a cardboard circle to a piece of wire. The person developing the film holds the cardboard just above the photo paper, blocking out or dodging the light.

For burning, the cardboard circle has a hole or window, which directs the light to a specific area on the photo paper.

Adjusting Brightness and Contrast

Brightness is the overall lightness or darkness of the photo, while *contrast* is the amount of difference between the shadows and highlights. In a bright photo, the entire histogram is farther to the right end of the scale, while in a dark photo, it's farther to the left end. Further, in a high-contrast photo, the edges of the histogram are far apart, while in a low-contrast photo, they're closer together.

In Photoshop Elements, you can adjust both brightness and contrast from the Brightness/Contrast dialog box. Choose Enhance > Adjust Lighting > Brightness/Contrast to call it up, and then:

✦ **Drag the Brightness slider to the left to darken the photo.** This shifts the histogram to the left, pushing everything—including the highlights—toward the dark end of the scale.

✦ **Drag the Brightness slider to the right to lighten the photo.** This shifts the histogram to the right. The entire photo, including the shadows, moves toward the light end of the scale.

✦ **Drag the Contrast slider to the left to decrease the level of contrast.** This compresses the histogram, moving the edges closer together, which softens the photo.

✦ **Drag the Contrast slider to the right to increase the level of contrast.** This expands the histogram, moving the edges farther apart, which makes the photo look starker and harder.

These controls work great together. Use the Brightness slider to position the histogram where you want it in terms of shadows and highlights, and then use the Contrast slider to fill up the gaps or squeeze in more of the total tone.

Adjust brightness alone.

Adjust contrast alone.

For the best results, adjust brightness and contrast together.

You can adjust the brightness or contrast of a particular region in the photo by selecting it and then calling up the Brightness/Contrast dialog box. (To learn how to make a selection, see Chapter 9.)

Correcting Color

By now, the exposure level is looking pretty good, which is a perfect time to move on to the color. This section gives you guidance for correcting white balance, adjusting saturation, removing red-eye, and more.

Setting White Balance

In Chapter 3, we said that you can always adjust white balance in your image editor, even if your camera doesn't give you manual control. It's time to make good on that claim.

This shot could use some white balance.

To set white balance in Photoshop Elements, follow these steps:

1. **Choose Enhance > Adjust Color > Remove Color Cast from the main menu.** The Remove Color Cast dialog box will appear.

Set white balance with the Remove Color Cast dialog box.

2. **Move the mouse pointer onto any part of the photo that should appear as plain white, plain black, or neutral gray, and click the mouse button.**

If you can't find any portion of the image that gives you the white balance you want, try the Temperature slider in Quick Fix mode.

3. **Review the results.** Click Reset to try again, or click OK to keep the changes.

What a difference!

Adjusting Saturation

Saturation is the purity of the color in the photo. The higher the saturation, the lower the overall level of gray, which makes the colors in the photo more vivid and less muted. Many times, increasing the saturation makes the photo feel livelier or sharper, while decreasing the saturation calms things down or washes them out.

To adjust the saturation across the entire photo in Photoshop Elements, use the Hue/Saturation dialog box. Choose Enhance > Adjust Color > Adjust Hue/Saturation, and then drag the Saturation slider:

✦ **Drag the Saturation slider to the left to decrease saturation.**
This mixes more gray into the colors, washing them out.

✦ **Drag the Saturation slider to the right to increase saturation.**
This takes the gray out of the colors, making them more vivid.

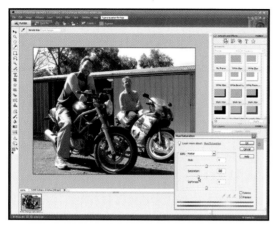
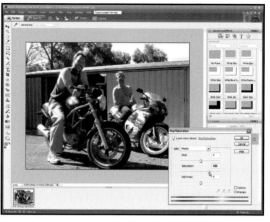

Decreasing saturation washes out the color. Increasing saturation makes the color more vivid.

You can also paint individual areas of the photo with saturation using the Sponge tool, much like the Dodge and Burn tools enable you to paint with lightness and darkness:

1. **From the Toolbox, select the Sponge tool.** It's at the very bottom of the Toolbox. If you don't see it, look under the Dodge or Burn tool.

2. **Adjust the properties.** Set the size and style of the brush. Then, from the Mode drop-down menu, choose Saturate to make the colors more vivid, or choose Desaturate to make the colors more muted. The Flow parameter determines how quickly the Sponge works: the higher the value, the faster the tool affects the colors in the photo. Use a low Flow value to make more subtle changes.

3. **Move the mouse to position the tool, and hold down the mouse button to adjust the saturation.** For the best results, scrub the tool back and forth until you get the level of saturation or desaturation you want.

Another way to adjust the saturation in a particular area of the photo is to select the area and then call up the Hue/Saturation dialog box.

The moss on the left and along the bottom got scrubbed with the Sponge in Saturate mode.

Removing Red-Eye

Everyone's seen red-eye before. It's where the eyes of people or pets come out looking a particularly demonic shade of red. Believe it or not, red-eye isn't a camera malfunction. You're actually seeing through the subject's eye to the retina in the back of the eyeball!

Ah, red-eye. You're looking at the retinas of these good people.

When taking pictures of pets, you might run across blue-eye, yellow-eye, and green-eye along with good old red-eye. The reason is more or less the same. What's happening is that you're seeing into the back of the eyeball, but the difference is that most mammals have a pearly or marble-like texture back there, which reflects vivid colors when it catches the light. Human eyeballs don't have this texture in the back, which is why we're the red-eye-only type.

As cool as that may be, you probably want to see the subject's eye, not his or her retina, unless you're training to be an optometrist. To take out red-eye in Photoshop Elements, follow these steps:

1. **From the Toolbox, select the Red Eye Removal tool.** Look for it near the middle of the Toolbox.

2. **Move the mouse pointer to the corner of the eye.**

3. **Hold down the mouse button and drag the mouse to the other corner of the eye.** This will form a selection rectangle around the eye.

4. **Release the mouse button.** Photoshop Elements will take out the red.

5. **Review the results.** If you didn't quite get the red out, choose Edit > Undo, and go back to Step 2. This time, you might try changing the orientation of the selection rectangle—instead of making it landscape, make it portrait (or the other way around). You might also try increasing or decreasing the size of the selection rectangle.

The Red Eye Removal tool lives up to its name.

Intentional red-eye turns ordinary people or animals into creatures from another dimension. To enhance the red-eye effect, set the Sponge tool to Saturate mode, and scrub back and forth across the retina.

Going Grayscale

Where would photography be without good old grayscale? You might not have heard the term before, but surely you know what it is. *Grayscale* is a more accurate description for what most people call black and white, where there's no color in the picture, just varying levels of gray. There is such a thing as true black and white, which publishing people call *halftone*. Halftone images are pure black and pure white; they don't contain any shades of gray at all.

A grayscale image shows levels of luminance only.

Newspaper publishers print photos in halftone, not grayscale. To simulate the shades of gray, newspapers use black dots of different sizes.

Darker grays get larger dots, while lighter grays get smaller dots. Even the largest dots are pretty small, so when you look at the image from a typical reading distance, your eye blurs the dots together. The black of the dots mixes with the white of the paper, and you see gray. But look at a newspaper photo with a magnifying glass, and the halftone dot patterns become obvious.

There's a color halftone process, too, which creates the illusion of full color using dots of cyan (greenish blue), yellow, and magenta (reddish purple) in addition to basic black. Cyan, yellow, and magenta in different combinations can reproduce almost any color, while the black adds depth and shading.

As it turns out, grayscale and color photos aren't all that different. Both kinds of photos are records of the light that goes into the camera. But light has two important properties: *luminance*, which is its relative strength or weakness, and *frequency*, which is its color. In a grayscale photo, the camera records luminance only. Objects in the photo with low luminance appear darker, while objects with high luminance appear brighter. The frequency of the light doesn't enter into it. Not so in a color photo. Here, the camera records the luminance as well as the frequency of the light, so you see the relative brightness and darkness of objects as well as their color.

You might say, then, that color photography is really just grayscale photography —luminance—with a little something extra—frequency. So the easiest way to turn any color photo into a grayscale photo is simply to discard the frequency information while leaving the luminance information exactly as you found it. In Photoshop Elements, this is a one-step process: Choose Enhance > Adjust Color > Remove Color from the main menu. The software strips out all the color information, retaining the luminance information, and you get what Uncle Frank calls black and white.

It's very important to note that this is not a two-way street. You can turn any color photo into a grayscale photo with the flip of a switch, so to speak, but to turn a grayscale photo into a color photo, you have to go back in and add all the frequency information that the camera didn't record in the first place. This is a mammoth undertaking, and the results are far from perfect, as you know all too well if you've ever suffered through the colorized version of your favorite black-and-white creature feature.

Not all color photos look good when they go grayscale. What was once a nice contrast in color—the red S against the yellow shield on Superman's suit—becomes a muted mess of gray on gray, which is why the Superman suit for the 1950s TV show was gray and brown in real life! (Check out http://media.movies.ign.com/media/488/488884/img_3825501.html for a side-by-side comparison.)

You might not have the budget to dress all your friends in grayscale costumes, but if you use Photoshop Elements, you can always fall back on the Convert to Black and White command (Enhance > Convert to Black and White).

This corrects the color of the photo according to your specifications, much like substituting black for red in the Superman suit, which helps to improve tone and contrast after the image goes grayscale.

At the same time, it's very easy to go from grayscale to a gradation of any conceivable color. So instead of black and white, you can convert your photos to red and white, blue and white, green and white, orange and white, purple and white, chartreuse and white, and so on and so on. This process is also called *colorization*, although it isn't exactly the same as the colorization technique that disreputable rights holders use to "improve" old movies.

When it comes to colorization, you don't have to start with a grayscale photo. You can perform the same function on a full-color photo, and the results are exactly the same.

To colorize a photo in Photoshop Elements, follow these steps:

1. **Choose Enhance > Adjust Color > Adjust Hue/Saturation.** The Hue/Saturation dialog box will appear.

2. **Check the Colorize option.**

3. **Drag the sliders to set the color.** The Hue slider determines the base color: blue, red, yellow, orange, and so on. The Saturation slider adds or removes gray from the color. The Lightness slider lightens or darkens the color.

My favorite colorization setting is a fairly unsaturated sepia, with the hue at about 40 and the saturation between 10 and 15.

4. **Click OK.** The Hue/Saturation dialog box will close, and Photoshop Elements will colorize the photo.

Colorize a photo with Dave's favorite sepia tone.

Changing One Color into Another

Your image editor isn't just about adjusting white balance and cranking up or toning down the saturation level. It can also replace any color in the photo with any other. Your friend's orange sweater can be olive green instead, or your calico cat can have purple spots instead of cinnamon ones. The possibilities are endless.

Here's how it works in Photoshop Elements:

1. **Choose Enhance > Adjust Color > Replace Color.** The Replace Color dialog box will appear.

2. **Move the mouse pointer into the photo, and click on the color that you want to change.** The viewfinder in the Replace Color dialog box will show everything in the photo that has this color.

3. **Adjust the Fuzziness slider.** This slider determines the wideness of the color range. High fuzziness brings in a wider variety of related hues, while low fuzziness restricts the range to very few related hues. Keep your eye on the viewfinder in the dialog box to see how much of the photo will be affected.

4. **Mix the new color with the Hue, Saturation, and Lightness sliders.** As before, the Hue slider determines the base color, the Saturation slider determines its purity, and the Lightness slider determines its brightness or darkness.

5. **Click OK.** The Replace Color dialog box will close, and Photoshop Elements will replace the color.

What's this? A red flower?

Now that's more like it!

Photoshop Elements provides a whole set of automatic commands for adjusting exposure and color. Using them can save you time, although you don't get the opportunity to customize the effects, so your photos almost always look better when you make the adjustments manually. The various Auto commands are more for the Uncle Franks out there—those who don't particularly care to know about histograms and saturation levels.

Look for the Auto commands in the main menu under Enhance.

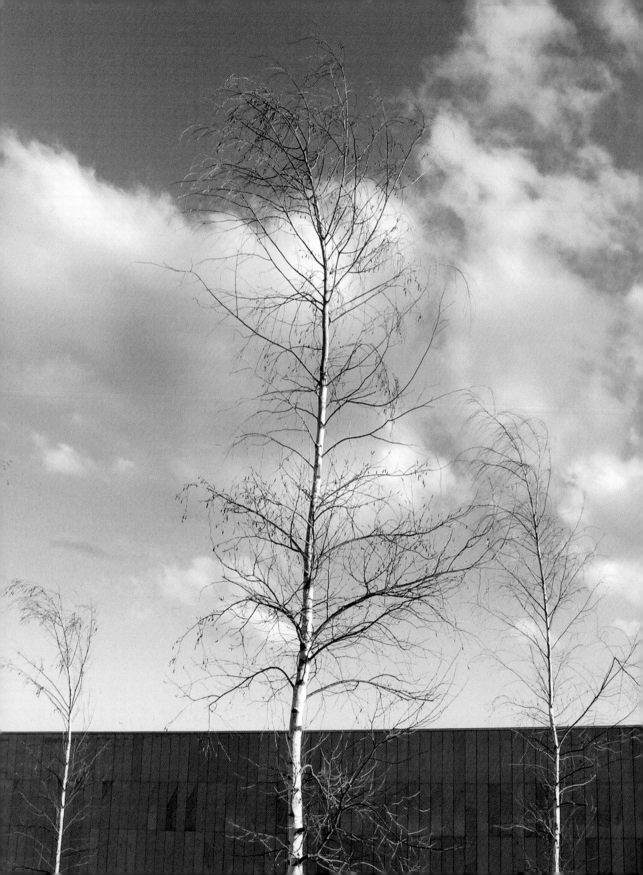

Pushing at the Edges (of a Digital Photo)

You want that digital photo cropped to wallet size? No problem. Blown up to poster size? No problem. Magnified with extra digital zoom? No problem. Stretched from 4:3 to 3:2? No problem. Don't believe us? Too good to be true? Read on!

Adjusting Resolution and Print Size

Your digital camera records a photo as a set of rows and columns of pixels. You know from Chapter 1 that pixels are very small colored squares. But just how small is very small? It all depends upon the resolution of the image.

Pixels don't come in a standard size the way a millimeter is always a millimeter or a mile is always a mile. As a matter of fact, pixels can be any size, but the smaller they are, the more useful they are. The more pixels you pack into the same amount of space, the more visual information your image conveys. You get better detail and subtler levels of color and shading.

In computer graphics, the density of pixels in an image is its *resolution*. A relatively low-resolution image, such as the kind you see on a Web page, doesn't have very

high pixel density. The pixels of the image are larger in size, so you can't fit as many of them into the area of the image. Therefore, you don't get as much visual information, but the overall memory requirement is smaller, which makes the image ideal for online use.

In contrast, a relatively high-resolution image, such as the kind you print out for your portfolio, has a higher pixel density. The pixels are smaller, so there are more of them in the image. As a result, you convey more visual information, but you pay for it with a larger file size. High-res images are essential for prints, but they don't make much sense online or in e-mail.

It's standard practice to talk about resolution in terms of *dots per inch* (dpi) or *pixels per inch* (ppi). Technically, pixels per inch is the more accurate of the two terms when it comes to pictures onscreen, while dots per inch applies to images on paper, although many people use these measures interchangeably. In digital photography, dots per inch is probably the more common unit, so that's the one we'll use in this book, even when we talk about onscreen photos.

A low-res image that looks good onscreen has a typical resolution of 72 dpi, which means that for every inch of space in the image, there are 72 pixels carrying the visual information. Even though these are low-res pixels—the larger kind—1/72 of an inch is still pretty small, and high-res pixels are smaller still. In a photo-quality color print, a typical resolution is 300 dpi, more than four times greater than the low-res image. Assuming that the images have the same physical dimensions, the pixels in the high-res image are more than four times smaller than the pixels in the low-res image. Glossy magazines contain photos in the 300-dpi range, while some art books and coffee-table books push the photo resolution toward 350 dpi.

So what does all this have to do with digital photography? As it happens, plenty! You know that your digital camera gives you a certain number of pixels. This is the megapixel rating, and it's written in stone. The only way to get more pixels is to buy a more powerful camera. You also know that the aspect ratio of your camera's sensor determines the aspect ratio of your photos. But the resolution of your photos is entirely up to you. You can set it to whatever you like in your image editor. Together with the dimensions of the pixel grid, the resolution determines how large your prints can be.

Here's an example. A typical 5-megapixel camera that shoots in the 4:3 aspect ratio creates a pixel grid of 2560 by 1920. At a resolution of 72 dpi, which is suitable for onscreen use, a photo from this camera can be as large as about 36 inches by 27 inches (2560 ÷ 72 and 1920 ÷ 72). At a resolution of 300 dpi, which is suitable for print, the same photo has a maximum size of about 8 inches by 6 inches (2560 ÷ 300 and 1920 ÷ 300). At a super-high resolution of 600 dpi, the photo can be about 4 inches by 3 inches (2560 ÷ 600 and 1920 ÷ 600).

It's easy enough to see resolution in action. Just go to your favorite website, choose a page with good, clear, full-color graphics—the bigger, the better—and then send the page to your printer. Compare the printed version of the page with the version that you see onscreen.

Notice anything about the images in the printed version? Some fuzziness, perhaps? A little blurriness in the details? These are the classic signs of a low-res image.

You might wonder, then, why the low-res image looks so good on your monitor. As it turns out, even the most sophisticated computer monitor works at a fairly low resolution. Good old-fashioned, low-tech paper can pack in a much greater pixel density! When you see a low-res image onscreen, it's harder to notice the lack of detail because the monitor is low-res, too. But get the picture onto any kind of paper, and the limitations of the resolution jump right out.

When you open a photo in your image editor, it never hurts to have a peek at the current resolution and print size. Your image editor may assume that you want a certain resolution, when in fact you want a different one. To check resolution and print size in Photoshop Elements, follow these steps:

1. **Choose Image > Resize > Image Size from the main menu.** The Image Size dialog box will open.

2. **If the Resample Image option at the bottom of the dialog box is checked, uncheck it.** See "Scaling the Photo" later in this chapter for more information about resampling. For now, just know that you don't want this option, because you want to keep the total number of pixels in the photo at a constant level.

3. **Type a value in the Resolution, Width, or Height field.** All these fields are related, so pick the one that you want to set, and Photoshop Elements will calculate the correct values for the other two. For example, to set the resolution to a certain amount, say 300 dpi, type 300 in the Resolution field, and Photoshop Elements automatically will determine the appropriate print size. To set the print size to a certain amount, say 8 inches wide by 6 inches tall, type 8 in the Width field, and Photoshop Elements automatically will determine the appropriate height and resolution, or type 6 in the Height field to get the appropriate width and resolution.

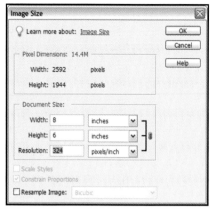

Deselect the Resample Image option, and when you change resolution, you change print size.

4. **Click OK.** The Image Size dialog box will close, and Photoshop Elements will set the resolution and print size to the specified values.

Keep in mind that this procedure doesn't affect the number of pixels in the image, so it doesn't change the amount of memory that the photo takes up. A 5-megapixel image at 36 inches by 27 inches and 72 dpi is still 5 megapixels at 8 inches by 6 inches and 324 dpi. Does this mean that you're stuck with a bunch of memory-hogging photos, no matter what you do? Not in the least! It's just as easy to maintain the desired print size, say 8×6, while reducing resolution from 300 dpi to 72 dpi (and therefore reducing memory), as you'll see in Chapter 11, "Showing Your Photos Onscreen."

When you set the resolution, you might not be happy with the print size. For example, setting the resolution to 72 dpi for a typical digital photo gives you completely unwieldy dimensions better measured in feet than in inches. To bring the photo back to a more manageable size, see the "Scaling the Photo" section later in this chapter.

Even when the print size is closer to what you want, it still might not be perfect. For instance, you might want to make a 4×6 print, but setting the resolution of the photo to 300 dpi puts you in the neighborhood of 4.3×6.5. In this case, the resolution is good, and the dimensions are close enough, so simply crop the photo to the desired size. See the "Cropping the Photo" section later in this chapter for more information.

A Tale of Canvases and Images

When you change the dimensions of a digital photo, there are two different approaches that you can take: editing the canvas or editing the image. The method that you use determines whether the photo is stretchy or not.

To visualize the difference, open up any digital photo in your image editor, and imagine that the photo sits on a background mat. Right now, the mat—the *canvas*—has exactly the same dimensions as the photo itself—the *image*. So if the photo is four inches wide by six inches tall, that's the size of the canvas, too. When you change the size of the canvas, you change the size of mat upon which the image sits. Making the canvas smaller than the image shaves off a portion of the photo, while making the canvas larger than the image adds white space around the photo. In either case, the image doesn't change. All you're doing is changing the dimensions of the background mat. *Cropping* a photo, or chopping off its edges, falls in the category of canvas size.

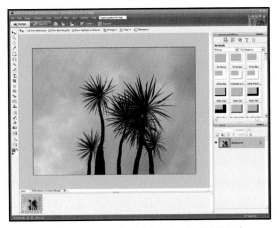

This photo has a canvas size of 4 inches by 5 1/3 inches.

Decreasing the canvas size to 3×3 reduces the amount of the photo that you see.

When you change the size of the image itself, the size of the canvas changes too, but the image upon it gets larger or smaller so that it perfectly fits the new canvas size. You don't cut away at the sides of the photo or add white space around it. Instead, you blow up or shrink down the image as a whole. *Scaling* a photo, or making it larger or smaller, is a function of image size.

So whether the photo is stretchy or not depends upon which set of dimensions you're editing. The photo isn't stretchy when you edit the canvas size. The picture remains exactly as it was, while the canvas behind it changes dimensions. The photo is stretchy when you edit the image size. It blows itself up or shrinks itself down so that it fits onto the new canvas.

Increasing the canvas size to 6×5 adds white space around the photo.

Decreasing the image size by half makes the entire photo smaller.

Doubling the image size makes the entire photo larger.

Changing the Canvas

Changing the canvas is all about adjusting the background mat. Take away space from the background mat, and you see less of the photo. Add space to the background mat, and you get a visible border around the photo. You can also rotate and even flip the canvas, as we demonstrate toward the end of this section.

Cropping the Photo

When you crop a photo, you chop off its edges. You might do this for any number of reasons. Maybe your photo is 5×7, and you want it to fit a 4×6 print. Or maybe you got too much of the background in a portrait, and you want to focus attention on the subject, so you cut away the unneeded area.

Photoshop Elements enables you to crop the photo several different ways, but the two most common methods are by using the Crop tool and the Canvas Size dialog box.

Using the Crop Tool

The Crop tool enables you to eyeball the part of the photo that you're keeping with great precision. At the same time, it isn't so good at telling you the exact dimensions of this region, so use the Crop tool whenever the final canvas size doesn't matter much. If the dimensions of the canvas are more important—for example, if your photo absolutely needs to be four inches by six inches—you might try the Canvas Size dialog box instead.

To be fair, the Crop tool in Photoshop Elements does come with size options. When you select the Crop tool, look in the tool properties, and you will see Aspect Ratio, Width, Height, and Resolution controls.

These are a little misleading, though. If you choose 4 × 6 from the Aspect Ratio menu, you don't get a selection rectangle that is absolutely 4 inches by 6 inches. Rather, you get a selection rectangle in 3:2 aspect ratio, the absolute dimensions of which you're free to change. The selection rectangle might end up being 4 by 6, 8 by 12, 12 by 18, and so on.

When you crop, Photoshop Elements makes the final print size 4 by 6, but it does this by manipulating the resolution (just like you did in the "Adjusting Resolution and Print Size" section at the beginning of this chapter) and perhaps also by resampling (see the "Scaling the Photo" section later in this chapter).

Your humble authors come at this from two different points of view. On the one hand, to ensure that Photoshop Elements doesn't do anything to your photo that you don't specifically request, you should avoid using the Crop tool's size options. On the other hand, if you don't mind giving up some control over resolution and resampling, the Crop tool's size options are certainly more convenient and easier to eyeball than the Canvas Size dialog box.

By all means, experiment with both methods, and decide which one makes more sense for you.

To crop a photo with the Crop tool, follow these steps:

1. **Select the Crop tool from the Toolbox.** It's toward the middle of the Toolbox, between the Horizontal Type tool and the Cookie Cutter tool.

2. **Move the mouse pointer onto the photo.** Position it in any corner of the region that you want to keep. You don't have to be perfect about it. In Step 4, you can adjust the position of the keep zone.

3. **Hold down the mouse button and drag the mouse to create a selection rectangle.** Everything inside the rectangle is what you're keeping. Everything outside the rectangle is what you're chopping off. To create a perfect square instead of a rectangle, hold down the Shift key while you drag the mouse. To move the selection rectangle without changing its shape or size, hold down the spacebar.

4. **Release the mouse button and review the selected area.** Reposition the rectangle by clicking anywhere inside it, holding down the mouse button, and dragging the mouse. Change the size of the rectangle by dragging any of its handles.

5. **Commit or cancel.** When you like what you see, click the check mark icon at the lower-right of the selection rectangle, or press Enter (Windows) or Return (Mac). To start over, click the cancel icon and go back to Step 2.

If you make a mistake, choose Edit > Undo and try again.

Drag the Crop tool around the portion of the photo that you want to keep.

Crop the photo to remove the excess background.

The problem with cropping using the Canvas Size dialog box is that you can't see what you're doing until after the fact. On the other hand, cropping with the Crop tool isn't as precise as it could be. Want the best of both worlds? Here's how Dave does his cropping.

1. Determine the size of the print in pixels. So if you want a 4×6 print at 300 dpi, then that's 1,200 pixels by 1,800 pixels (4×300 and 6×300).

2. Select the Rectangular Marquee tool, and in the tool options, choose Fixed Size from the Mode drop-down menu.

3. Type the pixel values from Step 1 into the Width and Height fields in the tool properties. If you already have your shot at the appropriate resolution, say 300 dpi, you can type the inch values in these fields instead. Be sure to include the abbreviation "in" after each (4 in and 6 in).

4. Click anywhere in the photo, and a rectangular marquee of a fixed size will appear. Drag it over the part of the photo that you want to turn into a print.

5. If the image is flattened, choose Edit > Copy from the main menu. If the image has more than one layer, choose Edit > Copy Merged.

6. Choose File > New from Clipboard. Photoshop Elements will create a new canvas and place your cropped region in it. Instant print (almost)! And it's already in a separate file, so you don't have to worry about saving over the original.

Using the Canvas Size Dialog Box

Cropping with the Canvas Size dialog box is the method to use when the final dimensions of the canvas are absolutely critical. The downside is that you don't get to see what you're cropping until after the fact.

To crop a photo using the Canvas Size dialog box, follow these steps:

1. **Choose Image > Resize > Canvas Size.** The Canvas Size dialog box will open.

2. **If the Relative option is checked, uncheck it.**

3. **Type the desired width in the Width field.** If you want your image to be four inches wide by six inches tall, type 4 and choose Inches from the drop-down menu.

4. **Type the desired height in the Height field.** To follow the previous example, type 6 and choose Inches from the drop-down menu.

5. **In the Anchor diagram, choose the portion of the image to keep.** The Anchor diagram is a set of nine boxes in three rows, with three boxes per row. To select a box in the diagram, click it. The selected box determines which portion of the image that you keep. So if you want to chop off the bottom-right of the photo, click the upper box on the left. But if you want to chop off the left side of the photo, click the middle box on the right. Clicking the center box crops the top, the bottom, and both sides of the photo.

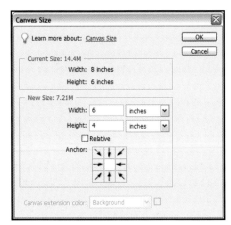

Use the Canvas Size dialog box to crop the photo to a specific print size.

6. **Click OK.** Photoshop Elements will warn you that you're about to crop the photo, but you know that already. Click OK again, and Photoshop Elements will crop the photo.

Didn't quite get the crop you wanted? Restore the canvas to the original size with Edit > Undo, and have another go.

One way to improve your results with the Canvas Size dialog box is to do a quick visual crop with the Crop tool first. Then go into the Canvas Size dialog box and shave off the remainder. If you cut off too much of the photo with the Crop tool, choose Edit > Undo and try again, this time with a smaller selection rectangle.

Adding a Built-In Border

Decreasing the size of the canvas crops the photo, but increasing the size of the canvas gives you a built-in border. Here's how it works:

1. **Set the background color.** By default, the background color determines the color of the border. We talk about foreground and background colors in Chapter 9, but for now, just look below the Toolbox. The foreground color is in the top box, while the background color is in the bottom one. To change the background color, click inside this box and pick a new color from the Color Picker window.

2. **Choose Image > Resize > Canvas Size.** The Canvas Size dialog box will open.

3. **If the Relative option is unchecked, check it.**

4. **Type the total width of the border in the Width field.** For a one-inch border on both sides of the photo, type 2 (one inch for the left side and one inch for the right), and choose Inches from the drop-down menu. For a two-inch border on both sides, type 4. For a three-inch border on the left side only, type 3. (You specify the exact location of the border in Step 6.)

5. **Type the total height of the border in the Height field.** Again, for a one-inch border above and below, type 2 and choose Inches from the drop-down menu. For a two-inch border above and below, type 4. For a three-inch border on the bottom only, type 3.

6. **In the Anchor diagram, choose where to position the photo on the canvas.** Choose the box in the middle to place the photo in the center of the canvas. Choose the lower-right box to put the photo in the lower-right corner, and so on.

7. **Choose the color of the border from the Canvas Extension Color drop-down menu.** To use the background color as the color of the border, leave the menu at its default setting. Otherwise, choose Foreground to use the foreground color, White for a pure white border, Black for a pure black border, Gray for 50% gray, or Other to open the Color Picker.

8. **Click OK.** Photoshop Elements will resize the canvas, giving you a border around the photo.

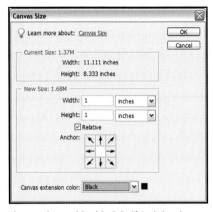

These values add a black half-inch border around the entire photo.

It worked!

Rotating the Canvas

Rotating the canvas is like turning the photo. When you want to change the orientation of the photo—such as making a landscape into a portrait—the rotation command is the one to use.

Giving an image a crazy angle is great for artistic effect. It helps to catch the audience's attention and imagination. But rotation can also be very practical. Having a photo come out tilted two or three degrees to one side is a very common occurrence, especially when you're shooting without a tripod. Apply a little rotation in the other direction to compensate, and you straighten the shot.

When straightening a photo, use the horizon line as your reference. You want to turn the horizon until it looks level. Then just crop the photo to get rid of any bits of empty canvas.

To rotate the canvas in Photoshop Elements, choose Image > Rotate from the main menu, and then select one of the rotation options. These are 90° Left for counterclockwise rotation, 90° Right for clockwise rotation, 180° for turning the photo upside down, and Custom. The Custom option opens up the Rotate Canvas dialog box. Just type a value into the Angle field, choose °Right or °Left for clockwise or counterclockwise, and click OK.

Compensate for the tilt with a 2-degree rotation to the left.

Look very closely at the horizon line, and you see that it tilts just a few degrees to the right.

DAVE SAYS

Want a faster, more visual way to straighten your photo in Photoshop Elements? Try the Straighten tool. (It's just above the Red Eye Removal tool in the Toolbox.) Drag the Straighten tool from one side of the photo to the other, tracing the horizon line. Release the mouse button, and Photoshop Elements will rotate the canvas so that the horizon is level.

When you rotate the canvas 90 degrees or 180 degrees, the canvas itself remains invisible, and the total area of the canvas stays the same. But if you use the Custom option and specify a different angle, such as 45 degrees, the canvas peeks out behind the rotated image, and the area of the canvas changes. Photoshop Elements makes the canvas as large as it needs to be to fit the rotated image. The background color determines the color of the canvas, so set the background color to what you want it to be before you open the Rotate Canvas dialog box, or crop the photo afterward to get rid of the empty canvas.

The photo rotates, but you see a bit of the canvas peeking out. Crop the photo to get rid of the empty canvas.

Flipping the Canvas

Flipping the canvas gives you the mirror image of the photo. You can flip the photo along two axes: the horizontal and the vertical. Flipping horizontally reflects the photo from left to right, while flipping vertically reflects the photo from top to bottom.

Uh-oh, it's quarter past eight, and we were supposed to meet Uncle Frank at six. Simply flip the canvas, and now it's quarter to four.

To flip the canvas in Photoshop Elements, choose Image > Rotate > Flip Horizontal or Image > Rotate > Flip Vertical.

Changing the Image

If the canvas is all about the background mat, the image is all about the picture itself. Changing the image makes the photo larger, smaller, more squished together, or more spread apart, as this section shows.

Scaling the Photo

Scaling a photo makes it larger or smaller without changing its resolution. Shrinking down your mammoth 27×36 photo to a more comfortable 6×8 while maintaining a steady 72 dpi is scaling in action. So is blowing up a 4×6 snapshot to a 24×36 poster without budging from 300 dpi.

You already played with these values in the "Adjusting Resolution and Print Size" section at the beginning of this chapter, and as you'll recall, they seem to be joined at the hip, just like every overly cozy couple in your social circle. Change one, and you change the other. Decreasing the print size makes the pixels smaller, so resolution goes up. Increasing the print size makes the pixels larger, so resolution goes down. You might wonder, then, how scaling a photo breaks up this seemingly perfect relationship.

The secret is in what your image editor does with the pixels. When you scale down a photo, reducing the print size doesn't make the pixels smaller. Instead, it gets rid of them. At a print size of 27×36 and a resolution of 72 dpi, you have 5,038,848 pixels in your image (27 inches × 72 pixels per inch × 36 inches × 72 pixels per inch). Scale that down to 6×8, and you end up with 248,832 pixels. The pixels are the same size. There are just fewer of them in the photo.

Likewise, increasing the print size doesn't make the pixels larger; it adds new pixels to the image. At a print size of 4×6 and a resolution of 300 dpi, you have 2,160,000 pixels (4 inches × 300 pixels per inch × 6 inches × 300 pixels per inch). Scaling up to 24 by 36 increases the pixel count to 77,760,000.

In both cases, the image editor *resamples* your digital photo. *Downsampling* is the process of removing unwanted pixels, while *upsampling* is the process of adding new pixels. When you scale down, your image editor downsamples your photo. When you scale up, the software upsamples the photo.

The only problem with resampling is that you lose image quality no matter which way you go, although scaling down is much, much kinder to your work than scaling up. Scaling down gets rid of pixels, so you don't have as much visual information to play with, but a lot of this information is too subtle for the casual observer to notice anyway. Scaled-down photos look almost as crisp and clear as the originals, if not exactly the same. You can afford to lose a lot of pixels before image quality suffers too much.

This photo is 800×600 pixels at 150 dpi resolution.

Downsample to 400×300 at 150 dpi, and the photo loses most of its pixels—not that you can tell.

Scaling up adds pixels, so you might be tempted to think that image quality goes up instead of down, but unfortunately, this isn't the case. In adding pixels to the photo, your image editor duplicates the ones that are already there. In other words, it doesn't put any new visual information into the photo; it simply magnifies the existing information. As a result, scaled-up photos tend to look blocky or hazy. This is *precisely* the same effect as digital zoom. When we said in Chapter 1 that you can add digital zoom to your photos after the fact in your computer, this is what we were talking about.

This photo is 800×600 pixels at 72 dpi resolution.

Upsampling to 1600×1200 pixels at 72 dpi increases the print size.

How much upsampling is too much? Every photo is different, so there are no hard-and-fast rules, although a photo with a lot of pixels and not so much detail tends to withstand upsampling much better than a photo with fewer pixels and a lot of detail.

One rule of thumb is to use the digital zoom rating of your camera as a guide. So if your camera comes with 4× digital zoom, you don't want to upsample by more than a factor of four.

For fooling-around purposes, you can usually get away with doubling or even tripling the print size before image quality degrades too noticeably. If you have a 5-megapixel camera, and if you're feeling lucky, quadruple the print size and see what happens. In any case, taking that 4×6 snapshot and turning it into a 24×36 poster—increasing the print size six times—will probably end up disappointing you. Then again, you view posters at a distance, not right up close, so maybe you can live with a little haze.

For serious prints such as the ones that go in your portfolio, it's wise to stay away from upsampling altogether or to use it very sparingly, for the same reasons that we advise you against using digital zoom.

At the end of the day, the only thing that matters is whether the photo looks good, not whether you upsampled or by how much, so it never hurts to experiment.

To scale a photo in Photoshop Elements, follow these steps:

1. **Choose Image > Resize > Image Size.** The Image Size dialog box will open.

2. **If the Resample Image option at the bottom of the dialog box is unchecked, check it.**

3. **Choose a resampling method from the drop-down menu.** There are five choices: Nearest Neighbor, Bilinear, Bicubic, Bicubic Smoother, and Bicubic Sharper. Try Bilinear or Bicubic Sharper if you're scaling the photo down. Try Bicubic or Bicubic Smoother if you're scaling the photo up. You're welcome to try Nearest Neighbor, especially if the image contains hard angles instead of flowing curves, although this method doesn't usually work well for photos. It gives you too many jagged edges. Save Nearest Neighbor for boxy graphic designs—the kind with lots of square angles.

4. **If the Constrain Proportions option is unchecked, check it.**
 This keeps the photo in the same aspect ratio. You know that
 you're constraining proportions when you see the bold brackets
 connecting the different fields in the dialog box. See the
 "Stretching or Squeezing the Photo" section later in this chapter
 to find out what happens when you uncheck this option.

5. **Type the desired width or height in the Width or Height
 field.** Because you're maintaining the same aspect ratio,
 Photoshop Elements automatically calculates the corresponding
 value. Notice that the resolution remains the same, while the
 number of pixels increases or decreases.

To scale a photo up or down, check
the Resample Image option in the
Image Size dialog box.

6. **Click OK.** The Image Size dialog box will close, and Photoshop
 Elements will scale the photo.

If you're not happy with the results, choose Edit > Undo and pick another resam-
pling method in Step 3.

 After scaling your photo, you might want to sharpen it up a bit. See Chapter 10,
"Adding Finishing Touches and Special Effects," for more information on sharpening.

Applying Your Own Digital Zoom

When your camera zooms in digitally, it does two things. First, it scales up the
entire photo, which increases the print size. Then, it centers the photo on the
area that you zoomed and crops the photo back down to the original print size.

You can achieve the same results in your image editor. Here's how to do it in Photoshop Elements:

To turn this shot into a close-up, apply your own digital zoom.

1. **Choose Image > Resize > Image Size.** The Image Size dialog box will appear.

2. **Check the Resample Image and Constrain Proportions options.** You're scaling up, so choose Bicubic or Bicubic Smoother from the drop-down menu.

3. **Note the print size.** For the purposes of this example, assume that the size is 8 inches wide by 10 inches tall. You might want to jot these numbers down, because you'll use them in Step 9.

4. **Multiply the width or the height by the desired magnification level.** So if the width is 8 inches and you want 3× digital zoom, multiply 8 by 3 for 24.

5. **Type this value into the appropriate field, either Width or Height.** You multiplied the width, so type 24 into the Width field. If you had used the height, you'd type the result into the Height field. Photoshop Elements automatically calculates the corresponding value.

6. **Click OK.** The Image Size dialog box will close, and Photoshop Elements will scale up the photo.

7. **Choose Image > Resize > Canvas Size.** The Canvas Size dialog box will open.

8. **Uncheck the Relative option.**

9. **Type the original width and height in the Width and Height fields.** These fields aren't constrained, so be sure to fill them both out. Type 8 in Width and 10 in Height.

10. **In the Anchor diagram, choose the area to zoom in on.**

For better control over exactly which area of the photo you zoom in on, use the Crop tool between Steps 6 and 7 to cut away the portions of the photo that you know you don't want. You can also skip the Canvas Size dialog box entirely. Starting with Step 7, substitute my surefire method of cropping using the Rectangular Marquee tool.

11. **Click OK.** The Canvas Size dialog box will close, and Photoshop Elements will crop the photo back to its original size. Instant digital zoom!

Lovely!

Stretching or Squeezing the Photo

So far in your scaling adventures, you've forced the image editor to keep the photo at its original aspect ratio. But nobody says that you have to play by these rules. Unchecking the Constrain Proportions option in the Image Size dialog box enables you to stretch or squeeze a photo to fit any conceivable set of dimensions, no matter the original aspect ratio.

Stretching or squeezing comes in handy when you need to make a photo fit a particular print size or aspect ratio and cropping is out of the question. You're distorting the image—there's no getting around that—but as long as you don't go too crazy with the dimensions, your audience will likely never know that you stretched and squeezed your way to success. Just keep in mind that too much distortion creates a funhouse-mirror effect, which is fine if that's the look you're going for. You also have to watch out for stretching and squeezing photos of people, because the distortion is a lot more obvious, especially on people you know.

Say that you're putting a 4:3 photo in 3:2, and the original dimensions of the image are 6 inches by 8 inches. Common 3:2 equivalents are 6 inches by 9 inches and 4 inches by 6 inches. Which do you use? The first set, 6×9, keeps the width the same but increases the height by an inch, so you're upsampling, and upsampling is never as desirable as downsampling. The second set, 4×6, downsamples both the width and the height, so that looks like it's the better option. Now, just go into Photoshop Elements and follow these steps:

This photo is in the 4:3 aspect ratio.

1. **Choose Image > Resize > Image Size.** The Image Size dialog box will appear.

2. **If the Resample Image option at the bottom of the dialog box is unchecked, check it.** Because you're changing one or both of the dimensions while keeping the same resolution, you need to resample the photo.

3. **Choose a resampling method from the drop-down menu.** For upsampling, try Bicubic or Bicubic Smoother. For downsampling, try Bilinear or Bicubic Sharper. For the purposes of this example, you're downsampling, so go with either Bilinear or Bicubic Sharper.

4. **If the Constrain Proportions option is checked, uncheck it.** This way, Photoshop Elements won't maintain the aspect ratio of the original.

5. **Type the desired width in the Width field.** Type 4, and choose Inches from the drop-down menu.

6. **Type the desired height in the Height field.** Type 6, and choose Inches from the drop-down menu.

To scale an image to any aspect ratio, uncheck the Constrain Proportions option in the Image Size dialog box.

7. **Click OK.** The Image Size dialog box will close, and Photoshop Elements will do its thing.

Now it's in 3:2, and no one will ever know that it used to be in 4:3.

Rearranging Pixels

In the last couple chapters, you've changed the exposure, color, resolution, and print size of your digital photos. It's time now to get into the photos themselves and push the individual pixels around. This chapter is all about selecting, cutting, copying, pasting, moving, painting, erasing, and cloning.

Making a Selection

When you look at a photo, you can usually pick out the people and objects in the picture without much trouble at all. There's your pet turtle. That's Melissa over there. That's a tree. That's a UFO. Easy, right? But the way that you see the photo is completely different than the way your image editor sees it. To your image editor, the photo is just a bunch of pixels of different colors. It doesn't know whether it's looking at Melissa, a UFO, the President of the United States, a mailbox, or a schematic diagram. It can't even tell which pixels belong to which person or object. All it knows is that different pixels in the photo have different colors. It doesn't know why. It doesn't *care* why.

So when you want to select a portion of the image—the part with Melissa, for example, or the part with the UFO—you can't just click on it and expect the image editor to know what you mean. Instead, you want to show the software exactly which pixels make up the portion of the image that represents Melissa or the UFO. The number of ways to do this in Photoshop Elements borders on the ridiculous:

✦ **The Marquee tools.** There are two of these: Rectangular Marquee and Elliptical Marquee. Drag the tool across the photo to create a rectangular or elliptical selection. Hold down the Shift key as you drag for a square or circle. These tools aren't so great at selecting individual objects, because hardly anything you photograph is perfectly rectangular or elliptical, but they are very useful for grabbing particular regions of the photo, such as the head and shoulders of an upper-body shot.

Use the Rectangular Marquee tool to select a particular region.

✦ **The Lasso tools.** These are the Lasso, the Magnetic Lasso, and the Polygonal Lasso. All three are similar in the sense that you use them to trace the area that you want to select. Use them when you want to grab a particular object in the photo. With the Lasso, you drag the mouse to create a selection, just as if you were drawing a circle around the object with a pencil. With the Magnetic Lasso, you position the tool close to the edge of the object, and then you hold down the mouse button and trace its outline. Photoshop Elements detects the edge of the object and places the selection snugly against it. This is *usually* what occurs, because remember, the software doesn't distinguish between individual objects in the photo, so its calculations can be off. With the Polygonal Lasso, you build the selected region out of straight lines, clicking the mouse whenever you need to change direction.

Use the Magnetic Lasso tool to select a particular object in the photo.

✦ **The Magic Wand tool.** The Magic Wand selects pixels based on color. Consider a landscape that includes a blue sky. Clicking in the sky with the Magic Wand selects all the blue pixels in that region of the photo within a certain range or *tolerance*. Increasing the tolerance brings in more shades of blue, while decreasing the tolerance restricts the selection to a narrower range of color.

Use the Magic Wand tool to select a range of color.

If you can't quite see which pixels you're selecting, simply zoom in with the Zoom tool. There's no sense fumbling around at too low of a magnification level. Get in nice and close.

◆ **The Selection Brush tools.** These are the Selection Brush and the Magic Selection Brush. You use them to "paint" the object that you want to select. In this regard, they're like the Dodge, Burn, and Sponge tools. Drag the Selection Brush back and forth across the photo, and whatever the tool touches will be selected. The Magic Selection Brush combines the Selection Brush with the Magic Wand. Photoshop Elements analyzes the colors and textures of the area that you've brushed over and extends the selection to include similar areas. This is a quick way to select a complex, multicolored object, such as one of Dave's famous flowers.

Use the Magic Selection Brush tool to select a complex object relatively quickly.

To scrap the current selection and start fresh, choose Select > Deselect from the main menu.

All the selection tools in Photoshop Elements include options for making multiple selections. The Add to Selection option brings in additional selected regions. The Subtract from Selection option cuts regions out of the selection. The Intersect with Selection option selects the area where multiple selections overlap. Find these options and others in the tool properties along the top of the screen.

In addition, the Select menu contains commands for modifying or transforming the selection. For example, to switch the selected and unselected regions of the photo, choose Select > Inverse.

If you prefer using the keyboard, holding down the Shift key while you select gives you the Add to Selection option, while holding down Alt (Windows) or Option (Mac) gives you the Subtract from Selection option.

Working with Layers

Layers are like transparent sheets that you stack on top of your photo. Each layer can contain its own set of pixels and settings, which gives you a tremendous amount of flexibility in editing, as this section shows.

Whenever you work with layers in Photoshop Elements, be sure to expand the Layers palette. Marc refers to it constantly over the next couple pages. If you don't see the Layers palette onscreen, choose Window > Layers from the main menu.

Moving Pixels from One Layer to Another

The best way to see what layers are all about is to look at an example, so we'll jump right in with one of Dave's flower photos.

Take a gander at the Layers palette, and you see that all the visual information contained in the photo appears in the default layer, which Photoshop Elements calls *Background*. But you can move one of the flowers from the Background layer to another, new layer. Here's how:

1. **Select the pixels that you want to transfer to a new layer.** Use any of the selection tools at your disposal.

When you first open the photo, it has one layer only: the default Background layer.

Select one of the flowers.

2. **Choose Layer > New > Layer Via Cut from the main menu.**
 Photoshop Elements will cut the selected pixels from the
 Background layer, create a new layer, and paste the pixels into it.

Photoshop Elements assigns a generic name to the new layer, but you can change it to something more specific, such as Flower, by going to the Layers palette and double-clicking the name of the layer.

You may wonder what the big deal is, because the photo looks exactly the same. In the Layers palette, if you click the eye icon next to the new layer, you can make the flower disappear, revealing the hole in the Background layer, but why would you want to do this? Click the empty box where the eye icon was to bring the object back again.

No, the real convenience of putting the flower on another layer is that you can do whatever you like to the Background layer without affecting the flower layer. Change the brightness of the background, and the brightness of the flower remains exactly as it was.

Or change the brightness of the new layer instead, leaving the Background layer alone.

Most of the editing commands at your disposal, including levels, shadows and highlights, hue, saturation, and brightness, work on a layer-by-layer basis. That is, when your photo contains multiple layers, the currently selected layer is the

Move the flower pixels to a new layer. The photo looks exactly the same.

When you hide the layer, the flower disappears.

Decrease the brightness of the Background layer, and the brightness of the flower layer stays the same.

Decrease the brightness of the flower layer, and the brightness of the Background layer stays the same.

one that gets edited, while the unselected layers aren't changed at all. How do you know which is the currently selected layer? You set it yourself in the Layers palette. Click a layer to select it. You can select more than one at the same time by holding down Ctrl (Windows) or Command (Mac).

So to change the brightness of the background and not the flower, you select the Background layer in the Layers palette, and then you open the Brightness/Contrast dialog box, just like you did in Chapter 7. But to change the brightness of the flower and not the background, you select the flower layer instead. To change the brightness level of both layers, you select them both.

Bringing in Pixels from Other Photos

The pixels that you paste into the new layer don't have to be from the same photo. Remember the UFO hoax from Chapter 1? We created that from two separate photos: one of the landscape and one of the UFO. We borrowed the UFO pixels from the one and pasted them into a new layer of the other.

Here's how to combine photos in Photoshop Elements:

1. **Open the photos.**

2. **Make sure all the photos have the same resolution.** Different resolutions means different pixel sizes, so you aren't combining like with like. The pixels that you transfer from one photo to another end up being larger or smaller than you were expecting. But setting all the photos to the same resolution standardizes the size of the pixels and eliminates this problem entirely.

3. **Select the pixels that you want to transfer.**

4. **Choose Edit > Copy from the main menu.**

5. **Switch to the photo to which you want to move the pixels.** Click its thumbnail in the Photo Bin.

6. **Choose Edit > Paste from the main menu.** Photoshop Elements will create a new layer and paste the copied pixels into it.

Select the UFO pixels.

Paste the UFO pixels into a new layer of another photo entirely.

We'll position the UFO shortly, in the "Managing Multiple Layers" section, to be precise. While we're talking about combining photos, we should mention that the pixels you select don't even have to be from a photograph. You can bring in cartoons, clip art, illustrations, or anything else, as long as it's in a file format that your image editor can open.

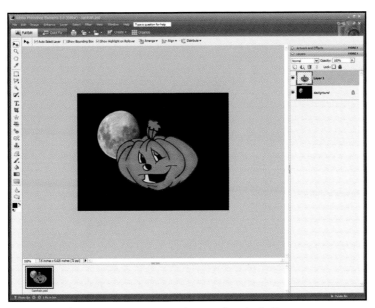

Paste a pumpkin cartoon into a moon photo, and you're halfway to a custom invitation to your annual Halloween bash.

Managing Multiple Layers

Back to the UFO hoax. Right now the photo has two layers, but you can easily add a third. Or a fourth. Or a fifth. You can create an entire fleet of UFOs, with each set of UFO pixels in its own layer.

To add a new, blank layer to the image, click the Create a New Layer icon in the Layers palette. (This is the very first icon on the left.) For five new layers, click five times.

Pasting the UFO pixels to the new layers is a breeze. You've already copied the pixels, so they're ready to go. Select each layer in turn by clicking on it in the Layers palette, and choose Edit > Paste from the main menu. When you're finished, you'll have five identical UFO layers.

Create a total of five identical UFO layers.

A quicker way to make an identical copy of a layer is to go to the Layers palette and drag the layer onto the Create a New Layer icon. You can also right-click the layer (Windows) or Command-click it (Mac) and choose Duplicate Layer from the context menu. Yet another way is to select the layer, click the More button at the top of the Layers palette, and choose Duplicate Layer from this menu.

At least that's what the Layers palette says. At this point, you can't tell how many UFO layers you have without looking at the palette. The Paste command plops each UFO into the center of the canvas. As a result, all the UFOs stack one atop another. They won't stay this way for long! The Move tool—the one at the very top of the Toolbox—enables you to reposition the contents of the currently selected layer. So grab the Move tool, select a UFO layer from the Layers palette, move the mouse pointer onto the photo, and drag the UFO into position.

The Move tool's Auto Select Layer option is really handy for multilayered photos. With this option turned on, you can click anywhere on the canvas, and Photoshop Elements will automatically select the appropriate layer. So click a UFO, and you select that UFO's layer.

From bottom to top, notice that each successive layer superimposes all the other layers beneath it. To change the position of a layer in the stacking order, drag the layer up or down in the Layers palette.

Use the Move tool to position each UFO layer individually.

Adjust the stacking order of a layer by dragging it up or down the Layers palette.

Dragging layers around the Layers palette to restack them works for all layers except the one called Background. By default, Photoshop Elements prevents you from restacking this one. But you can always convert the special Background layer into a regular old layer like all the others:

1. **Double-click the Background layer in the Layers palette.** Normally, double-clicking a layer calls up the Layer Properties dialog box, but double-clicking the Background layer calls up the New Layer dialog box.

2. **Type a name for the layer in the Name field.** Photoshop Elements calls it Layer 0 by default. If this is okay with you, then just leave it as it is. Otherwise, feel free to type Background or any other name.

3. **Click OK.** Photoshop Elements will convert the Background layer into an ordinary layer. Now you can restack it or change its opacity.

To delete a layer, select the layer and click the Delete icon at the top of the Layers palette.

You can convert the Background layer to an ordinary layer as you need.

Scaling and Rotating the Contents of a Layer

So far, you've used the Move tool to reposition the contents of a layer, but you can also use it to scale and rotate these contents. Just grab the Move tool from the Toolbox, go to the tool properties along the top of the screen, and make sure that the Show Bounding Box option is checked. When you select a layer from the Layers palette, Photoshop Elements draws a rectangle—a bounding box—around the contents of the layer. The bounding box has handles and a rotation knob just waiting for you to use.

Drag any of the square handles on the bounding box to resize the contents of the layer. To maintain the original aspect ratio, drag the corner handles. Hold down the Shift key while you drag to change the original aspect ratio.

The rotation knob is the round handle that comes off the bottom side of the bounding box. Drag this one to change the angle of the layer contents. Hold down Shift to restrict the rotation to common angles.

For even more control, try the Transform commands. Look for them in the main menu under Image > Transform. Using these, you can skew or distort the shape of the bounding box, making for some funky pixel transformations. You can also change the *reference point* or pivot, which is the focus point of the transformation.

With the Move tool, drag a corner handle of the bounding box to scale the layer contents and maintain the original aspect ratio.

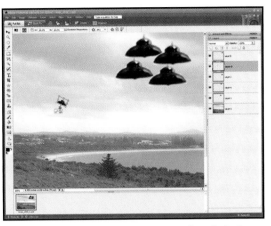

Drag the rotation knob with the Move tool to tilt the layer contents.

Normally, this is dead center in the bounding box. But when you choose one of the Transform commands, a reference-point diagram appears in the tool properties. Click any of the squares on this diagram to change the position of the reference point.

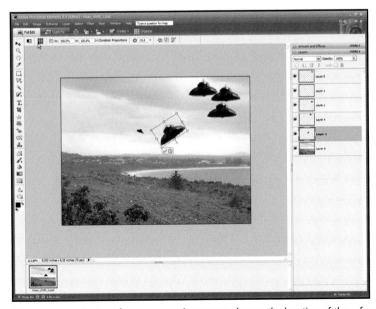

When you use the Transform commands, you can change the location of the reference point.

Whether you use the Move tool or the Transform commands, Photoshop Elements asks you to confirm the change. For full-speed ahead, click the check mark icon beneath the bounding box. To scrap the edit, click the cancel icon.

To protect a layer from accidental edits, you can lock it down by selecting it in the Layers palette and clicking the padlock icon. A fully locked layer is invulnerable to every tool in the Toolbox. You don't even get a bounding box around the layer's contents.

Photoshop Elements has a second kind of locking called *transparency locking*, which protects all the transparent pixels in the layer, but not the pixels that already have a color value. You can distinguish between the two kinds of locks by looking at the Layers palette. A fully locked layer has a black padlock icon next to its name, while a transparency-locked layer shows a silver padlock.

To apply transparency locking to a layer, select the layer in the Layers palette and click the checkerboard icon. (The checkerboard pattern represents transparency in Photoshop Elements and other image editors.)

To unlock a layer, select it and click either the padlock icon or the checkerboard icon.

Adjusting Opacity

The *opacity* of a layer determines the level of transparency (or see-throughness) of its pixels. By default, the pixels on a layer are 100 percent opaque. You can't see through them to the pixels on the layer below. But by selecting a layer in the Layers palette and dragging the Opacity slider to the left, the pixels from the lower layer begin to peek through. The lower the opacity goes, the more transparent the pixels become. At 0 percent, the pixels are perfectly transparent and therefore completely invisible.

You can set the opacity for any layer except the default Background layer. That one is locked in at 100 percent. Convert the background into a normal layer (see the "Managing Multiple Layers" section earlier in this chapter), and you can make it as transparent as you like.

You can't use the Move tool to reposition any layer whose opacity is less than 50 percent. Crank the opacity up to at least 50, and then break out the Move tool. When you're finished, don't forget to turn the opacity back down!

A layer's Opacity value determines the level of transparency of its pixels.

Saving a Layered Photo

When you save an image with layers in a standard format, such as JPEG, Photoshop Elements *flattens* the image—that is, it combines all the layers into a single Background layer once again. So in the example of the UFO hoax, five UFO layers and the landscape merge to form a single layer that includes all the visible pixels in the image. Covered-up pixels, such as the places where the UFOs overlap or block out part of the sky, get erased completely.

If you're saving a copy of your work to send to your friends, the flattening effect is fine. Your audience doesn't need to see how you composed the layers. (Plus, your UFO hoax wouldn't be much of a hoax if everyone could tell that you doctored the image!) At the same time, you might want to edit the layered version later, so it would be nice to keep a copy of the photo with all the individual layers separate, just as they are now.

To keep the layers separate, save the photo in your image editor's native file format. For Photoshop Elements, it's PSD. PSD files are no good to share with friends (unless your friends also have software that can read Photoshop files), and browsers don't know how to display them, so don't bother posting them on your website or blog. Instead, keep your PSD files around for your own reference. Maybe save them in the Work folder with all the other edited versions. Then, when you need to make a flattened JPEG to post to the Web or send to your friends, you can open up the PSD file—the one with the layers—and create from it a regular old flattened JPEG.

Here's how to save a layered file to PSD format in Photoshop Elements:

1. **Choose File > Save As from the main menu.** The Save As dialog box will appear.

2. **Pick a location and file name for the image file.** So far, this is just like saving the photo in a standard format.

3. **Make sure that Photoshop (*.PSD; *.PDD) appears in the Format drop-down menu.** Photoshop Elements is pretty good about pre-selecting this format for you whenever your photo contains more than one layer. But if for some reason the dialog box shows a different format, open the drop-down menu and choose this option.

4. **Click Save.** The Save As dialog box will close, and Photoshop Elements will save your photo as a PSD file with all the layers intact.

You can flatten a multilayered image at any time. Choose Layer > Flatten Image from the main menu. To combine two or more layers, choose Layer > Merge Layers. To combine all the visible layers (the ones showing the eye icon in the Layers palette) while leaving the hidden layers alone, choose Layer > Merge Visible. To combine the currently selected layer with the one immediately below it, choose Layer > Merge Down.

Touching Up the Photo

You can do a lot of decent editing by selecting pixels and moving them around, but sometimes there's just no substitute for good old-fashioned touching up. This section shows you how to paint, erase, and clone the pixels in your digital photo.

A recurring theme over the next couple of pages is setting the foreground and background color. Photoshop Elements and many other image editors keep these colors on hand for your touchups. Unless you're painting or erasing pixels, they hardly ever come into play, which is why we haven't really discussed them until this point. So, for the record, here's how to set the foreground and background colors in Photoshop Elements:

1. **Go to the color swatches immediately below the Toolbox.** These controls look like two boxes, one on top of the other. The top one contains the foreground color, while the bottom one contains the background color. By default, these colors are black and white.

2. **Click inside the color swatch of the color that you want to change.** So to change the foreground color, click inside the top box. To change the background color, click inside the bottom box. Either way, the Color Picker window will appear.

To swap the foreground and background colors, click the little curved arrow between the color swatches. To use white for the foreground and black for the background (which is the default color set), click the small swatches icon just beneath the actual color swatches.

3. **Choose a color.** Select the H option in the Color Picker. (*H* stands for *hue*.) Drag the slider to the right of the large color window to change the base color, and then click anywhere in the color window to set the exact shade. Alternatively, if a photo is currently open, you can move the mouse pointer onto it. The pointer will change into an eyedropper icon. Click anywhere in the photo to select the color underneath the eyedropper.

To save you the bother of mixing common colors, the Color Swatches palette provides several ready-to-sample colors. Choose Window > Color Swatches to open this palette.

Choose a foreground or background color with the Color Picker.

4. **Click OK.** The Color Picker will close, and Photoshop Elements will set the foreground or background color that you specified.

Remember in kindergarten when you mixed food coloring to make different colors? You can do the same thing to set the foreground or background colors in Photoshop Elements.

The Color Picker gives you two sets of values: H, S, B and R, G, B. The first set stands for *hue, saturation, and brightness*. Hue determines the base color, while saturation determines the amount of gray in the color, and brightness determines its lightness. Adjust these three values to get the color you want. Hue is in degrees, from 0 to 360. Saturation and brightness are both in percent, from 0 to 100.

The second set of values stands for *red, green, and blue*, the three component colors that mix to form every color onscreen. Mix the desired color by adjusting the amount of its red, green, and blue components. The values for each go from 0 (none of that component) all the way to 255 (the highest value for that component). So the brightest, most vivid, pure, full-on red is red 255, green 0, and blue 0. A more toned-down, darker brick red is red 100, green 0, blue 0. Mix in some blue (red 100, green 0, blue 100) to turn the color purple. Mix in more blue (red 100, green 0, blue 200) to make the color bluish purple, or mix in more red (red 200, green 0, blue 100) to make it a more reddish purple.

Painting

Want to paint your photos? Use the Brush tool.

As you know, every pixel in your photo has a certain color. The Brush tool changes the pixels' colors to match whatever the current foreground color is. So if the foreground color is red and you drag the Brush across the photo, you get what looks very much like a streak of red paint. It's not quite correct to say that the paint goes on top of the existing pixels, the way that real paint in the real world goes on top of a canvas. When you paint with the Brush, the pixels *themselves* change color. No matter what color they were originally, they become red pixels when you paint them as such. Their original color isn't underneath the red paint; it's as if they were always red.

We mention this for a very important reason: Be careful about which layer gets the paint! Painting the pixels of the Background layer changes their color for good, so if you ever want to go back and remove the paint, you have a much harder time doing it.

It's almost always smarter to paint into a new, blank layer. For one thing, as long as the new layer appears above the Background layer in the stacking order, the

finished result looks exactly the same as if you were to paint in the Background layer itself. More importantly, each layer is independent of the others, so painting into the new layer doesn't affect the pixels in the Background layer in the least. In other words, you don't lose any of the original visual information. Plus, the paint is easier to erase—more on that a bit later, in the "Erasing" section. When you're finished, just save an unflattened copy of the photo in your image editor's native format, and you're golden.

To paint pixels with the Brush in Photoshop Elements, follow these steps:

Take a photo from Dave's archives.

1. **Click the foreground color swatch below the Toolbox, and choose a color from the Color Picker window.** Remember, the foreground color is the color of the paint. If you're happy with the current color, skip ahead to Step 2.

2. **Click the Create a New Layer icon in the Layers palette.** Photoshop Elements will add a new layer to the photo. It's very smart to paint into a new layer instead of the default Background layer for all the reasons that we discussed previously, but if you'd rather paint into an existing layer, then select that layer instead.

Locking a layer prevents you from painting in it by accident—except when it's the default Background layer.

Look in the Layers palette, and you will see the padlock icon next to the Background layer's name. But notice that it's a silver padlock instead of a black one, which means that the layer is transparency-locked, but otherwise unlocked. Bottom line: You can still paint and erase the pixels in it.

If you convert the Background layer to a normal layer and then lock it fully with the black padlock, you can't paint or erase its pixels.

3. **Select the Brush tool from the Toolbox.** This one is toward the bottom of the Toolbox, between the Eraser and the Paint Bucket.

4. **Set the options for the brush.** You can change the size and shape of the Brush tip and the opacity level of the paint, among other properties.

5. **Move the mouse pointer onto the photo.** The pointer will become a representation of the Brush tip.

To sample a new foreground color, hold down Alt (Windows) or Option (Mac). This changes the Brush into the Eyedropper.

6. **Hold down the mouse button and drag the mouse to paint.** When you're finished laying down the stroke, release the mouse button. Then reposition the mouse pointer and drag the mouse to paint again. To paint with a different color, simply change the foreground color. To paint with a different Brush tip, change the tool properties.

A similar tool to the Brush is the Pencil, although this one is better for drawing finer, sharper lines. In Photoshop Elements, the Pencil is one of the hidden tools underneath the Brush.

Choose Edit > Undo from the main menu to erase the most recent Brush stroke.

Add a little paint for
a glow effect.

Erasing

The Eraser tool in Photoshop Elements is a lot like the Brush tool. You select it
from the Toolbox and set its size, shape, and opacity in the tool properties.
When you hold down the mouse button and drag the Eraser across your photo,
it changes the color of the pixels in the currently selected layer. But exactly how
the Eraser works depends upon the properties of the layer.

One of these window
panes wants to be
erased.

✦ **On the Background layer, the Eraser changes the pixels to the background color.** So if the current background color is white, scrubbing the Eraser across the photo turns the pixels on the Background layer white.

✦ **On a normal, unlocked layer, the Eraser makes the pixels transparent.** In essence, the pixels disappear instead of turning white or whatever the background color happens to be. This enables you to see through the spots that you have erased to the pixels on the layer immediately below.

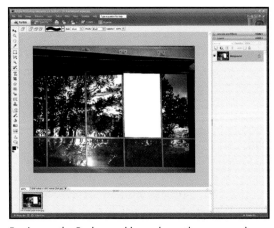

Erasing on the Background layer shows the canvas color.

Erasing on a normal layer makes the pixels transparent.

To make the Eraser erase with the background color instead of transparency on a normal layer, lock the layer's transparency. Go to the Layers palette and click the checkerboard icon next to the padlock icon.

Using the Eraser to create a window of transparency, so to speak, does have its creative advantages. Take any photo. Convert the Background layer into an ordinary layer and erase some pixels. Then copy pixels from another photo and paste them into a new layer. Rearrange the layers so that the new one is directly beneath the original, and you get a framing effect. Don't forget to save your creation as a PSD file!

Position another photo underneath the one with the erased window, and you get an instant frame.

Cloning (or How to Remove Old Boyfriends)

Your humble authors aren't ashamed to admit it: The Clone Stamp tool in Photoshop Elements is just plain fun to use. Surely you've heard of the process of cloning. It's when scientists make a genetic duplicate of a living thing, be it a microorganism, a cat, a sheep—maybe even someday a human being. Cloning in Photoshop Elements isn't anywhere near as controversial, but the idea is very much the same. The Clone Stamp looks at the pixels in one part of the photo and duplicates them exactly in another part of the photo. You can paint the cloned pixels on the same layer as the original pixels or on another layer entirely.

Here's how it works:

Before cloning, there is one helicopter.

1. **Go to the Layers palette and click the Create a New Layer icon.** Photoshop Elements will add a new layer to the image, which is where you'll paint the cloned pixels. If you'd rather paint them into the Background layer—which is entirely possible but not advised, because this changes the original pixels of the photo—skip ahead to Step 2.

2. **Select the Clone Stamp tool from the Toolbox.** The Clone Stamp is directly above the Eraser.

3. **Set the options for the Clone Stamp.** For instance, you can change the size and shape of the tip and its opacity level. The larger the size of the Clone Stamp, the more pixels that you clone at the same time.

4. **In the Layers palette, select the layer from which you want to clone.** Assuming that you want to clone from the Background layer, select this one. To clone from another layer, select that one instead.

5. **Move the mouse pointer into the photo, and hold down Alt (Windows) or Option (Mac).** The pointer will become a target.

6. **Position the target over the pixels that you want to clone, click the mouse button, and release Alt (Windows) or Option (Mac).** You've now set the target.

7. **Go back to the Layers palette and select the layer that you created in Step 1.** This ensures that the cloned pixels don't go into the original layer. But if you'd rather paint them into the original layer, you should skip this step.

8. **Hold down the mouse button and drag the mouse to paint the cloned pixels.** As you go, notice that the target will follow your mouse movements precisely. Drag to the left, and the target will move to the left. Drag to the right, and the target will go right.

To set a new target, switch to the source layer—Background or whichever layer you're using. Then hold down Alt (Windows) or Option (Mac) again, and click the mouse button to reset the target. Switch back to the layer into which you're painting, and clone away. To choose a different layer as the source, select that one instead of the Background layer. To clone the pixels of all the layers, not just the currently selected one, check the Sample All Layers option in the tool properties.

You can even clone pixels from an entirely different photo. Make sure both document windows are open, and set the target in the source photo. Then just move the mouse pointer onto the destination photo, and go to town.

After cloning, there are two.

The Clone Stamp comes in handy for touching up photos with complex, textured backgrounds, such as a shot of Uncle Frank standing in front of a lush forest. Taking the Eraser tool to Uncle Frank leaves you with a glaring hole in the backdrop. But painting over Uncle Frank with cloned pixels from another section of the photo helps to preserve the overall color and texture. You still have to watch out for tree trunks not lining up properly or branches coming out of nowhere, so the Clone Stamp isn't perfect, but it's often less obvious than an Uncle-Frank-shaped (or an old-boyfriend-shaped) hole.

DAVE SAYS
When you're using the Clone Stamp to touch up photos, you might want to pick a brush with soft edges. This helps to blend the edge of the new cloned area into the existing picture.

This bird is r *! !r *k nor is he your boyfriend.

Clone him out of the photo anyway.

Adding
Finishing
Touches and
Special Effects

You may not realize it because you haven't broken a sweat, but all the hard work with image editing is done, and you know what that means. Playtime is here. This chapter will give you a quick introduction to polishing and spicing up your photos.

Adjusting Sharpness

Sharpness is the level of definition in a digital photo. When the photo is sharp, the edges of its objects are crisp and clear, not fuzzy or blurry.

If digital photos have one weakness, it's that they tend to be less sharp than traditional photos, just because of the way that the camera sensor captures the image. In fact, digital data of all kinds have this very same problem. Ask your parents about all those record albums in the milk crates in the attic. Back when CDs first came out, critics argued that digital recordings didn't sound as good as analog

recordings, even though the digital ones weren't as prone to scratches, skips, pops, and dust. Proponents of the CD format responded with a steady stream of hard-of-hearing jokes, but in this case the critics actually had a point. An analog recording, such as a musty old LP, stores the actual sound waves that Pink Floyd or Bob Dylan blasted out of the amplifiers—the very ones! Talk about an intimate performance. But a digital recording such as a CD reduces the sound waves to a bunch of numbers—a representation or *sample* of the sound—which your CD player converts back into a sound wave, but not without little gaps or steps in the tonal range. It's a bit like listening to the band members through a wall instead of being in the same room with them. Of course, digital music isn't really as bad as that. The gaps in the tonal range are so small that the human ear has a very hard time picking them out, and the convenience of digital recordings more than makes up for whatever limitations they have, but nevertheless, the gaps are there.

Digital photos do the same thing with images. Instead of recording the light exactly as it goes in, which is what happens in a traditional camera, a digital camera records a digital representation of the light, which, no matter how accurate, is nevertheless a representation, so sharpness takes a hit. Remember also that pixels are square in shape, whereas the real world is full of curves, round edges, and diagonals. Try drawing a circle or even a diagonal line using nothing but squares, and you'll see what the camera is up against! The digital technology in your camera compensates, but the very process of smoothing out the edges tends to reduce sharpness even more. Then factor in the human element, such as holding the camera by hand at a low shutter speed, and you'll see what we mean when we say that almost all digital photos benefit from a little sharpening after the fact.

"The vast majority of digital cameras (particularly, many of the more popular consumer models) generally default to doing some image sharpening in-camera. Although this is handy if you don't have the time to edit the images one by one later, for best results it's better to sharpen each image individually. See your camera's manual for how to change the image-sharpening settings."

When you adjust the sharpness of a photo in your image editor, it's important to note that the software doesn't improve the actual level of sharpness. In other words, your software doesn't go back in and add the detail that your camera didn't capture in the first place. Instead, it improves the *appearance* of sharpness by putting an outline or halo around the edges, which helps the objects in the photo to jump out of the background. It's an optical illusion—but, hey, it works.

Normally, you sharpen an image after you've corrected the exposure and color. But if your photo has a lot of noise or grain, such as from shooting at high ISO, you might want to do a couple sharpening passes. Sharpen first, before you adjust anything else, to minimize the effect on the grain dots. Then work on the levels and contrast, and sharpen again as needed.

Tech editor Ron suggests cleaning up the noise in the image from the get-go, before you do any sharpening. To give this a try, go to the Artwork and Effects palette, click the Effects and Filters icon, and choose Filters from the first drop-down menu. Then look under the Noise category and drag the Reduce Noise, Despeckle, or Dust and Scratches icon from the palette onto your photo.

For more information on filters, see the "Applying Filters" section at the end of this chapter.

The amount of sharpening you need varies from photo to photo, but higher-resolution photos almost always require a more pronounced sharpening effect than lower-resolution ones. For this reason, it's a good idea to put the photo in the correct resolution before you try to sharpen it. Photos that you plan to print out should be at a high resolution—say, 300 dpi—while photos that you plan to display onscreen should be at a lower resolution of 72 dpi. Remember in Chapter 8 when you adjusted resolution and print size? Those techniques will serve you well in preparing a photo for sharpening. (If the print size is right and resolution is still too high, see Chapter 11, "Showing Your Photos Onscreen.")

Unfortunately, when it comes to sharpening, one size doesn't fit all. If you want to display a photo onscreen *and* print it out, you'll get the best results by creating two separate versions—a low-res version for screen and a high-res version for print. This approach enables you to apply just the right amount of sharpening to each.

Using the Adjust Sharpness Command

The Adjust Sharpness command in Photoshop Elements gives you the most control over the sharpening effect. It works best when the photo is softer overall, without areas that are sharper or blurrier than others.

To use the Adjust Sharpness command, follow these steps:

This photo could use a little sharpening. The edges of the leaves are a bit soft.

1. **In the Layers palette, select the layer you want to sharpen.** If you're working on a flattened photo, this isn't so much of a concern. The Background layer is the only choice. But if you're working on a layered photo, be sure to choose the right layer.

2. **Choose Enhance > Adjust Sharpness from the main menu.** The Adjust Sharpness dialog box will appear.

3. **Set the view.** Click the plus and minus buttons to set the level of zoom, and drag the image around the viewfinder window as needed.

4. **Drag the Amount slider to determine the strength of the effect.** By default, the value is 100 percent. Drag the slider to the right for a more pronounced effect, or drag the slider to the left for a subtler effect.

5. **Drag the Radius slider to determine the size of the outline or halo.** This value is 1.0 by default. For high-res images—the kind to print out—use a higher value. For low-res images—the kind to display onscreen—use a lower value.

6. **Choose the method of sharpening from the Remove drop-down menu.** There are three choices: Gaussian Blur, Lens Blur, and Motion Blur. Gaussian Blur works well when the image has an out-of-focus look in general. Lens Blur is often the best choice for images with a lot of fine detail, while Motion Blur helps to correct the jiggles or shakes that you might have introduced when you took the picture.

7. **If you chose Motion Blur in Step 6, type the angle of the blur in the Angle field.** You can also turn the dial to the right of this field. If you chose Gaussian Blur or Lens Blur, skip ahead to Step 8.

8. **Check the More Refined option for a slower but more precise sharpening effect.** In most cases, more refined sharpening takes a couple extra seconds. Unless you're in a real hurry and you have a ton of photos to process, go with this option.

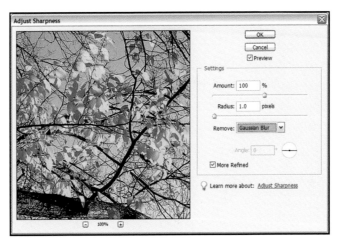

That ought to do it.

9. **Click OK.** The Adjust Sharpness dialog box will close, and Photoshop Elements will apply the sharpening effect.

Don't have Photoshop Elements 5? Can't find the equivalent of Adjust Sharpness? Try the Unsharp Mask command.

The name of this one might trip you up because when you're looking to sharpen a photo, you don't typically go for the unsharpening option. But think of it like this: An unsharp mask blocks or masks out everything in the photo that's unsharp, leaving you with sharpness.

Unsharp masking is a standard feature on many image editors, including Photoshop Elements 5, by the way. Its results are very similar to Adjust Sharpness when you specify the Gaussian Blur option.

If you do have Photoshop Elements 5, Adjust Sharpness gives you more options and typically better results than Unsharp Mask, but don't be shy about experimenting with the alternative.

Using the Sharpen Tool

To make a particular area of your photo a bit sharper—the face, the eyes, an important feature in the foreground—use the Sharpen tool. Think of this one as a kind of brush, much like the Sponge, Dodge, and Burn tools, only the Sharpen tool paints with sharpness instead of saturation or lightness. Here's how it works:

Take the Sharpen tool to this photo.

1. **Grab the Sharpen tool from the Toolbox.** It's one of the hidden tools under the Blur icon, toward the bottom of the Toolbox, right above the Sponge.

2. **Set the properties.** The bar at the top of the screen gives you the options, among them settings for the size and shape of the brush. Strength is like the Amount option in the Adjust Sharpness dialog box. Increase the strength for a more pronounced effect, or decrease the strength for a subtler effect. (Err on the side of caution on this one! It's better to apply sharpness little by little.) Finally, check Sample All Layers if you want to sharpen all the layers of your photo, or uncheck it to sharpen only the selected layer.

3. **Move the mouse pointer onto the photo.**

4. **Hold down the mouse button and drag the mouse to sharpen.** Brushing slowly and carefully is the way to go. The sharpening effect really adds up, so rapidly scrubbing the same area over and over will give you too much sharpness in a hurry.

Better!

 To soften an area of photo instead of sharpening it, use the Blur tool. It works just like the Sharpen tool, only it paints with softness, not sharpness. To soften the photo as a whole, go to the main menu and look under Filter > Blur.

Designing Captions and Word Balloons

Few things in life are more enjoyable than adding text to a photo, and when you work in an image editor, few things are easier to do. This section shows you how to put words in the mouths of people, pets, and inanimate objects.

Adding the Text

There are four different Type tools in Photoshop Elements, but for the purposes of this book, we will concentrate on the first one—the Horizontal Type tool. It's between the Selection Brush and the Crop tools in the Toolbox. Selecting the tool is a simple matter of clicking its icon, but there are two ways to use it; each method gives you a different kind of text.

✦ **Single-line text.** To add single-line text, position the mouse pointer where you want the text to begin, and click. The text will appear on a continuous horizontal line so that as you type, the length of the line will increase.

Single-line text is best for headlines, titles, and short bursts of wordage.

Despite the name, single-line text doesn't have to stay on the same line. To start a new line, press Enter (Windows) or Return (Mac). However, keep in mind that paragraph text is often the better choice for longer passages. Try to reserve single-line text for the short stuff.

✦ **Paragraph text.** Paragraph text appears inside a rectangular area. Position the mouse pointer as before, but hold down the mouse button and drag the mouse to set the width and height of the rectangle. As you type, Photoshop Elements automatically will jump to the next line when you come to the right margin.

Use paragraph text for longer passages.

Single-line text makes the most sense for short bursts of wordage, anything from a letter or two to an entire sentence. For anything longer, paragraph text is usually the better choice.

Notice the options in the bar along the top of the screen. From left to right:

Get into the options for the Horizontal Type tool to set the appearance and flow of the type.

✦ **Font Family drop-down menu.** This determines the typeface of the text.

✦ **Font Style drop-down menu.** If the font family comes with different styles such as bold or italic, you'll find them here.

✦ **Font Size drop-down menu.** The *pt* abbreviation here stands for *points,* a common measurement in typography. (Assuming that monitor resolution is 72 dpi, as it is by default on Macintosh computers, then one point is just about equal to one pixel.) Make the characters larger by increasing the font size, or make them smaller by decreasing it.

✦ **Antialiasing button.** *Antialiasing* is a graphics trick that makes type appear smoother than it actually is. Click this button to turn antialiasing off and on.

The top word is antialiased, but the bottom word isn't. Notice how much more jagged the bottom word is.

✦ **Faux Bold button.** Not all font families come with a built-in bold style. If your font doesn't, you can fake it easily enough by clicking this button. (*Faux* means fake in French. Maybe they should have called it *poseur bold* instead.)

✦ **Faux Italic button.** Likewise, if your font doesn't have an italic style, click this button to slant the letters.

When you have the choice, you're usually better off using the bold and italic styles that came with your font family, instead of the fake bold and italic styles that Photoshop Elements creates on the fly.

✦ **Underline button.** Click this button to underline the text.

✦ **Strikethrough button.** Click this button to draw a line through the middle of the text.

The top line uses the font's built-in bold and italic styles, while the bottom line uses faux bold and faux italic styles. Notice especially the difference in the shape of the italic *u*.

✦ **Alignment buttons (Left Align, Center, and Right Align).** Click these to align the text. For single-line text, these buttons change the place where the text begins. For paragraph text, Left Align and Right Align move the text to the left or right margin of the rectangle, respectively, while Center positions each line in the middle of the rectangle.

✦ **Leading drop-down menu.** *Leading* is the amount of space between lines of type. The default value is Auto, which means that Photoshop Elements calculates the correct amount of leading based on the font family, font style, and font size. Choose a different value to make the leading whatever you like. As a rule of thumb, setting the leading to double the font size gives you the equivalent of double-spaced lines. So if the font size is 12 points, make the leading 24 points for double-spaced type, 36 points for triple-spaced type, and so on.

Back in the day, typesetters inserted pieces of lead between lines of type to increase the amount of space between them, hence the term *leading.*

✦ **Text Color drop-down menu.** By default, the color of the text is the same as the current foreground color. Choose a different text color from this drop-down menu or click the More Colors button for the Color Picker.

✦ **Text Warp button.** Click this button to change the shape or flow of the text.

Warp the text for a variety of effects.

✦ **Text Orientation button.** Click this button to change normal, horizontal text (in which the lines read from left to right) into vertical text (in which the lines read from top to bottom and right to left). Click again to revert to horizontal text.

Horizontal text flows left to right and top to bottom, while vertical text flows top to bottom and right to left.

Feel free to adjust these options as you go. Different pieces of text can have different formatting, although antialiasing, warping, and orientation always apply to the entire line or paragraph, not just the current character.

Photoshop Elements puts the text you type into a separate layer, as you see when you look at the Layers palette. A *type layer,* as this sort of layer is called, is much like the layers that you worked with in Chapter 9. You can drag it up and down in the Layers palette to reposition it in the stacking order, you can adjust its opacity, and so on. At the same time, you can't use tools such as the Eraser, the Brush, or the Sponge on a type layer without *simplifying* it first, or converting it into an ordinary layer. A simplified type layer looks and reads exactly the same, but you can't edit its text anymore, so double-check your wording and spelling before you simplify! (You can, however, touch up the pixels that make up the letters and words with all the editing tools at your disposal.) To simplify a type layer, select it in the Layers palette and choose Layer > Simplify Layer from the main menu or click the More button in the Layers palette and choose Simplify Layer.

You can't edit the text on a simplified type layer, but you can touch up its pixels with the editing tools. Notice the hollowed-out *o* in *flower,* courtesy of the Eraser.

Speaking of editing text, the way that you go about doing so is a little different depending on whether the text is of the single-line or paragraph persuasion:

✦ **Editing the wording, format, or spelling (single-line or paragraph text).** With the Horizontal Type tool, click inside the text, or drag the mouse to highlight a string of letters.

✦ **Changing the dimensions of the text area (paragraph text only).** With the Horizontal Type tool, click inside the text, and the borders of the text area will appear. Drag any of the square handles to resize the rectangle and cause the current text to reflow.

To reposition, scale, stretch, squeeze, or rotate the text, use the Move tool.

Adding a Word Balloon

Freestanding text can get lost amidst the visuals, as comic book creators have known for a century. To call attention to the text, to make it more legible, and to show exactly who in the photo is speaking, use a word balloon. Here's how:

1. **Grab the Custom Shape tool from the Toolbox.** This one is hidden under the Rectangle tool. Its icon is a word balloon.

2. **In the tool properties, choose the word balloon from the Shape drop-down menu.** While you're at it, have a look at all the other custom shapes that Photoshop Elements gives you.

You don't have to use a word-balloon shape. Use a circle, a heart, a star—anything! There's a good thought balloon toward the bottom of the Shape menu as well. And you don't have to limit yourself to the custom shapes. The other shape tools, including the Rectangle, the Rounded Rectangle, the Ellipse, and the Polygon, are all fair game. Just substitute the shape tool that best suits your needs.

3. **Choose a color for the shape from the Color drop-down menu.** By default, the color of the word balloon is the same as the current foreground color.

4. **Move the mouse pointer onto the photo.**

5. **Hold down the mouse button and drag the mouse to draw the shape.** Photoshop Elements will add the shape to a new layer— a shape layer, to be precise.

To use editing tools such as the Eraser or the Brush on the shape layer, you first have to simplify it, just like you did with type layers. Once you do this, you can't change the dimensions of the shape without creating distortion, so don't simplify the shape layer unless you really need to, and only when you're sure that the shape is the right size.

6. **To turn the word balloon the other way, choose Image > Rotate > Flip Layer Horizontal.** Skip this step if you're happy with the shape as it is.

"DAVE SAYS" If the default shape isn't quite what you're looking for, you can freely transform it. Grab the Move tool, and go to town. While you're at it, try holding down Ctrl (Windows) or Command (Mac) to distort the shape as you drag the handles.

7. **Grab the Horizontal Type tool and add the text.** If you already added the text, drag the type layer so it's directly above the shape layer. This way, the text sits on top of the shape.

8. **Grab the Move tool and fine-tune the position of the shape.** If you're happy with the current positioning, just skip this step.

9. **Hold down Ctrl (Windows) or Command (Mac) and select both the shape layer and the type layer.**

10. **Click the Link Layers icon in the Layers palette.** This joins the layers together while keeping their contents separate.

Add a shape layer, add a type layer, link the type with the shape, and you have a word balloon.

MUSE FLASH Comic books tell stories with a sequence of images, but these don't have to be illustrations. You can just as easily create a comic book from a sequence of photos instead.

All good stories have three things in common: a beginning, a middle, and an end. Aside from that, anything goes. So grab the shot of your friend walking innocently through the door, the shot of the lights coming on and everyone yelling, "Happy birthday," and the shot of your friend opening presents. (That's a beginning, a middle, and an end, if you're keeping score.)

Now just write some word balloons. Arrange the pics in sequence on a blank page in your word processor or desktop publishing program, and you have a comic book.

Now that the two layers are linked, Photoshop Elements will treat the shape and the text as a single object. You can reposition it, resize it, or rotate it as a group using the Move tool or the Transform commands.

To unlink the layers, select either one in the Layers palette and click the Link Layers icon again.

Applying Layer Styles

Layer styles in Photoshop Elements are special effects such as shadows and glows that you add to the contents of a layer. They give you all kinds of ways to spice up your digital photos. Spicing up is a good metaphor, too. If you're a fan of chili, you know that a little hot pepper or Tabasco sauce goes a long way. So, too, is this the case with layer styles. Although you can pile style after style onto a single layer, you tend to get better results when you limit yourself to one or two. It's like shouting all the time. If you're always talking at full volume, after a while people stop listening.

To apply a layer style in Photoshop Elements, follow these steps:

1. **In the Layers palette, select a layer.** This is the layer that gets the style.

2. **In the Artwork and Effects palette, click the Apply Effects, Filters and Layer Styles icon.** This is the middle icon at the top of the palette. If you don't see the Artwork and Effects palette onscreen, choose Window > Artwork and Effects.

3. **Choose Layer Styles from the drop-down menu on the left.**

4. **Choose the style category from the drop-down menu on the right.** For the sake of argument, assume that you want to add a drop shadow to the word balloon, so you selected the shape layer in Step 1. Now choose Drop Shadows from the menu. The Artwork and Effects palette will fill with all the available drop-shadow styles. To pick from a different set of styles, choose a different category from the drop-down menu.

You might have trouble applying a layer style to a linked layer. If so, just unlink the layers before you apply the style. To do this, select the layer in the Layers palette and click the Link Layers icon.

5. **In the Artwork and Effects palette, click the style you want to apply.**

6. **Click the Apply button at the bottom of the palette.** Photoshop Elements will apply the style to the contents of the layer. In the Layers palette, notice that the layer you chose in Step 1 now shows a blue starburst icon, meaning that this layer has a layer style.

These shape layers have drop shadows, which helps them to stand out.

To change the attributes of the layer style, such as the direction in which the drop shadow falls, go to the main menu and choose Layer > Layer Style > Style Settings. This will call up the Style Settings dialog box. Make your adjustments using the controls in this dialog box, and then click OK.

Edit the properties of a layer's styles from the Style Settings dialog box.

To turn off a layer style temporarily, choose Layer > Layer Style > Hide All Effects, and then choose Layer > Layer Style > Show All Effects to turn it on again. To remove a layer style permanently, choose Layer > Layer Style > Clear Layer Style.

Copying a custom layer style and applying it to other layers is a simple matter of selecting the layer with the style and choosing Layer > Layer Style > Copy Layer Style. Then select each target layer in turn, and hit them with Layer > Layer Style > Paste Layer Style.

Be sure to save a copy of your photo in the native format of your image editor to preserve the layers and all the styles.

Applying Filters

Want to transform your photos into watercolors? Frescoes? Chalk and charcoal sketches? The graphical filters that come with Photoshop Elements are good for hours upon hours of creative experimentation.

Filters are a lot like layer styles in that you apply them to individual layers in your photo from the Artwork and Effects palette. However, there is one important difference: Once you filter the pixels on a layer, you filter them for good. The only way to edit the effects of the filter is to choose Edit > Undo and try again. Once you save the photo and close its window, not even Edit > Undo can help, so for maximum flexibility, always copy the layer you want to filter, and filter the copy, not the original. (Remember how to copy a layer? Just drag it from the Layers palette up to the Create a New Layer icon.) You can hide the original layer by clicking the eye icon in the Layers palette, or you can put the filtered version on top of the original layer in the stacking order, so that the filtered version completely superimposes the original. Either way, you have the unfiltered version at your fingertips if you happen to need it later.

To apply a filter in Photoshop Elements, follow these steps:

1. **In the Layers palette, select the layer or layers you want to filter.** It's better to filter a copy of the layer, not the original.

2. **In the Artwork and Effects palette, click the Apply Effects, Filters and Layer Styles icon.** Once again, if you don't see the Artwork and Effects palette onscreen, choose Window > Artwork and Effects.

How about a watercolor filter for this shot?

3. **Choose Filters from the drop-down menu on the left.**

4. **Choose the filter category from the drop-down menu on the right.** There are a lot of choices here, but the Artistic and Sketch categories are good places to start. For instance, to turn your photo into a watercolor painting, choose the Artistic category.

5. **Select a filter from the Artwork and Effects palette.**

6. **Click the Apply button.** A preview window will appear. Depending on the filter you chose and the resolution of the photo, it might take a few seconds for Photoshop Elements to generate the preview.

7. **Adjust the attributes of the filter.** Drag the sliders in the preview window or enter new values into the fields.

8. **Click OK.** Photoshop Elements will apply the filter to the selected layer. Remember, this is permanent! If you don't like what you see, choose Edit > Undo before you close the photo's window.

Adjust the attributes of the filter, and keep your eye on the preview window.

Photoshop Elements isn't quite up to French Post-Impressionist standards, but that's still a cool effect.

11

Showing Your Photos Onscreen

Enough editing! It's time to present your photos to the world. In this chapter, you will take your digital pics and format them for easy viewing in e-mail, on the web, and in your own movies.

Getting Your Photos Ready

Digital photos do better onscreen when you tailor them especially for the conventions and quirks of electronic display. Doing this isn't difficult, but it is important. As you'll see in Chapter 12, prints have a different set of requirements, so if you plan to show your photos in print as well as onscreen, you'll want to create two sets of files.

So what makes a good onscreen photo? It's pretty straightforward, as this section shows.

Downsampling to Screen Resolution

Many times over the course of this book, your authors have hinted, alluded to, and come right out and said that onscreen photos look good at low resolutions because computer monitors themselves are low-res devices. By default, Macintosh monitors display at 72 dpi, while Windows monitors display at 96 dpi. The actual resolution of your monitor depends upon a whole host of factors that we're not going to get into here, so it's better to think of those 72 and 96 numbers as being somewhere in the ballpark. But even if all the variables tip in your favor, your monitor doesn't get much better than 120 dpi, which isn't even half of the 300 dpi that you need for decent color prints.

So what happens when you view a high-resolution photo on a low-res monitor screen? See for yourself. Fire up your image editor, open a high-res photo, and set the zoom level to 100 percent (or click the Actual Pixels button in Photoshop Elements). You'll find that the image looks much larger than it ought to, way beyond the print size that your image editor reports. What's happening here is that the pixels in the photo *can't* get any smaller, so the print size does the only thing it can do—it gets larger.

The print size is 6×4.5 inches, but the resolution is 300 dpi, so the photo looks much larger than 6×4.5 at 100-percent zoom.

Happily, if you send this photo to your printer, you'll find that your computer was just playing tricks with you, and the print size is exactly what it should be. But what if you don't want to print the image out? What if you want to show it onscreen? It's no good displaying the photo at high resolution because the dimensions become too big and clumsy. The answer is simplicity itself: Reduce the resolution.

"Hold on a minute," you might be tempted to say. "When you guys had me reducing resolution back in Chapter 8, the print size kept changing. Resolution went down, and print size went up. I don't see how that's helping me here. I want to lower the resolution without affecting the print size. Is that too much to ask?"

That's absolutely not too much to ask. The trick is to downsample the photo, just like you did when you scaled it down to a smaller print size. In this case, the dimensions of the photo don't change, but you do nevertheless toss out unwanted pixels. Suppose your photo is 6×8 inches at 324 dpi, and you want it to be 6×8 inches at 72 dpi. The print size will stay constant, but the resolution will go down—and look what will happen to the pixels as a result. In the high-res version, you have 1,944 pixels (6 inches × 324 dpi) by 2,592 pixels (8 × 324), but in the low-res version, you have 432 pixels (6 inches × 72 dpi) by 576 pixels (8 × 72). You have far fewer pixels at 72 dpi, even though the print size doesn't budge.

So downsampling to screen resolution while maintaining print size is the way to beat the high-res bloat. Here's how to do it in Photoshop Elements:

1. **Choose Image > Resize > Image Size from the main menu.**
 The Image Size dialog box will appear.

2. **Check the Resample Image option at the bottom of the dialog box.**

3. **Choose a resampling method from the drop-down menu.**
 You're downsampling, so go with Bilinear or Bicubic Sharper.

It doesn't matter whether you check or uncheck the Constrain Proportions option because you're not changing the print size of the photo.

4. **Type 72 in the Resolution field and choose Pixels/Inch from the drop-down menu.** Even though Windows computers display at a higher resolution of 96 dpi, the Macintosh default of 72 dpi has emerged as the standard for onscreen images. For slightly better-quality pics, feel free to type 96 instead.

Downsample to 72 dpi without affecting print size.

5. **Click OK.** The Image Size dialog box will close, and Photoshop Elements will adjust the resolution of the photo without changing the print size.

If the layers of your photo have layer styles, be sure to check the Scale Styles option in the Image Size dialog box. Otherwise, your photo will scale, but the styles will stay the same.

There's an extra added benefit to downsampling like this. A lower-res photo contains fewer pixels and therefore takes up less memory, so the file size becomes dramatically smaller. A smaller file size means less waiting around when you e-mail the photo or post it to your blog.

Resizing the Width

So far, whenever we've mentioned print size, it has always been in the context of printing something out. In Chapter 8, you cropped and scaled your photos to dimensions such as 4×6 inches, 6×8 inches, and 6×9 inches, all of which make good, convenient physical prints. But in this chapter you're making virtual prints, and although 4×6 is on the small side in the real world, it's on the large side in the virtual world—a world in which smaller is often better.

Even talking about inches or centimeters for onscreen photos isn't as helpful as good old pixels. The settings of your monitor are in pixels—800×600, 1,024×768, 1,280×1,024, and so on—so you might as well compare like with like. For purposes of onscreen sizing, that 4×6 photo at 72 dpi translates to 288×432 pixels, which demonstrates, by the way, why smaller is better. Assuming that your display is 1,024×768, a 288×432 photo takes up more than a quarter of the available width onscreen and more than half of the available height!

This brings us to an important point. Photos that you display onscreen usually appear inside an application window, such as an e-mail document or a Web browser. If the height of the photo is larger than the height of the window in which it appears, you get vertical scrollbars, which can be a bit of a pain, but they're no big deal. People are used to scrolling down. But if the width of the photo is larger than the width of its window, you get horizontal scrollbars, which are *always* a pain. Nobody likes to scroll sideways—it's too much like old-school video games.

So after you've jettisoned unneeded resolution, the next step is to scale the photo by width:

✦ **For photos that you share by e-mail, scale down to a maximum of 400 pixels wide.** Larger widths are more likely to cause horizontal scrollbars.

✦ **For photos that you post to the Web or your blog, scale down to a maximum of 300 pixels wide.** This number is smaller than the one for photos to e-mail because there are usually more elements on a Web page to take into account. You might have text, animations, navigation buttons, or other images, all competing for the same precious screen width. And don't be shy about going lower than 300. A width of 200 pixels is plenty big for the web. Depending on the photo, 100 or even 50 pixels might be just right.

When you're thinking about how big you want your image to be for the web, think about how you plan to use it. If the image is going on a page that highlights your best photos, then a larger image size is in order, so people can appreciate the detail of your work. On the other hand, if the pic is adding a little atmosphere to your blog about your trip to the coast, a smaller size will do the job just fine.

In Photoshop Elements, use the Image Size dialog box to scale down the dimensions, just as you did in Chapter 8. Check the Constrain Proportions option to maintain aspect ratio, and check the Resample Image option, too. You're downsampling, so choose Bilinear or Bicubic Sharper as the resampling method. And don't forget about sharpening afterward! As we said in Chapter 10, whenever you scale, it's a good idea to sharpen.

Scale the width to 400 pixels for an e-mail-sized photo.

You can combine width scaling with resolution dumping in the same procedure. In fact, it's smart to do this because every time you resample, you lose a little image quality.

Between Steps 4 and 5 in the "Downsampling to Screen Resolution" section, insert Step 4 1/2: Check the Constrain Proportions option in the Image Size dialog box, and then set the width to 400 pixels for photos to e-mail, or set the width to 300 pixels (or smaller) for photos to post on the Web.

It's important to dump the excess resolution before you scale the width. If you scale the width first, say from 1,944 to 400 pixels, reducing the resolution from 324 dpi to 72 dpi makes the width even smaller—89 pixels, to be precise.

Crushing the Image File

The last step in preparing your photo for the screen is saving it as a JPEG. Of all the file formats out there, JPEG is the best bet for onscreen photos. No matter what software you use to view the photo, whether it's a web browser, an e-mail application, a word processor, a multimedia studio, or a movie creator, the software will read JPEGs just fine. We can't say the same for other formats, such as TIFF, so stick with JPEG for all your onscreen needs.

You know from Chapter 2 that JPEG compression reduces the amount of memory that the photo takes up, which is to say that it makes the file size smaller. A smaller image file is easier to send by e-mail or post to the web because it takes less time for you to upload, and it takes less time for your recipients to download.

When you save in JPEG format, you're free to adjust the level of compression, a process called *crushing* by computer graphics people. You also hear the term *optimizing* to describe the same thing. No matter what you call it, it's all about getting the smallest possible file size while maintaining overall image quality. Done properly, crushing is a balancing act. When compression goes up, image quality goes down. The trick is to find the comfortable middle. It's no good crushing the daylights out of a photo, because although you get a very small file size, the image quality is often so poor that no one would care to look at it. On the other hand, not crushing the photo enough is a waste of memory and bandwidth because the image quality isn't that much better in the end.

The Save for Web command in Photoshop Elements is ideal for striking the perfect balance. It gives you a high degree of control over the compression level, and it shows you the crushed version side by side with the original for quick and accurate comparisons. Despite the name of the option, you don't have to post the crushed JPEG to the web if you don't want to. Photoshop Elements doesn't upload it to a web site or anything like that. You can just as easily send the photo out by e-mail or use it for any other purpose.

Crushing is great for onscreen photos, but you should avoid using it for photos that you plan to print out. The little defects and imperfections that come with compression are more obvious in print than they are onscreen. Besides, the main reason you crush photos is to make them easier to transfer over the Internet. Since you're sending your prints to your printer, not to your friend's e-mail address, you don't need to worry so much about large file sizes.

To crush the image file in Photoshop Elements, follow these steps:

1. **Choose File > Save for Web from the main menu.** The Save for Web dialog box will appear.

2. **Choose JPEG from the Optimized File Format drop-down menu.** This menu doesn't have a label, but it's right below the Preset menu.

3. **From the Compression Quality drop-down menu, choose a general setting.** Again, this menu doesn't have a label, but it's directly under the menu from Step 2. There are five choices: Low, Medium, High, Very High, and Maximum. Your goal is to pick the setting that best meets your needs, balancing file size with image quality. As you test each setting, keep your eye on the image preview on the right, and compare the crushed version with the original on the left. At the Low setting, compression is

high, which crushes the file size tremendously, but in all likelihood, the image quality will degrade too much. At the Maximum setting, compression is low, so you don't crush the file size nearly as much as you might like, but in terms of quality, the image looks virtually identical to the original.

In the balancing act between compression and image quality, the High setting tends to be your best bet. You get a fair amount of crushing, so file size is on the low side, and image quality is high, so the photo looks good. That said, every photo is different, so don't hesitate to experiment. Some photos look good at the highest levels of compression, while others lose a significant amount of image quality after just a little compression.

4. **If necessary, fine-tune the quality setting by dragging the Quality slider.** Increasing the quality reduces compression, so file size goes up. Decreasing the quality increases compression, so file size goes down.

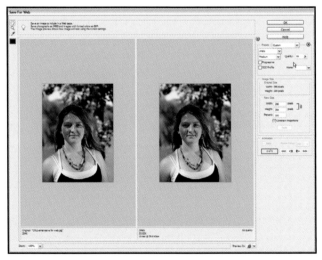

The original file size is 324K, but these settings crush the photo to a hair over 25K without sacrificing much in the way of quality.

5. **Click OK.** The Save Optimized dialog box will appear.

6. **Choose the location and file name for the crushed version of the photo.** Saving the file to your Work folder makes good sense.

7. **Click Save.** Both dialog boxes will close, and Photoshop Elements will save the crushed version as a JPEG.

When you use the Save for Web command, you can't choose to save the crushed photo in a version set with the original. If you like the convenience of version sets, try this workaround.

Instead of File > Save for Web, go with File > Save As. Choose the save location and file name, and pick JPEG from the Format menu. Also check the Include in the Organizer and Save in Version Set with Original options. Click Save.

When the JPEG Options dialog box appears, check the Preview option and drag the Quality slider to set the level of compression. This control isn't as precise as the one in the Save for Web dialog box. Worse yet, the quality values don't match up. In Save As, JPEG quality is on a scale of 0 to 12, while in Save for Web, it's on a scale of 0 to 100. Also, you don't get to compare the crushed version side by side with the original, but if you want to include the crushed file in a version set, it's a small price to pay.

Keep your eye on the photo as you drag the slider. When you get the right level of compression for your needs, click OK to save.

Displaying Your Work

Now that you've resampled, resized, sharpened, and crushed your photo, you're ready to show it to the world. From Photoshop Elements, you can send your photo as an e-mail, post it to the web, or include it in a slideshow or flipbook. This section will show you how.

Put your favorite photo on your computer desktop by selecting the photo in the Organizer and choosing Edit > Set as Desktop Wallpaper.

Before you begin, you may want to switch from the Editor workspace to the Organizer. Although the Editor gives you pretty much the same options, it's easier to pick and choose your photos in the Organizer. Besides, when you start a project in the Editor, it shuttles you over to the Organizer anyway, so you might as well start out there.

E-Mailing Your Photos

The easiest way to send your photos by e-mail is to open up a blank message window and attach the image files, although many image editors, including Photoshop Elements, enable you to send custom photo e-mails to people, complete with your choice of stationery and your own text captions. To do this, go to the Organizer workspace, select the thumbnails of the photos you want to send, and choose File > E-mail from the main menu. Alternatively, click the icon with the envelope along the top of the screen, and then choose E-Mail. Either way, you get the Attach to E-Mail dialog box, which works like a wizard. Just follow the step-by-step instructions to build your custom e-mail.

Send photo e-mails to friends and family from within Photoshop Elements.

Posting Your Photos Online

If you already have your own website or blog, you don't need us to tell you how to post digital photos. We couldn't give you exact instructions anyway, because every web host is a little different.

If you don't have a website and you don't plan to get one, there are plenty of sites where you can post and share your work for free. One of the first (if not the very first), and certainly one of the best, is Fotolog (www.fotolog.com), which boasts a community of more than five million photographers from all around the world. Another very worthy photo-sharing site is Flickr (www.flickr.com), which isn't as large as Fotolog, but its tools are more polished. Both sites offer free accounts, so there's no need for you to pick a favorite. Sign up for both if you like, and that's just for starters. Do a quick search for photo sharing and you'll find dozens of possibilities, everything from virtual parlor rooms for special-interest photographers to mega stadium–like global gathering places.

Photoshop Elements links directly with Kodak EasyShare Gallery (www.kodak-gallery.com), as well as Adobe Photoshop Showcase (www.photoshopshowcase.com) for your photo-sharing pleasure. To connect to either one, click the e-mail icon in the Organizer workspace, and then choose the Kodak or Adobe site from the menu. Like Fotolog and Flickr, both are free to join.

Share your photos for free on sites such as Adobe Photoshop Showcase.

Kodak EasyShare Gallery enables you to buy prints of your work. If you think you might take them up on the offer, be sure to send them uncrushed, print-ready versions of your photos, not crushed, screen-ready ones.

If you don't have a website of your own but you always wanted one, Photoshop Elements provides. You can create a custom mini-site or *photo gallery* for your digital pics and upload it to your personal web space or the Adobe Photoshop Showcase site, all within the software—a fantastic feature. You can even burn the site to a CD for your very own CD-ROM. To create a photo gallery, go into the Organizer and select the photos you want to include. Then click the Create button and choose Photo Galleries, or just choose File > Create > Photo Galleries from the main menu. The Photo Galleries Wizard will take you through the process step by step.

Set the options for your photo gallery in the step-by-step wizard.

When you're finished, you get a completely interactive mini-site featuring your photos.

Making Movies from Your Photos

Photoshop Elements enables you to create two kinds of movies from your photos: slideshows and flipbooks.

In a slideshow, you take a sequence of photos and present them onscreen one at a time. Your slideshow can be a low-budget creation with photos only, or it can be a big production number with background music, text captions, clip art, and your own voiceover narration. Save your slideshow as a movie file to view on your computer or e-mail to friends, or burn it to CD for playback in most DVD players. To create a slideshow, go to the Organizer and select the photos you want to include. Then click the Create button, and choose Slide Show from the menu. Photoshop Elements gives you a chance to set your preferences, and then the Slide Show Editor appears.

Build a slideshow in Photoshop Elements.

You can also burn a number of slideshows to the same CD by clicking the Create button and choosing VCD with Menu.

In a flipbook, you take a sequence of still photos and play them back very quickly, creating an animation. As with slideshows, you can save the flipbook as a movie file or burn it to CD. To make a flipbook, select the photos you want to include from the Organizer, click the Create button, and choose Flipbook.

Build the flipbook in Photoshop Elements.

Any chronological sequence of stills is a candidate for flipbook treatment.

Don't have a sequence of photos for a flipbook? Create one! Open any photo in the Editor, select an object in the photo, and move it to a new layer. (Don't forget to fill the hole in the background.) Now you have the main character for your movie. Reposition the object ever so slightly using the Move tool (or rotate it, or scale it), and save a copy of the photo as a flattened JPEG. Now repeat the process again and again, moving or transforming the object a little bit each time. When you're finished, you'll have a set of photos ready for the flipbook treatment.

You can use the same trick to create special effects. For instance, to fade gradually to black or white, take a photo, decrease or increase the brightness by a couple steps, and save it as a separate file. Keep going until you reach solid black or white. Then just string all the photos together in order of decreasing or increasing brightness.

Making Prints

Back in the old days, you dropped off your film, waited, picked up your prints, looked at them, put them in a shoe box, and forgot about them. These days, prints are just the starting point for all kinds of creative projects.

In this chapter, you will prepare your digital photos for print, and then you will use them to make photo books, greeting cards, CD jackets, and everything else. If you can print it, you can build it and design it on your computer.

Determining the Optimum Resolution

Chapter 11 had you downsample your photo to screen resolution, which is 72 dpi by convention, if not in actual point of fact. We've said many times that photos for print require higher-res image files, and we've given 300 dpi as the all-purpose standard.

Here's where your authors hedge a little. Although 300 dpi is a good benchmark for photo-quality prints in general, it isn't necessarily the best resolution for your specific printer. Inkjet printers, for instance, often do better with image files in the neighborhood of 200 dpi, and if your printer is older—particularly if it was one of the less expensive models at the time—the best resolution might be as low as 150 dpi.

So what happens if you send a 300-dpi photo to a printer that does better with 150-dpi image files? The bottom line: Nothing bad. The printer driver processes the image file and gives it to the printer in an acceptable format, and you get a print that looks pretty good. At the same time, the print isn't as good as it could be.

The printer driver doesn't have the benefit of eyes or a brain, so when it processes the image, it can't see the effect that this has on quality. As a result, the print might be a little blurry or blocky.

Unlike the printer, you do have eyes and a brain. More than that, you're the photographer, and you know what you want your prints to look like. If your printer prefers image files at 150 dpi, you can resample your photos to this resolution exactly. You're free to choose the method that gives you the best results, and if you need to sharpen the photo or touch it up afterward, you're free to do that, too. It's not uncommon for your handmade 150-dpi version to look better than the printer's interpretation of 300 dpi, in spite of the fact that the 300-dpi version has four times as many pixels.

Unfortunately, figuring out the optimum resolution for prints can be tricky business. Printers vary by model, whether or not they're from different manufacturers, and inkjet printers, laser printers, thermal printers, or what have you, all tend to get fussy in their own little ways. Apart from good old trial and error, which is often the best way to get the most from your printer, this section gives you a place to start.

Printing at Home

The whole issue of resolution is enough to give anyone a headache, and printer manufacturers don't help matters when they brag about specs. Consult your printer manual, and you may find that your printer prints at a much higher resolution than this book has led you to expect. Your printer resolution could very easily weigh in at 600 dpi, 1,200 dpi, 1,440 dpi, 2,880 dpi, and upward. Based on this information, you might assume that the optimum resolution for your image files should be 600 dpi, 1,200 dpi, and so on, which is much more than the 300 dpi we've been throwing around. What gives?

The difference lies in the ways that a monitor and a printer reproduce color images. Onscreen (especially in the case of an LCD monitor) each pixel is a single dot, but in print, each pixel is a combination of several dots of different colors. For instance, a red pixel on your LCD screen is just a single red dot, but to get the same shade of red in print, the printer creates at least two dots: one colored cyan and one colored magenta. So although your printer may indeed print out at 1,200 dpi, it has to put more dots on the page, which drastically brings down the optimum resolution of your image files.

So if your printer resolution is out, what's in?

- ✦ **Look for the manufacturer's recommended image resolution.** Some printer manufacturers come right out and tell you the optimum image resolution for the printer, so check your manual or the manufacturer's website, and use that measure as the target resolution for your photos. Just don't confuse the printer resolution for the optimum image resolution, because as you've seen, they're two different things.

- ✦ **Look for your printer's lines per inch (lpi).** While you're checking in your printer manual and the manufacturer's website, see whether you can find the spec for lines per inch (lpi). Multiply the lines per inch by 1.5, and that's the optimum resolution on the low end. Multiply by 2, and that's the optimum resolution on the high end. So if your printer prints at 133 lines per inch, the optimum resolution for your images is anywhere from 200 dpi (133 × 1.5, rounded up) to 266 dpi (133 × 2). Try printing out versions of the photo at 200 dpi and 266 dpi and maybe something in the middle to see which resolution gives you the best results.

- ✦ **When in doubt, go with 300 dpi.** That's the magic number. It's one to live by, but it's not one to die by! So print out a couple sample photos at 300 dpi, and compare them with versions at 200 dpi and 150 dpi. If you find that a lower resolution looks better on your particular printer, by all means, go lower.

Printing Elsewhere

So what happens when you use a service provider to make prints of your photos? What's the optimum resolution for your image files then? You can't just jump behind the counter and run a couple tests on their printers in the back (at least not without causing a diversion), but thankfully, it doesn't have to come to that:

- ✦ **Just ask.** If you're using a walk-in service, ask the person behind the counter what resolution is best. If you're using a web service, try the Frequently Asked Questions or the Help page, and if you don't find an answer, send the service an e-mail or give them a call.

- ✦ **When in doubt, submit your photos at 300 dpi.** Nine times out of ten, that's what the answer is going to be anyway, but do try to ask first, just to be sure.

Another question to ask: What's the preferred file format? Unless you know for sure that the service provider can read Photoshop PSD files—a safe assumption, but not a definite thing—you should submit your photos in a universal file format,

such as JPEG or TIFF. But finding out exactly which format to use is as simple as asking or scanning the FAQs, and it takes the guesswork out of it completely.

If you're ordering the prints directly through Photoshop Elements, PSD files are fine. (See the "Ordering Prints Online" section later in this chapter.)

Resampling the Photo to the Optimum Resolution

Once you have the optimum resolution, the rest of preparation is a breeze. All you have to do is resample the photo to that resolution. In Photoshop Elements, follow these steps:

1. **Choose Image > Resize > Image Size from the main menu.**
 The Image Size dialog box will open.

2. **Check the Resample Image option at the bottom of the dialog box.**

3. **Choose a resampling method from the drop-down menu.**
 You're downsampling, so Bilinear or Bicubic Sharper is the way to go.

4. **Type the optimum resolution for your printer in the Resolution field, and choose Pixels/Inch from the drop-down menu.** Assuming 300 dpi is your target, type 300.

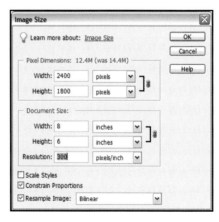

Downsample to your printer's optimum resolution.

5. **Click OK.** The Image Size dialog box will close, and Photoshop Elements will resample the photo to the optimum resolution for your printer.

If you haven't already cropped the photo to the print size you want, now's the time to do it, especially if you aren't printing at home. No matter how much care your service provider takes (or doesn't take) in cropping your work, it isn't as good as you cropping it the way you want it.

When you're finished, be sure to save the resampled photo under a new file name. This way, the next time you need to make a print, you don't have to bother with resampling. Just don't overwrite the original file! If you ever print the photo on a different printer, you'll want to go back to the original file and resample it according to that printer's optimum resolution.

Remember, if you're using a service provider to make prints, the resampled version is the one you want to submit, not the original.

Printing

With your resampled photo files in hand (or in your computer, on a CD, or on a DVD), you're ready to print. In this section, we talk about printing from your computer, printing directly from your camera or memory card, and ordering prints online.

Go to the local office supply superstore, and you'll find aisles and aisles of printer paper stacked to the rafters. It's enough to make the head spin. Which paper is the best for digital photography?

First of all, to narrow down the market a little, look for paper from your printer manufacturer. You tend to pay more, but at least you know that the paper has received the manufacturer's seal of approval. The off-brand or generic stuff can't say the same, so you don't know how it's going to work out.

Second, look for paper for your specific printer model or model family. Some papers work well with high-end printers or certain kinds of inks, but not so well with others.

After that, go for the photo print stuff rather than the general-purpose stuff. Photo paper has a special coating that prevents the ink from scattering or bleeding, which makes your prints sharper and longer-lasting. You probably use your printer for more than just making prints, so get yourself some general-purpose paper too, and save the photo paper especially for your photography.

Printing from Your Computer

To make prints from your computer using Photoshop Elements, follow these steps:

1. **In the Editor, open the file you want to print.** If it's already open, make sure it's selected in the Photo Bin. Remember, the resampled version is the one you want, not the original!

2. **Click the Print button or choose File > Print from the main menu.** The Print Preview dialog box will appear.

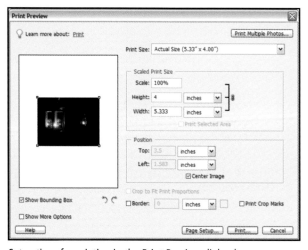

Set options for printing in the Print Preview dialog box.

The Print Preview dialog box warns you if the image resolution is less than 220 dpi. You're already well in control of the resolution situation, so this message shouldn't come as a surprise. Also, depending on your printer, a resolution below 220 dpi may be perfectly fine, so don't let Photoshop Elements rattle you.

3. **Click the Page Setup button at the bottom of the Print Preview dialog box.** The Page Setup dialog box will appear.

4. **In the Page Setup dialog box, choose the size of the paper from the Size drop-down menu.** If the print size and the paper size aren't the same, use larger paper, not smaller paper. You can cut off the excess later.

5. **Choose the orientation of the print.** That's either portrait or landscape.

Get into the Page Setup dialog box for more options.

To review and change the printer settings, click the Printer button at the bottom of the Page Setup dialog box. When you do this, a new dialog box will appear. Choose your printer from the drop-down menu in this dialog box and click Properties. It's important to check what's in here, because the printer generally needs to be told if you're using photo paper rather than standard paper. Also, if your printer has different quality settings, you'll want to select the most appropriate. Normally, this is the highest quality setting.

6. **Click OK in the Page Setup dialog box.** The dialog box will close.

7. **Back in the Print Preview dialog box, choose Actual Size from the Print Size drop-down menu.** This way, you won't get any unwanted resampling.

8. **If the paper size in Step 4 is larger than the print size, review the position of the print on the paper.** Reposition the print by unchecking the Center Image option and then dragging the photo's thumbnail in the preview pane. To add crop marks to your print, check the Print Crop Marks option. (Crop marks make it easier for you to cut the paper just right.)

To include the photo's file name and its description metadata, check Show More Options, and then check File Name to print the file name and Caption to print the description.

9. **Click Print.** The Print Preview dialog box will close, and the Print dialog box will open.

Nearly there! Click Print, and you're finished.

10. **Review the printer settings and click OK.** The Print dialog box will close, and Photoshop Elements will send the photo to your printer.

If you want to print two or more different photos at the same time, start in the Organizer instead of the Editor. Select the photos to print and click the Organizer's Print button. You can also start in the Editor as usual and click the Print Multiple Photos button at the top of the Print Preview dialog box. The dialog box for printing multiple photos—the Print Photos dialog box—is a little different than the Print Preview dialog box, but you should be able to use it easily enough.

Watch out, though, because there is a catch. When you print from the Print Photos dialog box, whether it's a single photo or multiple photos, Photoshop Elements imposes a maximum resolution on your image files. By default, this resolution is 220 dpi. If your photos are higher-res—say, 300 dpi—the software goes ahead and resamples the print data to 220 dpi, undoing all your careful preparations from the first part of this chapter.

To make sure that this doesn't happen, click the More Options button at the bottom of the Print Photos dialog box and type your printer's optimum resolution in the Max Print Resolution field.

Printing from Your Camera or Memory Card

You may be able to bypass the computer completely by connecting your camera directly to your printer or inserting your camera's memory card. The exact process depends on your printer, so see your printer manual for the specifics, but it general, it goes something like this:

1. **Connect the camera to the printer or remove the memory card from the camera and put it in the printer.**
2. **From the printer's LCD, select the photos that you want to print.**
3. **Edit or crop the photos using the printer's built-in tools.**
4. **Print the photos.**

The convenience of connecting directly is undeniable, but you usually end up with less than perfect prints. You've seen what an image editor can do for your photos. Even a basic computer application gives you more precise control and better editing options than the most sophisticated printer tools or the editing capabilities of your digital camera. Also, you've seen the kind of resolution and resampling games the computer plays when you leave it to its own devices. Given half a chance, your printer does exactly the same thing. Fiddling around with print sizes and Bicubic Sharper might not be your idea of fun, but if creative decisions and judgment calls have to be made, you might as well be the one to make them.

When you need prints in a hurry, printing directly from your camera or memory card is fine. But for finished, polished, portfolio-quality work, there's just no substitute for taking the longer way around.

Ordering Prints Online

Photo software makes it easy—maybe even a little *too* easy—to order prints of your photos online. You need the parents' credit card to complete the transaction, so you may not use this feature much, but just in case, here's what you do in Photoshop Elements:

1. **In the Organizer, select the photos you want to print.**
2. **Click the icon for printing online.** This is the one immediately to the right of the Get Photos icon.
3. **Choose Order Prints from the menu.** The Order Prints dialog box will appear. Now just follow the step-by-step instructions. You'll be surprised (or maybe you won't) by how easy it is to buy things right in your image editor.

Click the icon for printing online and choose Order Prints.

It isn't only Adobe that uses your personal computer to drive business to their strategic partners. The companies offering free photo software make it even more glaringly obvious that they're in it for the deals, not the photography.

If you don't like it when your software tries to sell you prints, there's something you can do about it. Don't buy prints through your software. Take your business to a local provider instead.

Creating a Photo Book in Photoshop Elements

You're nearing the end of our photo book, but how about creating a photo book of your own? The subject or theme can be anything you want: vacation, family, friends, favorite shots, favorite UFO hoaxes—the sky's the limit. When you're finished, you can print the book at home or send it off to Kodak for printing and binding.

This section shows you how to build, design, and edit a photo book in Photoshop Elements.

Photo books and other Photoshop Elements creations have a resolution of 220 dpi. For the best results, all the photos that you include in the project should match the resolution of the book.

If you're printing at home, and if your printer has an optimum resolution other than 220 dpi, choose Image > Resize > Image Size from the main menu right after you create the book, and reset the book resolution to the optimum value, just as you would for an individual photo. Be sure to check the Resample Image option so the print size doesn't change.

If you're ordering your book from Kodak, don't change the book resolution. Resample your photos to 220 dpi instead.

Building the Book

Start in either the Editor or the Organizer workspace. If you already know which photos you want to include in the book, start in the Organizer and select these photos. To add photos to the pages as you go, start in the Editor.

If you know that you're going to change the resolution of the book, start in the Editor instead of the Organizer, and set the resolution of the book before you add the first photo. This way, Photoshop Elements doesn't resample the photos on the pages when the book resolution changes.

Now click the Create button and choose an option from the menu:

✦ **Photo Book Pages.** Choose this option to create a photo book that you order online through Kodak. You're free to print the book yourself on your own paper, but the dimensions of the book pages —10.25×9 inches—don't fit nicely on standard, 8.5×11 sheets.

✦ **Photo Layout.** Choose this option to create a photo book that you print at home. The size of the pages can be 8.5×11 inches, 12×12 inches, 210×297 mm (also called A4), or 300×300 mm.

You want to choose the page size that best matches the dimensions of the paper that you have on hand and the capabilities of your printer. The 12×12 and 300×300 options are for scrapbook-sized pages, so be sure your printer can handle larger scrapbook paper before building the book at these dimensions.

✦ **Album Pages.** This option gives you the flexibility of ordering your photo book through Kodak or printing it at home, depending on the page dimensions that you choose. To go the Kodak route, pick 10.25×9 inches. To print at home instead, choose 8.5×11 inches or A4. Notice that this option doesn't offer scrapbook-sized pages, so if you want to create a scrapbook, go with Photo Layout instead.

For the sake of argument, let's say that you're printing the book at home on standard 8.5×11 paper, so pick either Photo Layout or Album Pages.

Photoshop Elements will open the Photo Creations dialog box:

1. **Under Select a Size, choose the dimensions of the pages.** If you chose Photo Book Pages from the Create menu, you have one choice: 10.25×9 inches. Otherwise, pick the page size that makes the most sense for your printer. You're printing the book on regular paper, so choose the option for 8.5×11 inches.

If you're creating Album Pages, the available choices for the graphical theme (see Step 3 below) depend upon the page size.

2. **Under Select a Layout, choose the layout of the pages.** You don't have to use the same layout on every page of the book. This is just to get you started.

3. **Under Select a Theme, choose a graphical theme for the pages.** As with the layout, you don't have to use the same theme on each page.

4. **Under Additional Options, make your selections.** Check Auto-Fill with Selected Images from the Organizer to use the photos you selected in the Organizer workspace, and check Include Photo Captions to add the captions to the pages. If you call for more than one page in the Number of Pages field, all the pages will have the same layout and theme from Steps 2 and 3. You can always change the layouts and themes later, but you might find it easier to start with one page now and add additional pages to the book as you go, designing each with a different layout and theme.

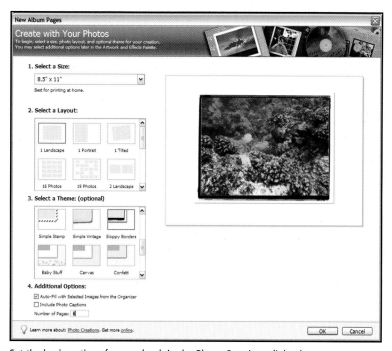

Set the basic options for your book in the Photo Creations dialog box.

The maximum number of pages per book file is 30. To make a longer book, simply break it into two or more files. An 80-page book, for instance, needs two 30-page files and a 20-page file.

Kodak books must be at least 20 pages in length, but you don't have to add all 20 pages right now. You can always tack on the pages one at a time once you've built the book.

5. **Click OK.** The Photo Creations dialog box will close, and Photoshop Elements will build the book according to your choices.

In the Editor, you see the various book pages in the Photo Bin. To select a page, click its thumbnail. You can page forward or backward through the book by clicking the arrow icons directly above the Photo Bin. To rearrange the order of the pages, select a thumbnail in the Photo Bin, drag it to its new place in the book, and release the mouse button.

Your book appears
in the Editor.

Working with Frame Layers

To see how Photoshop Elements composes the book, have a look at the Layers palette. The theme you chose in Step 3 appears in the Background layer, while the photos appear in special layers called *frame layers*. Each photo on the page gets its own frame layer.

A frame layer has two parts—the frame itself and the photo inside the frame. The size of the frame determines how much of the photo appears on the page. If the photo is larger than its frame, the frame essentially crops the photo. You can also change the photo inside the frame without changing the frame itself, just like you can replace the photo in the frame that you keep on your dresser or your bedroom wall.

Working with frame layers is pretty easy. First, select the frame layer in the Layers palette. Then:

✦ **To edit the frame and its photo at the same time, single-click the photo with the Move tool.** You can scale, rotate, transform, or reposition the frame along with the photo inside it. Just make sure to check the Show Bounding Box option in the tool properties.

✦ **To edit the photo in the frame without affecting the frame itself, double-click the photo with the Move tool.** A slider control will appear. Drag the slider to the left to scale the photo down, or drag the slider to the right to scale the photo up. To reposition the photo inside the frame, drag the photo with the Move tool.

This photo is much larger than its frame, but you can easily fix that.

Rotate the photo along with its frame.

To transform the photo independently of the frame, drag the handles on the edges of the photo, drag the Rotate knob, or click the Rotate button next to the slider. To put a different photo in the frame, click the folder icon next to the slider. When you're finished, click the check mark icon to confirm your edits or click the cancel icon to scrap them.

✦ **To make the frame the same size as the photo, right-click (Windows) or Command-click (Mac) the photo and choose Fit Frame to Photo from the context menu.**

Move the photo without changing the position of the frame on the page.

Resize the frame to match the dimensions of the photo (and move the frame to the right to make room for some text).

✦ **To empty the frame, right-click (Windows) or Command-click (Mac) the photo and choose Clear Photo from the context menu.** Don't choose Clear Frame! That gets rid of the frame, leaving the image by itself on the page.

✦ **To add a new frame layer to the page, drag the selected layer to the Create a New Layer icon in the Layers palette.** This will duplicate the frame layer. Now just reposition the copy with the Move tool and replace the photo inside the frame.

✦ **To change the stacking order of the frame layer, drag the selected layer to a new position in the Layers palette.**

✦ **To delete everything in the frame layer, click the trashcan icon in the Layers palette.**

Frame layers have the blue starburst icon to the right of the name in the Layers palette, which means they have a layer style. Double-click the icon to edit the style.

Changing the Theme of a Page

We've said it before, but it's worth saying again: Each page in your book can have a different graphical theme. To change the theme of a page, follow these steps:

This page would make a good cover for the book. Now, how about a summery theme?

1. **Select the page in the Photo Bin.**

2. **In the Artwork and Effects palette, click the theme icon.** This is the second icon from the left at the top of the palette. If you don't see the Artwork and Effects palette onscreen, choose Window > Artwork and Effects.

3. **Under Themes in the Artwork and Effects palette, choose a theme category from the drop-down menu.** The available choices in your selected category will appear in the palette.

4. **Drag a theme from the palette to the page.** Photoshop Elements will apply the theme to the page.

Apply the new theme, and the design of the page changes. You get a new background and a new frame style for the photo.

Play with the layout and add some text, and you have a book cover.

Adding New Pages to the Book

There are two ways to add a page to your book in progress:

+ **Add a blank page.** A blank page is just a simple white background with no graphical theme and no frame layers. You're free to fill this page with whatever you like. To add a blank page, choose Edit > Add Blank Page from the main menu.

To add a frame layer to a blank page, go to the Artwork and Effects palette, and drag any theme onto the page. Choose the No Theme option if you don't want background graphics on the page.

✦ **Add a page based on an existing layout.** The existing layout can be one that Photoshop Elements created automatically when you built the book, or it can be a custom layout you designed by adding and rearranging the frame layers. Just select the page whose layout you want to copy, and then choose Edit > Add Page Using Current Layout from the main menu.

Saving and Printing the Book

To save your book, choose File > Save or File > Save As from the main menu. If the book contains more than one page, Photoshop Elements will save your work in PSE format instead of the more usual PSD. PSE files are fine to send to Kodak, but other print services may not be able to read them, so you should probably ask if PSEs are okay before you submit your book for printing.

Printing the book at home is a simple matter of clicking the Print icon in the Editor. The Print Preview dialog box will appear as usual. Click the Print button in this dialog box, and you're on your way.

If the page size of your book doesn't work with your printer—for instance, if you built a Kodak book that you decide to print at home instead—you will get the Print Clipping Warning message box, which tells you that the pages don't fit. Click the Scale to Fit Media option to resize the pages to fit your printer. Keep in mind, though, that any sort of scaling involves resampling and possibly also distortion, which can affect the appearance of your work.

If your printer doesn't like the dimensions of your book pages, you can scale them to fit, although you might get some distortion.

To order a copy of your book from Kodak, click the icon for printing your photos online (the one to the right of the Print icon) and choose Order Kodak Photo Book from the menu. Photoshop Elements will connect to the Kodak site and step you through the order and checkout process.

Be sure to save your book before you place an order with Kodak. If you don't, Photoshop Elements will bark at you and prompt you to save.

Making Other Photo Creations

The photo book is just one print project you can build in Photoshop Elements. There are about a half dozen others. Most of them are very similar to the photo book in that you start out in the Photo Creations dialog box, where you set the basic options for the size, the number of pages, the layout, and the graphical theme. Photoshop Elements builds the project to your specifications with frame layers, just like the frame layers from the photo book. You can freely change the layout by adjusting these layers, and you can change the appearance of a page by dragging new themes onto the canvas from the Artwork and Effects palette. To add additional text—a silly poem or a personalized message on a greeting card, or maybe the names of the tracks on a CD jacket—use the Type tools.

Here's a quick rundown of the other print projects in Photoshop Elements:

✦ **Greeting card.** This project gives you something more like a post-card than a card that you fold and open. You can print the card at home, or you can order prints online on the parents' good credit. To make a greeting card, click the Create button and choose Greeting Card from the menu. To print your greeting card at home, click the Print button as you normally would. To buy a print of your greeting card, click the icon for printing online and choose Order Photo Greeting Card.

✦ **CD jacket.** This project creates an insert for a CD jewel case. You fold the insert in half with the printing on the outside. The inside is blank. To make a CD jacket, click the Create button and choose CD Jacket from the menu.

Build a greeting card from a photo, a theme, and some paragraph text.

It looks to me from this CD jacket that Stellar's music is heavy on the synth solos.

✦ **DVD jacket.** This project gives you an insert for a DVD box. As with the CD jacket, you fold the insert in half with the printing on the outside. Click Create and choose DVD Jacket to do this project.

The front of the CD or DVD jacket is on the right side of the canvas, while the back of the jacket is on the left side of the canvas.

✦ **CD or DVD label.** This project gives you a label to stick on the top of a CD or DVD disc. For best results, use specially designed adhesive labels. To do this project, click the Create Button and choose CD/DVD Label from the menu.

Design DVD jackets for your home movies.

If you're filming your exploits, you might as well put a custom label on the DVD.

✦ **Photo calendar.** In this project, you take any 12 photos and turn them into a calendar through Adobe Photoshop Services. You build the calendar online rather than in Photoshop Elements, and you pay with a credit card. (Unfortunately, there's no option for printing the calendar at home, so you have to pay.) To get started, select 12 photos, click the Create button, and choose Photo Calendar from the menu.

Phooey on credit cards! Here's a photo calendar that you *can* print at home. All you need are 12 photos and a 24-page Photo Layout or Album Pages project. Put the photos on the odd-numbered pages. Then design the grids for each month with the Type tools, and put these on the even-numbered pages. Enhance with seasonal themes.

✦ **PhotoStamps.** The people at PhotoStamps create honest-to-goodness, completely usable U.S. postage from your photos. Like the photo calendar, you build the project online and you have to pay with credit card. To create PhotoStamps, select your photos in the Organizer, click Create, and choose PhotoStamps.

And these projects are just what you can do in Photoshop Elements. There's software out there for building anything else you can imagine. So if your image editor doesn't give you exactly what you want, fire up your favorite search engine and see what other applications are available.

One of the advantages to working in Photoshop Elements is that a lot of other graphics and design applications can read PSD files just fine, but this isn't always the case. When you work with your photos in other applications, you might need to convert the photo files from your image editor's native format to JPEG or TIFF. This highlights another good feature of Photoshop Elements—it saves files in all the major formats.

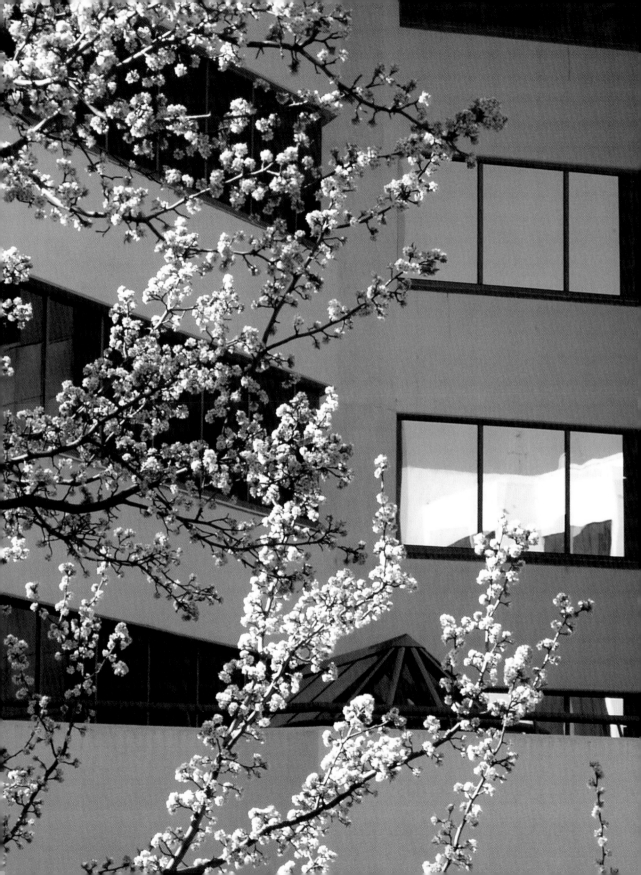

Index